Conservation of Photographs

Including Information on:

- *Collection Management*

- *The Stability of Black-and-White and Color Photographic Images*

- *Preservation by Means of Photographic Reproduction*

- *Restoration of Deteriorated Artifacts*

© 1985 Eastman Kodak Company
Library of Congress Catalog Card No. 84-80244
ISBN 0-87985-352-2

Cover: The photograph on the cover is a platinum print reproduction by Alvin Langdon Coburn of an original photograph by Julia Margaret Cameron. The original made by Mrs. Cameron in 1865 is entitled "The Whisper of the Muse." It is a study of George F. Watts, the painter, and two children.

Mrs. Cameron is one of the most important artistic photographers of the 19th century. Photographic historians believe her friendship with Watts undoubtedly provided the artistic inspiration for many of her compositions. Coburn made this reproduction nearly 50 years after the photograph was taken to commemorate the accomplishments of a 19th century leader in the use of photography as art. This print is from the Alvin Langdon Coburn Collection at the International Museum of Photography at George Eastman House.

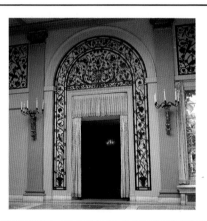

Scattered throughout this publication are photographs of architectural motifs from the George Eastman House. Mr. Eastman took a personal interest in these motifs, selecting many of them himself. They are extraordinarily beautiful in themselves and for this reason we have chosen to illustrate some of them in this book. Following are some notes about several of those shown.

The iron work on the doorway arch and panels shown above are from the Marble Room and were done by the famous iron craftsman, Samuel Yellin. The scrollwork has been honored by the Smithsonian Institution.

Carvings are prolific throughout the house, and are usually rendered in the classical tradition. Several illustrated here are from the fireplaces in the mansion. The fireplaces were usually made of Italian marble.

The spindles in the stairway in the entrance hallway have three distinct designs which are repeated in sequence. They represent rope designs which Mr. Eastman saw on board a ship.

Photos of architectural motifs and photographic equipment at the Museum by Don Buck, Eastman Kodak Company Photographic Illustrations Department.

Design by William Sabia

Contents

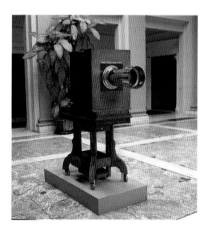

*A turn-of-the-century portrait camera by
the Folmer Graflex Corporation.*

Preface

Since the early nineteenth century, photographs have provided a historical record and a source of information about their times. For this reason, art galleries, museums, archives, libraries, historical societies as well as government, business and private individuals all have an interest in the preservation and restoration of photographs. Through the years there has been relatively little factual information published on this subject. As a result, while there are some conservators who know a great deal about photographic conservation, there are many custodians of collections who have little knowledge or experience with photographic materials and processes and how they affect the lifetime of a photographic image. Similarly, they have no knowledge of the techniques and procedures that can be used to preserve or restore photographs.

In recent years there has been concern over the image stability of photographs, particularly that of color photographs. Sharing that concern and to meet the information needs of photographic conservators, Eastman Kodak Company has brought together in this publication the best information it can offer on the photographic image, both black–and–white and color, and the factors that determine its stability. In a chapter devoted to color images, the company states its position on their stability as well as its procedure for testing the stability of its color products. Information is also included in the publication on collection management and restoration of deteriorated images.

In preparing this publication, Eastman Kodak Company drew upon the expertise of many individuals and institutions both inside and outside the company. Mr. George T. Eaton served as author of the publication. He was formerly a research chemist at Eastman Kodak Company where he was involved in the field of photographic processing chemistry. While he was with Kodak, Mr. Eaton served as an assistant division head in the Research Laboratories.

In compiling the information for this publication, Mr. Eaton drew upon the vast technical resources of the company. Of particular importance was the assistance of Charleton C. Bard, Ph.D., and William E. Lee, Ph.D., both of the Photographic Technology Division who provided the most current technical information and scientific data on the subject of image stability. Dr. Bard and Dr. Lee possess technical expertise on the subject which they have provided to many organiza-

tions as well as to this publication. In addition to his position as supervisor of the Image Stability Technical Center of Eastman Kodak Company, Dr. Bard is a member of the following national committees:

Advisory Committee on Preservation to the National Archives and Records Services, United States.

Advises the National Archives on appropriate methods for preserving historically valuable artifacts in the Archives.

Advisory Committee on Preservation Technology of the Society of Photographic Scientists and Engineers.

Advises on the appropriate technology to preserve photographic materials.

American National Standards Institute Task Group on Stability of Processed Color Photographic Materials.

Establishes test methods for processed color photographic materials that will predict the stability of these materials to the various factors that can cause fade.

Working Group on Storage of Motion Picture Films, Society of Motion Picture and Television Engineers.

Identifies the best method for preserving and restoring motion picture films.

Dr. Bard regularly consults with museums, historical institutions and other organizations throughout the country and has discussed this subject with the conservators, archivists, and concerned individuals in those institutions. This has provided an exchange of technical data which has proven valuable to both parties. It has allowed Eastman Kodak Company to learn first hand of the needs and experiences of photographic conservators and to include this information in the documentation of the subject. Among the institutions Eastman Kodak Company has consulted with on the subject of image stability have been the following:

American Film Institute
Columbia University
Environmental Protection Agency
International Museum of Photography
 at the George Eastman House
Institute of Photographic Chemistry,
 Academia, Sinica, Beijing, China
Library of Congress
Lyndon B. Johnson Presidential Library
Metro Goldwyn Mayer
Museum of Modern Art
National Archives
National Bureau of Standards
National Film Archive, Australia
National Film and Television Sound
 Archives, Canada
National Geographic Society
Porter Conservation Services
Public Archives of Canada
Rochester Institute of Technology
Royal Observatory, Edinburgh, Scotland
San Diego Historical Society
Smithsonian Institution
United States Navy
University of Texas Humanities Research Center

Many other scientists and specialists in the manufacturing and marketing divisions of the company provided data.

Mr. Grant Romer, chief conservator at the International Museum of Photography at the George Eastman House, reviewed and contributed significant information to several chapters of the manuscript: Collection Management, Early Processes, and Restoration of Deteriorated Artifacts. In addition, staff members at the Museum provided additional information and assistance.

Miss Elizabeth Eggleton of the company's Commercial Publications Department was the editor.

Eastman Kodak Company

Using Photographic Chemicals

Before starting the text of this publication, it seems appropriate to say a few words about the safe handling of photographic chemicals and chemical experimentation. All chemicals should be handled with care. Unnecessary skin and eye contact should be avoided as well as inhalation of dust or vapors. Packages of Kodak chemicals bear precautionary labels where necessary. Additional health and environmental data, and safe handling recommendations are described in the Material Safety Data Sheets on our products. Conservators should have some knowledge of chemistry and of the methods of mixing and storing solutions made from chemicals. Technicians and trainees should be given appropriate instruction on proper use and safety procedures before using chemicals or solutions of them.

Safe Handling of Photographic Chemicals

Some of the chemicals and chemical solutions described in this publication are caustic, toxic or otherwise hazardous to health if not used and handled with great respect. They can also be hazardous to photographic collections and artifacts if not kept in a separate laboratory or darkroom area located away from collections.

There are several general conditions that should be observed by the photographic conservator when handling photographic chemicals:

1. All chemicals and chemical solutions should be kept in an area separate from photographic collections and should be carefully labelled. The label should include the name, date of preparation, and warning instructions.

2. Some chemicals should never be stored or used in a photographic darkroom especially those that can affect unexposed film and paper.

3. Chemicals considered most hazardous or chemicals that are legally controlled should be kept under lock-and-key and under the control of a knowledgeable custodian. They should be kept away from untrained personnel especially in a home darkroom.

4. Volatile liquids should be stored in tightly closed containers in a vented area and in as cool a place as possible.

5. Chemicals or solutions should not be stored in a refrigerator used for food because they may contaminate food or be mistaken for edible materials.

6. All chemical mixing should be done in a laboratory space, separated from both the collection storage area and the darkroom (if there is one), that is well ventilated and equipped with an efficient fume cupboard or hood. Similarly, the area in which the mixed chemicals are used should have adequate ventilation. For a discussion of processing room ventilation, refer to Kodak publication No. K-13, *Photolab Design*.

7. No smoking, food, or drink should be permitted in a laboratory, darkroom, or photographic collection area. Laboratory glassware should not be used for either eating or drinking purposes. Mistakes do and have occurred involving contamination of a luncheon drink by some unknown chemical in an unclean beaker.

8. Skin and eye contact with chemicals should be avoided. In case of accidental skin contact, flush with plenty of water. If chemicals are splashed into the eyes, the eyes should be washed at once with running water for at least 15 minutes and medical attention sought. A hose for washing the eyes should be kept attached to a cold water or tempered water tap in the chemical mixing area.

 Some constituents of photographic solutions can cause an allergic skin reaction especially following prolonged or repeated contact. This allergic reaction is most commonly caused by developers but it can be caused by other solutions as well. In case of skin contact with a photographic developer immediately flush with plenty of water and apply a pH balanced soap, such as Phisoderm—ordinary soaps, which are alkaline, are not so effective.

9. A waterproof apron and protective gloves should be worn when mixing solutions. Safety glasses or goggles should also be worn when mixing or handling chemicals. Protective gloves should be worn during processing operations to keep chemicals off the skin.

10. Spilled chemicals should be cleaned up as soon as possible. Contaminated surfaces may lead to skin contact and dermatitis. Powdered chemicals or the residue from dried solutions may become airborne and be inhaled, or they may contaminate other solutions and the collection storage area.

11. Used chemicals should be disposed of safely. The most common method of disposing of used photographic solutions is to flush them down the drain with a good quantity of water. To avoid undesirable chemical reactions between solutions, they should be discarded one at a time and plenty of water run into the drain after each solution is discarded. However, before disposal of any chemicals the Material Safety Data Sheets should be consulted for recommended disposal procedures. Water pollution is of paramount concern. Therefore, in case of doubt, local authorities should be consulted. Federal, state, and local regulations take precedence.

If emergency poison information is needed about a Kodak product, Eastman Kodak Company maintains a 24-hour telephone service to answer urgent questions. The telephone number in the United States is 716-722-5151. Inquiries from Europe and Africa may be directed to Kodak Ltd., Harrow, England, phone number 01-427-4380; inquiries from Asia and the Western Pacific to Kodak Australasia PTX Ltd., Coburg, Victoria, Australia 3058, phone number 03-350-1222 Ext. 288. Additional information on the safe use of photographic chemicals can be found in the Kodak publication J-1, *Processing Chemicals and Formulas*, and in the publication *Chemicals in Conservation: A Guide to Possible Hazards and Safe Use* (see the bibliography for further information on this publication). Questions regarding chemical characteristics and use can be obtained by writing directly to the Customer Technical Services Dept., Eastman Kodak Company, Rochester, N.Y. 14650. Material Safety Data Sheets can be obtained on specific Kodak products from Publications Data Services, Eastman Kodak Company, 343 State St., Rochester, N.Y. 14650.

Chemical Experimentation

During the early years of photography, especially in the nineteenth century, photographers were often chemistry experimenters. They had little or no formal chemical training and serious accidents were frequent. Fortunately, during the twentieth century, photographic manufacturers have supplied most processing chemicals in proprietary packaged form or as published formulas based on approved chemicals and mixing procedures. Therefore, serious accidents are rare especially when the user has some knowledge of chemistry or when appropriate safety procedures and attention to instructions are followed.

However, there are two areas of experimentation today included in conservation studies in photography. Kodak recommends that no one undertake work in either of these areas unless they have been educated in the safe and proper use of the procedures and chemicals involved. One of these involves the possible use of potentially hazardous chemical solutions in image restoration studies and techniques. Some of the chemicals employed are foreign to the general practice of photography and photographic conservation. Therefore, it is very important to have specific information and instruction in the use, preparation, storage, and disposal of these chemicals. This information should be readily available from your suppliers of these chemicals.

The second experimentation area involves attempts to repeat or regenerate the older nineteenth century processes; for example, making daguerreotypes, albumen paper, or collodion wet plates. Chemical and photographic knowledge are mandatory in order to avoid some of the nineteenth-century hazards from explosions and poisons.

The formulas for the processing chemicals and solutions mentioned in this publication are given in the appendices. For information on other chemical solutions see Kodak publication J-1, *Processing Chemicals and Formulas*.

Chapter I Introduction

Conservation has been associated most often with the protection of our nation's natural resources. In recent years, however, it has also come to be of significant importance in the preservation, use, and restoration of some of our most valuable artifacts in public and private collections. Such artifacts may include books and printed papers in libraries; works of art in museums and galleries; photographs in institutional collections or any of these objects that are privately held — including photographs held in family albums. Quite often, they are pieces of great beauty which not only serve as a source of aesthetic pleasure but also provide important historical information. Whatever the reason for their value, the realization is becoming more acute that not all of these artifacts will last year after year without some deterioration unless they are properly protected. Photographic artifacts, because they are derived from chemical materials which may be unstable by nature, are also subject to deterioration. It is to this area of conservation that this publication is addressed.

The American Institute of Conservation of Historic and Artistic Works (AIC) characterizes *conservation* as an activity encompassing *preservation and restoration*.[1] It defines the initial objective of preservation as action taken to prevent or retard deterioration. In the case of photographic conservation this includes the initial processing of the print for long term stability, displaying and storing the photographic artifact in an environment that will be hospitable, or the systematic duplication of originals by means of photographic reproduction. It further defines *restoration* as the action taken to correct deterioration. Typically, this involves the use of a chemical or the treatment of a photographic image to restore its original condition and appearance as closely as possible.

One of the greatest tasks facing conservators is the initial action to take and the decisions that must be made upon acquisition of a photographic collection. Such things as space and equipment requirements, staffing, financial planning, and the examination and identification of items must all be decided upon and undertaken. Before any of this can be accomplished, however, the collection must be evaluated and its worth balanced against the funds available for its maintenance.

Photographic collections may contain images made on a wide variety of materials produced during the last nearly 150 years. Little, if any, information may be available concerning the formation of the image and especially the processing and keeping conditions. Some photographs over one hundred years old are in excellent condition while others have deteriorated; in other instances, photographs that are much more recent have deteriorated badly. It is important to know how images were formed in the early processes and how to identify them in a collection. It is even more important for the conservator to understand the structure of contemporary photographic materials, both black-and-white and color, and how they can be processed to provide long-keeping images. Only if today's pictures are processed properly will maximum image stability be obtained.

The permanence of photographic records is dependent upon (1) the stability of the processed materials, (2) the control and completeness of the processing operations, (3) the post-processing treatment (lacquering, texturing, retouching), and (4) the storage and use environment. Deterioration of the photographic image may occur rapidly or slowly depending on the initial processing and the subsequent handling and keeping conditions. Changes may be visible, barely perceptible or invisible. This is so with most photographic processes including color. Before any action is initiated with an original that has deteriorated, it is essential to understand its structure and to diagnose correctly the cause of degradation. Deterioration usually is a progressive change and those pictures showing signs of deterioration should be considered first. Then appropriate action should be taken to prevent further damage to the whole collection. Often this involves changes in how or where the photographic artifacts are stored or displayed.

Considering the uncertainties involved, it is only realistic to assume that a photographic image has limited life as an original. The increased use of photo reproduction — an important preservation technique — has changed this. Modern photographic materials, both black-and-white or color, make repeated duplication possible with very little loss of sharpness, detail or tonal values. Even partially deteriorated images can be copied and printed. Photographic copies can be made to improve detail, change image contrast, or remove

stains by use of appropriate filters. Necessary retouching or airbrush work can also be done to a copy negative or a print made from the negative thus providing an improved rendition of the original while it remains intact and safe from handling or environmental effects. Thus, the life of an image and the information it carries can be substantially extended while preserving the original with its greater value.

When the original condition or appearance of an image has deteriorated and the cultural or historical value warrants it, restoration is sometimes a consideration. This may involve the application of a number of reparative techniques: cleaning, the removal of stains or fungus, retouching or air brushing. Since restoration is a controversial technique among conservators, such work should be performed only under the guidance of an individual who is experienced in photographic restoration. Even then there is no guarantee that the restoration will be satisfactory.

This book will examine all aspects of the conservation of photographs described in the foregoing: from the beginning when a collection becomes a reality and preservation a concern, to the types and causes of deterioration, the various methods of preservation available to the conservator or the individual collector, and finally, to the point where deterioration has occurred and restoration of the artifact is necessary if it is to be preserved. An explanation of early photographic processes and the structure of photographic materials is also included so that the complexity of the photographic artifact in terms of today's preservation and restoration techniques will be better understood. Not included in this publication is information on the conservation of motion picture and microfilm materials. For information on these applications, see the bibliography in the Appendices.

Chapter II Collection Management

Photographic collections exist for many reasons. They may have been carefully acquired through donations or by the systematic purchase of important cultural or historical objects, or they may have been incidentally amassed. The value of the individual pieces may vary considerably among themselves. There are collections of historical, aesthetic, scientific, educational, commercial, and personal value. Often, due to the documentary nature of the photograph, collections can have multiple qualities of interest far beyond their original purpose in being made. The number of pieces in a collection may be very few or they may be counted in the hundreds of thousands. Some collections are carefully organized and conserved. This, however, is an exception to the rule. Most collections, whether small or large, public or private, need a great deal of care if they are going to be useful and survive.

The varied nature of photographic collections makes it very difficult to give specific advice which would be of service to all. This difficulty is made all the more complex by the variety of photographic materials which have come into existence since 1839, which will only be added to in time. Photographic collections may contain a single type of photographic image or a wide range such as glass plate negatives, film negatives, prints, microform records, motion picture films, color negatives, transparencies, and prints or photographs made by a variety of early processes. Each of these materials can have its own conservation problems, requiring special treatment. Collections made up of a great variety of materials have very large management problems compared to collections of only one form of photograph. Further, the many different usage demands put upon a photographic collection will significantly alter the approach to organization and care.

There is one important factor that is universal among collections. A mismanaged collection will surely result in the degradation and destruction of its contents. Photographs, in particular, are extremely vulnerable to damage from mishandling and neglect. Many photographs, both vintage and contemporary, bear the marks of human indifference or ignorance of the factors which are harmful to them. Although photographic images from the 19th century abound today, they reflect only a small proportion of those that were made. A general consciousness of the value of photographs as cultural artifacts has only just begun to evolve. If the world's photographic heritage is to be preserved for the future to use, it is necessary to address the issues of preservation now. The first place to begin that process is with establishing sound methods of collection management.

Initial Steps

Once a decision has been made to establish a collection management program, the twin tasks of organizing and protecting the collection begin. Such factors as the value and purpose of the collection, the conservation interests of the institution and its long range plans for acquisitions must be considered. By whatever means a collection is acquired there should be a clear understanding, in writing, of any restrictions that may be attached to the use of the collection or any part of it. All questions relating to legal ownership of the collection should be resolved before acceptance in order to assure full-title ownership, freedom from copyright problems, and disposal rights. Legal rights and obligations of owners and users of photographic collections are discussed in a later section. The next activity should be to survey the collection and determine three points of information necessary for planning:

1. The number of photographs in the collection and their approximate volume.

2. The types of photographic processes represented and their comparative numbers.

3. The general condition and conservation requirements of the various types of photographs in the collection and the special requirements of individual ones which might require advanced care.

The first point of information is achieved by counting and measuring, but the other two require specialized knowledge and skill. It may be necessary to seek help from experienced photographic conservators or scientists in determining the types of photographic materials and the current recommended ways of tending to their conservation needs. Those institutions with large photographic collections and long experience in the science of photography are best looked to for advice. Archivists should be particularly alert for collections containing large quantities of photographic negatives on cellulose

nitrate support. This material can present serious fire hazards and threaten other photographic materials. For further information on this subject, see the chapter on deterioration.

Figure 1 If a stabilization treatment is required, cotton gloves should be worn to protect the artifact. Large or brittle items should be picked up with two hands. Jerry Antos.

During this work, items may be encountered which require some immediate stabilization treatment to prevent serious loss or damage, such as in the case of a daguerreotype without a protecting cover glass or a badly shattered negative. Temporary methods of securing such items until permanent treatment can be carried out are described fully in the chapter on deterioration. Such material awaiting treatment should be segregated from the main collection in appropriate containers and clearly marked to prevent further damage through handling.

In the case of new material entering an existing collection, it is very important to inspect it thoroughly and the containers it arrives in for the presence of gross dirt, mold or insect infestation. Photographs are particularly susceptible to such deleterious elements, particularly if they have been long neglected in poor storage conditions such as are found in basements and attics. This inspection is best done in an area permanently reserved for such work and far separated from the main storage facility. Infected material should be well isolated and possibly, after thorough review of its importance and options for treatment, be discarded since the problems may spread to "healthy" material.

When a general idea of the number, nature and preservation needs of a collection has been gained, it is then possible to begin to formulate an appropriate policy for its use and care which will be commensurate with the function and resources of the collecting institution or individual. An ideal program assures that the collection be safely housed in a controlled environment appropriate for the material with each item carefully housed and conserved to the optimum level possible. The entire collection should be thoroughly identified, cataloged, and arranged in an easily accessed manner and utilized to its maximum worth. The collection should be maintained by a trained staff in a facility designed specifically for the collection. Such a staff should have some knowledge of photographic history, the factors that cause deterioration of photographs and the current methods of conservation. Some knowledge of restoration procedures and experience in working with them is also necessary. Unfortunately, there are few such ideal situations for collections and the ways of achieving such an ideal are far beyond the means of most custodians.

The cost of special storage facilities, enclosure materials, adequately trained staff, and the techniques involved in preservation of photographs is a prime consideration in planning. Circumstances will often dictate that priorities must be set based upon the intrinsic worth of individual items or their practical worth to the individual or institution faced with caring for them. In certain instances, decisions must be made to limit the size or nature of a collection to manageable dimensions, or to extend a conservation program to only certain parts of a collection. There is often a serious dilemma in deciding whether to extend efforts in preservation to badly deteriorating materials or to maintaining material in good condition. Whatever the case, these decisions should be made with due deliberation and with the best information about the photographs which can be gained.

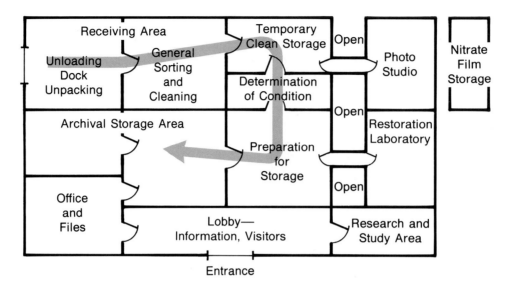

Figure 2 The drawing illustrates an ideal conservation area for photographic collections. The primary conservation functions are indicated in this floor plan. They are not drawn to any given scale. The ideal flow of operations indicates a receiving area, a temporary clean storage area, an area for determining the condition of the artifact and the future action to be taken, space in which the artifact is prepared for final storage (enclosures etc.) and the archival storage area. The restoration laboratory, photo studio, and nitrate film storage area are physically separated from the collection area. The arrow indicates the normal flow of operations with the artifact sometimes being diverted to the photographic studio or the restoration laboratory. Available space and financing will dictate the degree to which this design can be realized.

Space and Equipment Requirements

When the purposes and contents of a collection are thoroughly established, the space required to house the collection must be estimated. Ideally there should be a receiving area, a temporary clean storage location, an archival storage area, and a restoration laboratory. These are not possible in all cases and compromises will be necessary. The space allocated for the collection must have the proper atmospheric conditions and appropriate storage facilities. *A controlled atmosphere in the storage area is probably the most important protective measure.* In addition, collections of photographs should be organized and stored in such a way as to permit easy retrieval at any time and to permit periodic inspection of the material to make certain that deterioration has not occurred. These objectives can best be accomplished if planned for when a photographic collection, a photographic department, or an archival record is initiated (see the chapter on storage). Once the decision has been made to file and store a collection, the selected filing system should be implemented from the beginning and practiced regularly as materials are prepared and identified. The procedure to be implemented should indicate the work hours required per day or over any other time period and the number of persons needed to accomplish the filing. Filing and cataloging are discussed in detail later in this chapter.

Proposed Staff

There are at least three important functions in the operation of any institution concerned with photographic conservation: management, appraisal, and conservation. Depending on the size of the institution and the qualified staff available, these three functions may be performed by a single individual or by three or more individuals. The management function is concerned with decisions on funding and space and the over–all direction of the project. Appraisal involves the evaluation of the collection either in its entirety or by individual artifact, the institution's viewpoint on the collection, and, in conjunction with the manager, the decision to make acquisitions. Conservation is the responsibility of the conservator or custodian charged with all of the aspects of the preservation and restoration of the photographic artifacts. This requires a knowledge of early and contemporary photographic processing and chemistry as well as practical experience in the latest techniques of photographic preservation and restoration.

Financial Planning

The custodian of a photographic collection also has financial problems to resolve. It requires considerable funding to accomplish good conservation practices. Because of this, it is almost imperative that the custodian

first determines the scope of the conservation program, present and future, and then acquires the necessary financial support to assure implementation.

A proposed budget to maintain a photographic collection should include estimated costs for space, equipment, supplies, and personnel. In arriving at a budget that is in accord with the financial support available, some important questions may arise and some hard decisions may have to be made.

In the case of a proposed new collection, some compromise may be necessary, such as pursuing a part of the long–range plan. In the case of a contributed collection, a preliminary general sorting of the material can be made; the collection can then be placed in temporary storage containers and appropriately identified but without filing or cataloging until funds are available. At that time, the classification can proceed in greater detail.

Periodic Inspection

Much of the deterioration that can be observed in collections of photographs has been compounded by failure to make periodic inspections of the material. In sorting negatives and prints it is not sufficient to provide good environmental conditions and then to leave the material alone for a number of years in the hope that the collection will maintain its original form. There is no substitute for checking for deterioration at regular intervals. In this way, any degrading effects that may be taking place will be seen in time for corrective action to be taken.

Small collections of photographs consisting of a few thousand items can be checked in their entirety in a reasonable time. Larger collections that consist of hundreds of thousands of items must usually be checked by a sampling method, unless continuous inspection is possible.

One method of sampling is to take a few negatives or prints at random from the various containers and examine the material for deterioration. While this system is better than none, it may leave many areas without examination. A more efficient system, such as the following, is suggested: Break the collection down into groups distinguished by essential differences: size, kind of film, origin of the material, or age. Examine 5 out of 100 items in each group. Collections that are systematically filed as discussed in the next section can be sampled similarly.

In the case of new material, inspection should be carried out at two-year intervals until the material is about eight years old. If no deterioration is observed in that time, the intervals can be extended to three years. Older material should be examined every five years; if deterioration has not occurred in twenty years, for example, it is unlikely to do so during the next five years.

This checking system should reveal any general deterioration that may be taking place, but it cannot locate, except by chance, isolated incidences of trouble. These can be located only by examining the whole collection, a procedure that is not feasible if the collection is a large one. When samples are taken from their drawers or other containers, they should be marked so that they can be returned to the same position or to the same sequence from which they were taken. For example old negatives should be examined carefully over an illuminator and compared with freshly processed ones. Any overall yellow stain or uneven brownish stains in the silver image should be noted. Silver sulfide stain often develops on old negatives and is particularly prevalent on old glass plates. This is a grayish stain with a metallic sheen when viewed by reflected light, but which appears brown by transmitted light. See the chapter on deterioration.

Figure 3a The photo above shows silver sulfide stain on an old print. Also called silvering or tarnish. Photo courtesy of Jerry Antos.

Figure 3b This stain can also occur in negatives as illustrated above. Photo courtesy of Thomas T. Hill.

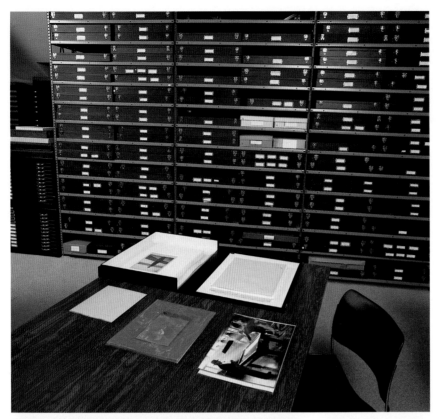

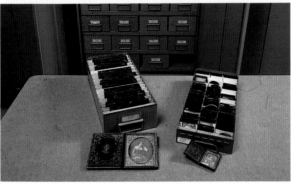

Figure 4 Filing systems used in the archival storage area at the International Museum of Photography at George Eastman House, are shown. Photo on the top shows the print storage files. Prints are filed alphabetically by photographer in large or small print cases which fit into the file. The print cases, one of which is shown in the foreground, are made of special archival material. Center photo shows the storage cabinet for the Museum's collection of daguerreotypes. This cabinet holds ninth-plates and half-plates in drawers which are available through any large supplier. Each drawer contains dividers which can be die cut to the customer's specifications. These dividers each hold a daguerreotype and provide easy accessibility, while protecting the artifact. The cabinets are locked because the collection is important. Photo on the right shows Chief Archivist Joan Pedzick examining a print from the carte dé visite file. This is a small photograph mounted on a card approximately the size of a calling or visiting card used in the nineteenth century. The cabinet and drawers in this file are similar to those used for daguerreotypes. There is a sleeve and a piece of vacuum board for each print. The file is alphabetical by photographer. Many historical societies and libraries use a card-format type of filing. The temperature and humidity are controlled in this archival area. Don Buck, Eastman Kodak Company Photographic Illustrations Department.

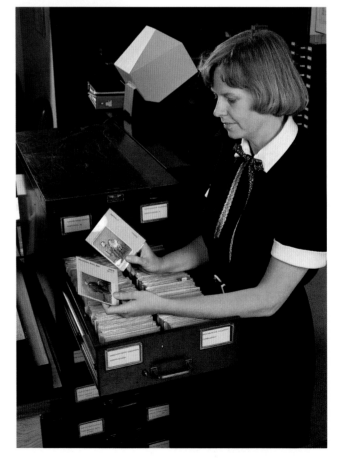

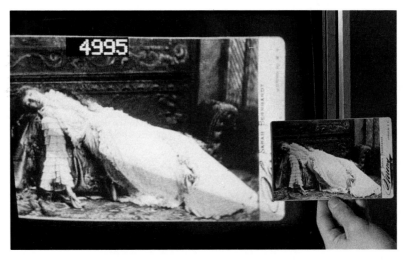

Figure 5 Indexing and cataloging can be done by means of video disc technology. The original photo is on the right. The video disc has had this information recorded on it. The photo on the left shows how it appears on the monitor. The frame number shows on the disc. Courtesy International Museum of Photography at George Eastman House.

Filing and Cataloguing

The design of a filing system requires extensive study of the collection with respect to variations in the size of photographic negatives, prints, and transparencies; the protection of the originals; access to the files; and release of copies or duplicates for external use. For certain collections, the originals should be kept under archival storage conditions and generally, should not be made available for use by the public. In order to accomplish this, two photographic copies should be made of each archival original before it is stored: two copy negatives of photographs; two duplicate negatives of original negatives; and two duplicate color slides or transparencies of color originals. This procedure permits originals of different sizes to be reduced or enlarged to a standard negative size for the master file; the second reproduction provides a scanning file for the public. Another option involves making small standard-size negatives—for example, 35 mm negatives—from which prints can be made for use on visual catalogue cards. A scanning file can also be developed from prints made from the first copy of the original. Some of these techniques are expensive and many involve tasks which are labor intensive and time-consuming so the cost must be weighed against the value of the collection. In addition, they significantly increase the size of the collection. Reproduction is discussed in detail in Chapter X.

Each custodian develops a filing system to suit the collection and its users and, therefore, there are many kinds of filing systems in use.

The major concern to archivists today is to provide not only efficient indexing and cataloguing but safe keeping with easy access to individual artifacts. Many technologies involving word-processing, microfilm, microfiche, video discs, and optical discs are being investigated. Computers certainly will constitute an integral part of any system but only time and experience will determine the best system for the most efficient managment of a collection.

Filing systems, to be effective, must satisfy two basic requirements. First, they must provide for the secure storage of the material, so that it will be well insulated from the damaging effects of dust, finger marks, scratches, abrasion, and pollutants. Second, it must be arranged systematically according to an easily understood classification scheme that will facilitate the prompt location of any article. These requirements apply equally to all materials: to color transparencies mounted as slides, to unmounted transparencies enclosed in KODAK Sleeves, or to prints where no negative exists as is often the case in many historical collections.

Before photographic artifacts are consigned to a central file, the classification system must be set up so that the retrieval of any item will be definite and obvious to others: the reasoning that originally placed an artifact in a certain position in the file must be apparent enough to be duplicated by anyone searching the files for the same artifact at a later date. Equally important is the requirement that the user be able to return the item easily to its proper place in the file after use.

Subject Name. There are many classification systems that will suggest themselves to suit the types of work being done by individual photographic organizations. For the commercial photographer, the name of the subject or client is the best filing key, and alphabetical sequence in the file is usually all that is required. This same self-indexing method is useful to all photographers whose assignments almost exclusively involve human beings: police identification, industrial personnel, passport, and medical photography. Regardless of the filing system employed, the selection of appropriate terminology is one of the most important responsibilities in cataloging individual items in a collection. See the bibliography at the end for an article by Eskind and Barsel on the subject.[2]

Job Name or Number. Commercial illustrators and industrial photographers, on the other hand, are not so concerned with individuals as with jobs or products, and for them filing by product name, company, department, job name or number, or even part or style number is a desirable system. It is only necessary to decide the identifying feature that will best serve the majority of the work. Thus, if the product name is used as the file key, it is imperative that each item be correctly identified by its accurate product name. If job order, part, or style number is the chosen key, then filing should be in numerical sequence. Within classification divisions under one name or number, it is best for convenience purposes to keep the material in chronological sequence in the order in which it is made.

Accession or File Number. If the character of the photographic work is widely diversified or cannot be anticipated well enough to decide between a numerical and an alphabetical system, or if neither system will fit a large portion of the work, then it is necessary to resort to a chronological accession sequence or a "file number" system. In this type of file, all materials are filed in the order in which they are acquired, regardless of subject, and they are assigned file numbers denoting their file locations. Since these numbers are descriptive of file position only and have no bearing on the subject matter, an index and possibly cross-indices are required. The purpose of an index is to find items quickly without leafing through a collection and thereby avoid possible damage.

The master index can be simply an entry log arranged by file numbers and dates in the same order as the items in the file. Cross-indices can be made up by subject name, number, or any other scheme by which the photographs can be described adequately. The file number must be placed on each item and print. See the section entitled "Identifying Negatives and Prints" on the next several pages.

This system allows the location of any photographic image through its file number by one of three possible identifying factors: (a) from the file number; (b) by scanning the accession file in the region of the approximate date; and (c) from the cross-index by subject name, part number, geographic location, etc. The flexibility of this system is obvious, since any new subject category can be entered by use of a new cross-index.

A uniform filing system is not always possible, especially in the case of some acquired collections, which may consist of a mixture of negatives, prints, and transparencies in a variety of forms. Such collections may be very valuable and usually should be protected from public browsing. Sometimes it is advisable for each type of photograph to be filed in its own cabinet and keyed to a numerical accession file with an appropriate cross-index.

Often photographs of older vintage may have wide variations in appearance: they may differ in size; be mounted or unmounted, framed or unframed. They may require copying prior to filing or restoration treatments. Special storage arrangements may be needed for parts of some collections, such as in the case of framed items or oversized pieces.

A master file index utilizing catalog cards may be the most practical approach. All nonstandard size originals can be reduced or enlarged to a standard size: for example, 10.1 x 12.7 cm (4 x 5 inches) or 35 mm. Framed pictures can be copied and printed to file size or catalog card size. The catalog print is then mounted onto a file card large enough so that at least 50 percent of the area is available for suitable descriptive data. A 10.1 x 12.7 cm (4 x 5-inch) print mounted on a 12.7 x 20.3 cm (5 x 8-inch) card is an example of this.

TYPICAL FILE NUMBER AND ITS INTERPRETATION. An example of a typical file number and its interpretation might be as follows:

77-561-9

The first two digits indicate the year in which the photograph was made and serve as a key not only to location but to the review and retention program to be discussed later. The next three digits, 561, are the accession group number assigned serially from the master log. This number is the same for a whole group of photographs taken at the same time of the same general subject. The last number, 9, is the individual serial number within group 561. Letter designations (A, B, C, etc) are sometimes used instead of numbers to indicate individual items within a group.

Other coding systems can be used to suit individual filing problems. For instance, a letter can be inserted in the notation to designate negative size or file drawer, if

different film sizes are kept in different drawers. Or if 35 mm film is filed in rolls, separate from the other film sizes, each frame can be identified by a letter designation for the roll, followed by a frame number, thus:

BXT-23

Between "A" and "ZZZ" in this system, over seventeen thousand rolls can be described, while extension of the system to "ZZZZ" will accommodate almost a half million rolls.

Identifying Negatives and Prints.
Regardless of the classification system used, it is good practice to identify each negative, film positive, print and their respective enclosures. Identification is of crucial importance: if the enclosure is lost, destroyed, or rendered illegible, the item may become useless unless it is of some clearly recognizable subject. If photographs are important enough to preserve, they are important enough to justify careful, consistent effort to provide permanent identification.

Since photographs are often made in groups, it is effective to assign a number or name to each group, and a sequence number to each individual item within that group, as described in the preceding section. Thus, in the subject-type classification, the name used in filing can be abbreviated and followed by a number indicating the particular exposure. If a numerical system is used, the characteristic notation should be the accession or job number, followed by a sequence number on negatives and prints. The group accession number

needs to be written only once on each strip of exposure, but each frame should be identified with its individual sequence number or letter. Of course, every sheet-film negative and every frame of roll film that has been cut apart from adjacent frames should be identified in full.

In the case of negatives, the file number should be placed in an upper corner of each negative file envelope—oriented with regard to its filing position—and the same number should be marked with India ink in the clear marginal area on the back of the enclosed negative. This expedites the return of each negative to the correct envelope after it has been removed for printing. The reason for putting the notation on the base side of the negative is that the number then prints correctly if unmasked contact proof prints are made. See Figure 6a.

The placing of negative identification numbers on the clear margin area should relate to the proper image orientation for the viewer. The recommended location is readily determined when sheet-film negatives are involved because these films generally are notched for product identification by the manufacturer in the upper right-hand corner indicating that the emulsion side is facing the viewer. See Figure 6b. This is not the case when sheet film has been cut in size thereby eliminating the code notch when the manufacturer did not use code notching, or when roll-film negatives are involved. An experienced photographer can readily determine the emulsion side, in these cases, by the rather dull light reflectance from the emulsion side compared to that of the base side. Failing this a very narrow scraping from a density area near the edge of the negative will usually

Figure 6a The file number on both the negative and the envelope is illustrated. The negative number reads correctly when on the base side of the film.

Figure 6b The manufacturer's code notch in the upper right corner of the sheet film indicates that the emulsion side is toward the viewer.

provide the answer (Figure 6c). When the scraping removes the density, the emulsion side has been found and identification numbers should be put on the opposite side.

However, duplicate negatives made on a reversal film such as KODAK Professional B/W Duplicating Film / 4168 (formerly SO-015) require a different approach than indicated above. In order to avoid the printing of a laterally reversed image, the product notch code cannot be used in the normal manner. To be certain that the correct image orientation will be obtained in printing at some future date, the duplicate reversal negative can be identified by removal of the product code notch and placement of a new notch (for example, a punched hole or cut corner) in the upper left-hand corner with the emulsion facing the viewer as in Figure 6d. Thus, when this duplicate negative is printed and the notch is viewed in the upper right-hand corner, the printing operation will produce the correct image orientation. Duplicate negatives made on a reversal film should be numbered on the emulsion side as in Figure 6e as a guide to proper left-to-right orientation when they are printed.

Figure 6c The removal of density indicates the emulsion side of the negative.

It is best not to write complete data for each negative on the face of the negative envelope or other container, since this leads to duplication of information that needs to be written only once on the index card or group enclosure. There is also a possibility that some inks used for this purpose may strike through a paper enclosure and eventually cause disfigurement of the negative.

For some applications, the file number can be written within the exposed area of one corner of the negative; it will thus print automatically on the face of prints made thereafter. This idea is sometimes useful for service-type pictures, but it must be used with discretion to prevent marring a useful area of the scene. It should not be used where future publication is anticipated.

If it is necessary that the file number or a caption and file number be printed photographically on the face of the print, a line-copy negative can be prepared from printed or typed material and bound at the edge of the file negative for simultaneous contact printing. If enlargements are made, the line copy can be double-printed with the copy negative on a contact printer

Figure 6d The manufacturer's code notch has been removed from the upper right by cutting off part of the upper transparent border (note narrower nonimage border compared to that shown in Figure 6b). A new notch has been made on the upper left with the emulsion facing the viewer.

after the enlarging exposure has been made. Another approach to this requirement is the use of photographically opaque stencil material that can be cut with a typewriter. The resulting stencil can be used in the same manner as a line-copy negative.

NOTE: In historical collections, it will usually be found that identification within the image area is on the base side of the film. When the information appears in the border area, it may be on either side of the film, depending on which side held the ink better or some other consideration. If the identification is on the emulsion side of an original negative, there is danger that the person printing the negative may position it so that the identification will read correctly if included in the print or enlargement but the image will be reversed from left to right.

To prevent such inaccuracy in printing, the proper orientation of the negative should be checked, if possible. Internal indications in the image or in other negatives belonging to the same grouping may prove helpful. If the identification prints correctly with the image reversed from left to right, a legend such as "PRINT TO READ OK" can be put along the edge of the negative as a guide to anyone printing the negative at a later time. See Figure 6f.

Figure 6e This duplicate negative on reversal film shows the new notch in the upper left-hand corner but the file number has been placed in the upper left near the new notch. Note that the number is on the emulsion side.

Figure 6f For correct printing of a duplicate negative, the new notch should be placed in the upper right corner with the base side of the film toward the viewer. For further assurance of correct printing, add "Print to Read OK" on the base side near the new notch. Series, Jerry Antos.

Prints are most simply identified by a penciled file letter or number on the back. This designation can be picked up from the negative as it is inserted in the printer or enlarger, and transcribed by the operator with a soft pencil at one edge on the back of the print either before or after the exposure is made and before the processing begins. Any rubber stamping or embossing may lead to future conservation problems or difficulties in treatment. Prints which do not have corresponding negatives in the collection should be carefully identified in the same way. The attaching of identification numbers to photographs can also present serious problems, particularly in the case of early photographs, such as daguerreotypes, paper and collodion negatives, or any multi-elemental photographic object. Some photographs may have been made of materials which are not easily inscribed such as some of the older resin-coated papers. One of the guiding principles of good conservation practice is to never do anything which cannot be easily undone. This conflicts with the interest of some institutions who wish to permanently mark items for security reasons. However, the best security system is an external one. All marking should be discreet, well considered and done with materials known to be neutral.

File Retention Programs. Photographic files may become bulky and require more space than is justified unless the artifacts are of documentary importance. In these cases, separate archival dead-storage files should be provided. In the case of active commercial files, the files should be kept free of the deadwood of discontinued projects, completed jobs, and outdated products by a continuing program of review. One way of accomplishing this is to periodically remove and screen all of the items that have been in the file for certain prescribed times. Careful scanning of each artifact before it is filed will eliminate much useless material by keeping it out of the file from the very beginning. Almost every assignment will have several duplicates and poorly exposed or poorly framed photographs that will never be used. These should be discarded immediately so they will not take up space in the files.

Screening can be done by the head of the photographic department, but it is preferable that it be performed by the department or person who ordered the work originally. All photographs needed for purposes of record or possible future use should be separated and returned to the file. Photographs that are to be discarded should also be returned, but they should be marked for disposal. It is important that items intended for destruction be returned to the photographic department for final disposition. This routing gives the photographers an opportunity to see what is being destroyed and may save time that would otherwise be spent looking for a photograph that is no longer filed. It also allows a note to be made in the accession log as to which items have been destroyed and by whose authority.

Disposal of photographic artifacts by the photographic department also assures that some items are not retained loose in a desk drawer, subject to dust and mishandling, and then later brought out in poor condition for reprinting. At the same time, it prevents the possibility of photographic materials falling into unauthorized hands where their future use cannot be controlled. Finally, the accumulation of discarded black-and-white negatives and prints at a central point increases the likelihood that silver recovery from the scrap will be economically feasible.

Use of Collections

When collections have been evaluated, indexed, catalogued, and placed in safe storage, they are ready for use. This utilization may be very infrequent and light or very heavy. It may consist of purely "in-house" referral or involve outside demands. Whatever the case, it must be realized that use implies the threat of "wear and tear," which must be prevented or kept to the absolute minimum by careful planning and establishment of a "user" policy. Wherever possible, second generation copies should be used. If it is impossible to produce such copies or there is a good reason to use an original, certain standards must be set and implemented.

The space in which photographs are used should be ample, clean, adequately lit, and provided with the necessary work surfaces and tools for safe examination. All photographs being used should have the proper protective enclosure or supports to allow safe handling. *The principles of safe handling and use should be well known to any person entrusted with an original.* These points cannot be stressed too strongly. Institutions which have large collections that are heavily used can provide endless horror stories about materials being lost, damaged, or destroyed through the failure to establish a sound policy for use. It is absolutely necessary to remain constantly vigilant in this regard, particularly when valuable material is entrusted to people unfamiliar with its special requirements. If possible, a professional conservator of photographic material should establish guidelines. Such guidelines might include the following points:

1. After retrieval of an artifact from storage, instructions for careful handling and conditions of use should be prepared to be given to the user with the item.

2. A member of the archive staff should assist in the use of the artifact outside of the museum.

3. There should be collaboration with other museum staff members in order to take advantage of all areas of expertise.

4. Communication between the community and the institution holding the collection is essential so that the needs of both will be met.

Institutions which provide originals or copies of originals as prints, transparencies or slides for research purposes should be certain that the copyright status has been resolved beforehand.

Legal Rights and Obligations

This book is not intended to be a substitute for proper legal advice and therefore no details about the legal rights and obligations of owners and users of photographic collections are provided. Conservators should keep in mind, however, that photographs can be works of authorship protected by copyright if not in the "public domain." Copyright in a work can normally be described as the exclusive right to reproduce, distribute copies of, prepare derivative works from or publicly display the work, although there are certain limitations to that right such as "fair use." Moreover, a distinction exists between ownership of a photograph that embodies a copyrighted work and ownership of the copyright itself. Thus, the sale of a specific photograph does not of itself convey rights in any copyright in the work. Because of the U.S. copyright law and the laws of certain states which may also cover the sale of photographs as works of art, conservators should take advantage of their access to legal advisors to obtain the necessary understanding for buying, selling or reproducing works from photographic collections. The several references in this publication to such transactions assume that the conservator will have obtained appropriate advice before proceeding as described.

Custodial Standards of Practice

It is only very recently that original photographs have been perceived to be artifacts of value similar to rare historical documents and fine art works. The tendency in the past has been to regard photographs very lightly. This attitude has been responsible for the destruction of vast amounts of material. Admittedly, all photographs do not possess equal or great value. However, it is very difficult to judge, even for an expert, what the value of a photograph might become in the course of time. Many a photograph which had very little value at the time of its production has become of great cultural and monetary worth with the passage of time.

Thus, truly responsible custodians of photographic collections serve the interests of the past and future, as well as the present, by applying the highest standards in their practice. This is particularly important when it comes to conservation treatment. The American Institute for Conservation of Historic and Artistic Works (AIC) includes a Photographic Materials Group which is constantly involved in exchanging information and developing techniques and standards for the conservation of photographs. This organization and its membership have endorsed standards based upon long experience and from them are extracted the following

points. Membership in this organization is open to all concerned with the care of photographic collections.

1. All actions should be governed by respect for the aesthetic, historical, and physical integrity of the artifacts.

2. Conservation should be undertaken only within the limits of the professional competence of the staff and the facilities available.

3. Procedures not appropriate to the preservation and/or restoration of the artifact in question should never be used.

4. The conservator should recognize the moral obligation to render an honest opinion on what he/she considers to be the proper preservation and/or restoration treatment and to reach a firm understanding with his/her client or the client's representative on what is involved. The conservator should understand the importance of retaining the cultural value of the information. The owner should be advised of any potential change in appearance, superficial improvement, or lessening of the image stability as a result of the treatment used.

5. Whatever treatment is undertaken, it should be limited to that which can easily be reversed if necessary.

6. Careful records of any treatment or alteration of an artifact should be made and maintained.

7. In the event of a sale, a photographic copy should not be represented as an original nor should restored originals be presented as the originals in an unchanged condition. It is also unethical to withhold any information relative to the copyright or the correct name of the photographer.

8. Reasonable fees should be charged to those who use photographs for profit. A fair fee should be charged for all work taking into account the cost of time and labor, research, materials and insurance, and the degree of talent and creativity needed to do the work. In assessing such fees, representative charges for comparable work should be considered so that the cost of services is neither overestimated or underestimated. The holding archive has the obligation to provide the highest-quality photographic print possible fulfilling normal requirements for suitable reproduction. The using organization has the obligation to acknowledge credit for the source if publication is involved.

9. The conservator should provide prompt services to the institutions' clients; that is, meet delivery dates as promised.

10. The custodian should stay abreast of the current information pertinent to the care of photographic collections.

11. The responsibility for supervising and regulating the work of all auxiliary personnel and volunteers should be under the conservator's direction.

Chapter III Early Photographic Processes

Many photographic collections contain examples of photographs which differ significantly in form, appearance, and material makeup from the common photographic types of our own time. These early forms of photography have particular aspects such as the materials from which they were made and their age which require modifications in the ways in which they are handled, displayed, stored, and conserved. Since all photographs are by no means the same, the problems presented in caring for them are very complex.

There are many reasons why the custodian of a photographic collection should be able to identify correctly the process by which a particular photograph was made. For instance, process identification can be a valuable aid in correctly ascertaining the date of a photograph that has no clue clearly evident in its image information. From the standpoint of preservation, it is an absolute necessity for the conservator to be able to identify the nature of the materials used in photographic artifacts entrusted to his care in order to understand how they deteriorate and how they will react to modern preservation and restoration techniques.

The first one hundred years of photography was characterized by a decade-by-decade evolution and succession of photographic processes. Few were in popular usage for more than a decade and those that were underwent significant modifications as photographers and inventors sought to improve and apply photography evermore efficiently and profitably. One of the most amazing features of photography is that there is a seemingly unlimited number of ways to form a photographic image. No doubt, many ways exist that have not yet been utilized. This fact was a great stimulus to invention in the nineteenth century. There were a great variety of processes that were proposed, introduced, and practiced. Conservators today may encounter photographic images formed of metals, pigments, or dyes suspended in albumen, collodion, or gelatin, on supports of metal, glass, paper, cloth, wood, ivory, ceramic, or synthetic materials. Further, in order to enhance, utilize, and protect these images, another large number of different materials were added to the photographic object without regard for the long-term stability of the latter. Even when it was a factor, the choice was not always a successful one.

There are yet other factors which complicate the task of identifying and analyzing a photographic artifact correctly. Many forms of photographic images were made to imitate the look of another, more popularly accepted image. The photograph was often made to imitate the look of non-photographic forms of imagery, such as drawings or paintings. Frequently, it is very difficult to recognize that an artifact is a photograph or has a photographic element. Still further complications arise from the fact that a form of photography which had popularity in one geographical region may have been totally unpracticed in another, or, a process that had become unfashionable at one time may have come back into vogue years later.

Thus, it requires a great deal of specialized expertise based upon contact with a wide variety of material in order to make correct identifications. Even experts can not always make accurate identifications of processes based on eye inspection alone. Custodians of photographic collections are likely to encounter variant forms of photography which may behave very differently in display, storage, or handling situations from those they are familiar with. Consequently, caution in the use of vintage photographic material must be uppermost in the mind of anyone who wishes to be truly responsible in meeting the obligation to preserve the photographic record for future generations.

Although there exists a great variety of photographic types, there are certain processes that were widely used and survive in great numbers. These processes are the ones that are most likely to be encountered. The information which follows will provide a starting point for those who have no prior experience. It is necessary to combine a study of photographic history with actual experience in examining properly identified examples and comparing one form with another, in order to acquire the ability to identify process examples. A magnifying glass or microscope is a valuable aid in examining photographs. A knowledge of the different ways in which photographs deteriorate is, ironically, often an aid in properly identifying them in order to arrest further deterioration.

Historically, it is a fact that most of the early processes utilized light-sensitive silver salts as the basis for the formation of the photographic image. All silver-based photographic images are troubled by similar and related deterioration problems which arise from chemical attack upon the metallic silver which forms part of the image. This manifests itself as fading and staining.

Table III-1 lists the most common early types of photographs using silver.

Table III-1
Early Photographic Processes Using Silver

Process	Dates of Popularity
Daguerreotype	1839-1860
Calotype-Salted Paper	1841-1860
Wet Plate Collodion	1851-1885
Albumen Paper	1850-1900
Dry Plate Gelatin	from 1880
Collodion Papers	1885-1930
Gelatin Papers	from 1885

The dates given for the era of popularity for these processes are only general in limitation. It is often possible to find exceptions. For example, although the wet-plate negative passed out of general use in the 1880s, it continued to be of use in the photomechanical industry well into the twentieth century.

This chapter contains information on the identification and deterioration of the early photographic processes that used silver. However, there were many image-forming processes which utilized some other material. Many of these were created to avoid the problems of fading and staining that silver-based images are subject to. The major non-silver early photographic processes are listed in Table III-2. Because these processes were not widely used, they are not discussed in this book. Information on them can be found in the bibliography at the end of this book. Suggested restoration techniques for some of the silver-based processes may be found in the last chapter of this book.

Table III-2
Early Non-Silver Photographic Processes

Ferric Processes
 Cyanotype
 Kallitype

Platinum and Palladium Process

Dichromate Processes
 Carbon, Carbro & Three-Color Carbro
 Gum Printing
 Oil and Bromoil

Photomechanical Techniques
 Photogravure
 Collotype
 Woodburytype
 Letterpress/Halftone

Development of the Photographic Process

In the eighteenth and nineteenth centuries the chemical observations that were to provide the basis for the evolution of the photographic process occurred. In 1727, T. H. Schulze recorded that silver chloride was darkened by light. Silver chloride is one of the most important compounds used in photography. In 1737, Hellot spread a solution of silver nitrate on paper and noticed that it darkened when exposed to light. In 1802, T. Wedgewood and Humphrey Davy tried to obtain an image by coating a piece of paper with silver-nitrate and exposing the coated paper in a "camera obscura." This experiment failed. Later by coating the paper with silver chloride instead of silver nitrate, an image was produced but no treatment was known to remove the unexposed silver chloride. It was not until 1837 that J. B. Reade discovered the ability of sodium thiosulfate or hypo (a fixer or fixing bath), to convert the unexposed silver chloride to new compounds that could be removed by washing. Less than two years later the first photographic processes were announced.

Identification of Early Processes and How They Deteriorate

Daguerreotype. This process was the invention of J. L. M. Daguerre, the result of a colloboration with Nicephore Niepce, the acknowledged first individual to successfully make a photograph. The daguerreotype process was announced to the world in France on August 19, 1839. It was the first truly practical photographic process and began the era of photography. Millions of daguerreotypes were made in the years between 1839 to 1860. It was particularly popular in America where surviving examples are quite numerous. The very age of these images makes them important cultural artifacts deserving the greatest attention.

The daguerreotype process is distinctive for many reasons and stands apart from the rest of photography. It is photography on metal and produces an image directly, without the use of any intervening negative. The support for the image is a thin coating of pure silver on a copper subsupport. This silver surface was given a high mirror-like polish which was then sensitized by exposure to the fumes of iodine. After camera

Figure 7 Very early portraits were made by the daguerreotype process. Many had great aesthetic beauty as shown in this photograph. Note particularly, the gold nonimage area, the detailed border around the image, and the rich brocaded design opposite the image. The case in which the image was sealed for protection was usually decorative also. Courtesy International Museum of Photography at George Eastman House.

exposure the plate showed no visible image. The image was developed by exposure to the fumes of heated mercury. The mercury condensed on the plate surface wherever light had hit it during camera exposure. The silver-iodide layer was then dissolved by immersing the plate in a solution of water and sodium thiosulphate. After rinsing, the plate was dried. In essence, the image produced was something equivalent to a painting of white dots on a black velvet ground. The light tonalities of the image were formed by the deposit of mercury which scattered the light while the darker tonalities were formed by the specular reflection of the mirror surface of the plate. Thus, the image appears as a positive only under certain lighting conditions and angles of view, otherwise it may appear as a negative image or merely reflect the viewers face. The initial exposure times were relatively long, making portraiture difficult. However, others discovered that the exposure times could be greatly shortened by additional sensitization with the fumes of bromine, chlorine, or other compounds of halogens. This made portraiture a much easier thing to achieve and the vast majority of daguerreotypes made were portraits. Another improvement of the process entailed a treatment with gold-chloride which enhanced the contrast of the image, altered the cold hue of the image to a warm one, and helped to mechanically stabilize the delicate film of mercury, thus enabling color application with a brush.

Due to the limitations and difficulties of producing a large plate, daguerreotypes were rarely made any larger than 16.5 cm x 21.6 cm (6 1/2 x 8 1/2 inches) known as whole-plate size. The most common size produced was sixth-plate, 6.4 cm x 8.3 cm (2 1/2 x3 1/4 inches). The surface of the daguerreotype is very delicate. The soft silver is easily scratched and the mercury, which forms the image, is very easily wiped away with the slightest abrasion. Therefore, it was necessary to provide a protective enclosure. This enclosure usually took the form of a cover glass, separated from the plate surface by a paper or metal spacer, which also served as a decorative frame for the image. The entire ensemble was then sealed around its edges with paper or animal intestine membrane to hold the package together and make it airtight. Often this package was further enclosed in a decorative and protective case that was usually made of wood and covered with leather although other materials were used as well. Some were framed for wall display or set into jewelry mounts, such as lockets. It is important to consider all of these elements as being as worthy of preservation as the image.

The beginning of deterioration occurs when the protective enclosures suffer damage through rough handling and human tampering or degrade through some inherent factor. Many daguerreotypes are found in excellent condition. However, most show a greater or lesser degree of deterioration through tarnishing or abrasion. Once the original seal of the package ceases to function, sulphur bearing gases and oxidants enter the enclosure and begin to react with the silver. The most obvious result is the formation of a film of tarnish at the edges of the surface of the plate or along the line of a cracked cover glass. This silver-sulphide film grad-

ually thickens with time, going through a transition from light transparent yellow to a deep purple-blue color that is totally obscuring. Uncountable numbers of images have been destroyed by people trying to rub off this obscuring tarnish film.

Although tarnishing is the most commonly recognized form of daguerreotype deterioration, there are many other factors. A very common problem results from the decomposition of the covering glass especially flat glasses manufactured before 1900. Watery droplets may form on the inside of the glass, thus obscuring the image underneath. These droplets can fall to the surface of the plate and cause corrosion. The glass may secrete other materials which can attack the plate. Many people, seeking to clean or replace the glass, destroy whatever seal there might be and fail to replace it, thus setting up conditions for further deterioration. There are yet further problems which may result from corrosion or plating defects, which can result in serious blemishes or exfoliation of the silver from the copper support.

The daguerreotype's conservation problems are complex. As is the case with the other forms of early photography, the factors of deterioration have only recently begun to be seriously analyzed. It requires considerable specialized experience, knowledge, and skill to address the needs of the entire artifact in order to arrest deterioration. Some possible techniques that may be used in the restoration of deteriorated artifacts are discussed in the last chapter of this book. Even so these procedures should never be attempted by an amateur. Far too many historically important images have been irrevocably damaged or totally destroyed by well-meaning attempts at restoration.

Figure 8 This quarter-plate daguerreotype shows the type of tarnish that can develop on a daguerreotype that doesn't have a functional seal. Courtesy International Museum of Photography at George Eastman House.

Calotype (Paper Negative) Process. William Henry Fox Talbot had been experimenting with photo-sensitized paper, producing what was known as "Photogenic Drawings" from the mid-1830s. Soon after the announcement of Daguerre's process, Talbot patented the Calotype process in 1841 afterwards also known as the Talbotype. This was the first practical process to produce a negative from which positive prints could be made in great number and was the forerunner of the negative-positive printing system in use today. This principle formed the basis for most widely used photographic processes throughout the 19th century to the present day. The Calotype was modified and improved considerably by others. It was most popularly used in England and France, largely for landscape and architectural photography. American examples are quite rare. It, like the daguerreotype, fell out of wide usage when the Wet-Plate process was perfected.

The Calotype process utilized paper as the support for both the negative and positive photographic images. In its earliest form it involved five steps. First a good quality writing paper was impregnated with a solution of silver nitrate and potassium iodide by floatation or brushing. After drying and just before camera exposure, the paper was again coated with a solution of silver nitrate, acetic acid, and gallic acid. This greatly increased the paper's sensitivity. After camera exposure, the then invisible latent image was developed with the same solution, known as gallo-nitrate of silver. The negative was then fixed in a bath of sodium thio-sulphate, rinsed, and dried. From this negative a positive was produced by placing the negative in close contact with a piece of paper which had been impregnated with silver chloride and placed in a device known as a printing frame. The frame was placed in bright sunlight. The exposed parts of the sensitized paper gradually darkened due to the "printing out" effect of the light which caused the reduction of the silver. When the print had acquired the right level of darkening, it was removed from the frame, whereupon it was rinsed, fixed, and dried in the same way as the negative.

Figure 9 Left: Paper negative of a view taken in Rome circa 1855. Note the retouching in the sky area at the top. Right: Salted paper print made from the negative. Unlike the negative, the print has faded considerably. Courtesy International Museum of Photography at George Eastman House.

It was soon noticed that these prints were subject to fading, a fact which seriously affected its commercial viability. Investigations into the causes of this fading led to the realization of the importance of eliminating residual fixer from the paper.

Both the negative and the positive of the Calotype process involved impregnating the paper fibers of a sheet of paper with light reactive silver-salts (Figure 9). The paper negative contained silver iodide or bromide while the paper for making positive prints was impregnated with silver chloride and table salt. These were called "salted paper" prints. The negative image was "developed-out"—an image produced by chemicals—while the positive image was "printed-out"—or produced by light or sunlight—as described. The "developed-out" image was the forerunner of subsequent photographic images produced by chemical development. Most positive prints made in the 19th century

Print-Out
Spherical

Develop-Out
Filamentary

Figure 10 The differences in silver grain structure between images printed out and developed out are represented diagrammatically above: (a) in a printed-out emulsion and (b) in a developed-out emulsion. Magnification is about 20,000X.

28

were made by printing-out. Printing-out produces a significantly different silver-grain structure from that produced in developing-out (Figure 10). This affects the color of the print as well as the ways in which they deteriorate.

Prints produced on salted paper with paper negatives did not have the ability to render fine detail, due to the light scattering effect of the paper fibers. Broad effects were rendered very beautifully, resembling monochromatic wash paintings or drawings on rough paper. Depending upon the choice of paper and methods of altering the image tone, salt prints were made to have a wide variety of color hues, ranging from brick red to a rich purple black. The prints were displayed and mounted in a manner similar to graphic prints, drawings, or watercolors. They were frequently mounted in albums. Sometimes these prints were varnished or coated with other materials after mounting. These latter materials often cause the prints to be misidentified. The normal identification features of a salted-paper print are a smooth, yet dull surface, an obvious lack of very fine detail, and deep embedment of the image in the fibers of the paper support rather than being confined to a surface coating.

Since many of these prints were produced before the importance of proper fixing, washing, and toning were fully realized, many of them have suffered serious fading. Numerous beautiful examples do exist in a good state of preservation, largely due to fortuitous accidents of proper processing and storage history. The rule is, though, that most salted-paper prints have faded or lost their original aspect through chemical attack of the silver which forms the image. Deterioration of the image is manifested by reduction of density, loss of contrast, and color change. Of course, as is the case with all paper artifacts, salted-paper prints are also troubled by degradation of the paper fibers, biological attack, migration of deleterious chemicals from materials they are in contact with, and damage through mishandling.

Surviving paper negatives are quite rare and present slightly different problems of conservation. The image information is ordinarily well preserved, due to the combination of the larger size of the silver grain formed in developing and the fact that the negative was commonly waxed to make it more transparent. The wax has often served to protect the silver from atmospheric attack. The negative usually presents the blue-black hues associated with developed-out silver. The sky areas are often painted with india-ink to improve contrast in printing. Conservation problems result largely from the darkening of the wax through oxidation and cracks and tears resulting from mishandling. Paper negatives should not be subjected to exhibition rigors.

Figure 11 The photo on the left is a salted paper print in good condition of Greyfriars Churchyard, Edinburgh. Comparison with the print on the right shows that this one has faded a great deal due to one or more of the factors described in the text. Courtesy International Museum of Photography at George Eastman House.

Wet Plate Collodion Process. A number of individuals had proposed the possible advantage of using collodion (cellulose nitrate dissolved in ether and alcohol), as a photographic vehicle, but it was not until Frederick Scott Archer announced his process in 1851 that collodion found wide photographic application. Archer's process was a vast improvement in so many ways on what had preceded it, that it rapidly came to the forefront of photography. The process required coating a glass plate with a thin layer of liquid collodion carrying a dissolved iodide or bromide salt. After the coating set, the plate was immersed in a bath of silver nitrate solution, thus forming silver iodide or silver bromide in the pores of the collodion. In order to maximize sensitivity, the plate had to be exposed while still wet, hence its name. The latent image was developed with pyrogallic acid. Potassium cyanide or sodium thiosulphate (hypo) was used to fix the image. Thus, a very finely detailed and transparent negative was produced. Through various methods of altering its presentation, the negative could be made to appear as a positive. However, it was the use of wet-plate negatives to produce positive images on albumen paper, that truly altered the course of photography. Many efforts were made to evolve a dry-plate collodion negative process that was more practical and some success was achieved. When such mass-produced dry-plate gelatin negatives were introduced in the late 1870s, the wet-plate collodion process passed out of widespread usage fairly rap-

idly. Collodion still found photographic usage as an emulsion for paper prints.

Examples of photographs made by the wet-plate collodion process can be encountered in a number of forms which present widely differing characteristics. They may be found as positives, negatives, transparencies, or on opaque supports of glass, ceramic, cloth, leather, metal, and paper.

The negatives are significantly different from machine-made gelatin negatives in a number of ways. The image silver usually has a creamy grayish-yellow hue, although black-blue images are sometimes encountered. Since the collodion is flowed on by hand, it often shows tidal marks and varying thickness. Sometimes areas at the edges or corners remain uncoated. The glass is often thicker and more roughly cut than that found as a support for machine-manufactured gelatin negatives. Unvarnished negatives were and are very subject to attack from airborne reactants, thus it was common practice to varnish the negative, which also served to give protection from scratching and abrasion. Collodion is easily dissolved by alcohol and other solvents. Normally water has no solvent effect on collodion; however, many collodion-based photographs may be damaged by water because the properties of the collodion have changed due to aging. Of course, any photograph on glass is subject to damage by breakage. The glass support may also have decomposition problems similar to the cover glass of daguerreotypes.

Figure 12 The print on the left was made on glossy collodion printing-out paper. The brick-red color indicates little or no gold toning. Most of these prints were gold-toned to a rich purple or purplish-brown color to change the tone and in hope of improving the permanence. The print on the right is on matt collodion printing-out paper. The near-neutral (almost black) color illustrates the combined effect of gold and platinum toning. Courtesy James Reilly.

Ambrotypes. The first popular form of wet-plate collodion photographs was the ambrotype which was introduced in 1851. By backing the collodion negative with a dark material the image appeared as a positive. Various materials were used to achieve this effect ranging from black or dark brown paper to cloth or varnish. In some examples dark purple, blue or red glass was used as a support thus obviating the use of a backing. Many times, the negative was bonded to another piece of glass with Canada Balsam, a natural transparent resin, to protect it from atmospheric attack. Ambrotypes were presented in mounts and cases in the same fashion as daguerreotypes and because of this are commonly mistaken for daguerreotypes. It is a simple matter to distinguish between the two since ambrotypes appear as positives at all angles of illumination, as opposed to the daguerreotype which is truly visible as a positive only at certain lighting angles.

Since ambrotypes are found in a wide variety of forms depending upon the whims and methods of individual makers, restoration is a complex matter. They are often damaged due to the deterioration of the backing varnish, which, if cracked or peeling, destroys the positive effect. This can be remedied by replacing the backing material; however, care must be taken because the material chosen to replace a deteriorated backing material may contain elements which can attack the image. In addition, the emulsion is sometimes under varnish and any attempts to remove the varnish may damage the image-carrying emulsion. Thus, any restoration work should be conducted by a professional photographic conservator. A branched fern-like pattern may cover the image in cases where ambrotypes have been bonded to another piece of glass with Canada Balsam and deterioration has started. This is caused by the crystalline structure of the Canadian Balsam and is not, as is commonly assumed, a mold growth, which it resembles.

Figure 14 Tintype of a railroad brakeman in the 1870s. A tintype is a collodion positive on lacquered iron. Courtesy James Reilly.

Tintypes. The idea of using a thin sheet of iron with a surface coated with a black varnish, as a support, instead of glass with a dark backing, was patented by Hamilton Smith in 1856. This process is most properly called Ferrotype, since there is no tin at all in it.

This inexpensive and easily handled form of photography was a particular favorite of itinerant and street photographers from the time of its introduction to well into the twentieth century, when they were made by the gelatin-silver bromide process. They were made in the millions and are very commonly found today. America was the favorite place of production.

Early tintypes were cased like daguerreotypes and ambrotypes. It is very difficult to tell an ambrotype from a tintype when it is under glass in a case. Uncased tintypes are readily identified by the thin metallic plate

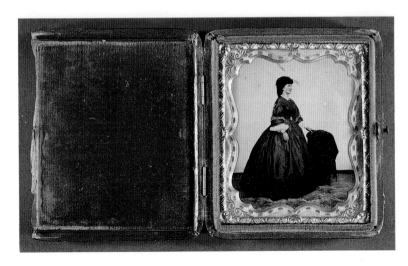

Figure 13 An ambrotype (collodion positive on glass) of a lady circa 1860. Courtesy Constance McCabe.

Albumen Paper. Albumen derived from the white of eggs was suggested and used as a photographic vehicle on glass just prior to the introduction of the wet-plate process. It found its greatest application, however, as an element in silver printing-out paper. Louis-Desire Blanquart-Evrard introduced albumen coated paper as an improvement over plain salted-paper in 1850. In combination with the wet-plate negative, it was able to render much more detail and subtlety of tone.

Initially photographers prepared their own albumen paper by coating, by the floatation method, a thin sheet of paper with egg-white containing sodium chloride or ammonium chloride. This paper was stored until it came time to use it, when it was sensitized by floatation on a solution of silver nitrate and acetic acid. The albumen served to hold the light sensitive silver salt on the surface of the paper, rather than in it, and also entered chemically in combination with the silver in an advantageous fashion. After drying it was used in the same manner as salted-paper, the image being formed by the printing-out action of sun light. For both aesthetic and preservation reasons, the prints were toned with gold chloride, which gave the image a rich purple-brown color.

A large albumen paper industry evolved in Dresden, Germany and by the 1870s most of the world was supplied with albumen papers made there. Albumen paper was widely used throughout the world and the majority of the surviving photographic record of the 19th century is on albumen paper. Therefore, it is very important for the conservator to be aware of this material's susceptability to factors which cause deterioration.

that the positive image is upon. Occasionally tintypes are found on plates that are brown or red instead of black. Most tintypes were varnished to protect the surface from abrasion and atmospheric attack. They were made in a great variety of sizes. The most common format is 6.4 cm x 8.9 cm (2 1/2 x 3 1/2 inches), the same size as carte dé visite paper prints. They are functionally direct positives, as are daguerreotypes and ambrotypes. When multiple identical images are found they were most probably made with a multilens camera.

Most tintypes were hastily produced and lack contrast and fineness of finish, which is often mistaken for deterioration. The most common form of deterioration of tintypes comes from mishandling, often done in extracting them from albums. The plate is very easily bent, which can cause the varnish to crack. Once air and moisture penetrate to the iron substrata it begins to form rust, eventually causing the loss of the image carrying surface. Tintypes which are not varnished with a protective coat over the emulsion are easily abraded.

Figure 15 Two albumen prints: The one on the left shows normal deterioration even though it has had good processing. Note the loss of highlight detail. The print on the right is a modern print in pristine condition: no yellowing of highlight areas, a full tonal range, and excellent highlight detail. Courtesy James Reilly.

With careful examination under magnification and comparison with other properly identified printing papers, such as gelatin printing-out paper, it is fairly easy to learn how to identify albumen prints. The paper support is characteristically very thin and obviously coated with the transparent albumen which gives a gloss to the surface. This gloss may be slight, as in the case of early single-coated prints, or very glossy, as in the case of double-coated and burnished prints. Under magnification it is possible to clearly see the paper fibers through the albumen. This is not the case with later gelatin and collodion papers which usually have a sub-coating of baryta which completely covers the paper fibers. Many albumen prints show a very fine lateral cracking of the overall surface, something similar to the lines apparent on the skin of the back of the hand. Early gelatin and collodion papers were made to imitate the look of albumen papers and may confuse the inexperienced examiner. Because the albumen tends to yellow, even in the case of very well-preserved examples, an albumen print will almost always have yellowed highlight areas. It was a common practice to give a tint of pink or green to the albumen by the addition of aniline dyes to mask this yellowing. This tinting is very light fugitive. Therefore any tinted albumen print can lose its tinting through a display. Also many albumen prints were hand-colored and this coloring may also be light fugitive.

Due to the thinness of the paper, most albumen prints were mounted onto stiffer papers and cardboards. A popular format was the carte dé visite. These support boards and the adhesives used to hold the print to them contribute very significantly to the conservation problems of albumen prints. Most albumen prints have suffered some degree of image degradation, many have changed to a marked degree. Characteristically albumen prints begin to lose density in the minimum density areas, thus losing highlight detail. This, in combination with the yellowing of the albumen, reduces the original image quality and contrast. With time, as the silver continues to be attacked by sulphur and other

Figure 17 This photo shows light damage to an albumen print. Note the deterioration in the area not protected by the oval overmat. Courtesy James Reilly.

Figure 16 A carte dé visite portrait showing a local hypo stain. Courtesy James Reilly.

Figure 18 An albumen print that has deteriorated due to poor processing, extended display, and a poor quality overmat is illustrated in this photo. Courtesy James Reilly.

oxidation-reduction reactions, the image changes color from the cooler purple-brown to a warmer reddish-brown, undergoing at the same time a corresponding loss of density. The print may suffer a wide variety of other problems typical of paper documents. It is very important to understand that prints which are in relatively good condition more through chance than through a careful program of preservation may not remain so if exposed to deleterious conditions of high humidity and temperature or exposure to oxidants and sulphiding agents. Therefore, high standards of storage and display are required to prevent deterioration of the image quality.

Transition to Modern Processes

In 1871 Dr. R. L. Maddox published the details of a process using gelatin as a substitute for collodion to hold a light sensitive salt of bromide of silver in suspension. During the 1870s many individuals suggested practical improvements of Maddox's process. The end result was the production of a very sensitive dry plate, with long-keeping properties that could be mass produced by machine. This essentially brought the era of "handmade photography" to an end and began the modern period we are still in, in which gelatin plays the dominant role as a vehicle for carrying the light-sensitive silver salt.

The gelatin dry-plate quickly replaced the wet-plate negative and new printing papers were also introduced. Both collodio-chloride and gelatin-chloride papers were popular in the 1880s and they gradually replaced albumen paper. Both of these papers were printing-out papers. Permanence was a commercial concern in this era and photographers evolved the practice of double toning these printing-out papers, first with gold and then with platinum. This produced a very beautiful warm, neutral-toned image. Time has proven this method to be very effective, since examples show virtually no fading or darkening of highlights. Roughly in the same period, developing-out gelatin emulsion paper was introduced and gradually became the main type of printing paper, leading to the total abandonment of printing-out papers in commercial usage. There is a significant difference in the size and structure of the silver grain produced in printing-out as opposed to developing-out, which is a very significant factor in both the look of the resulting image and the way in which the image is subject to deterioration. This fact further serves to divide early photographic materials from those popularly used from 1890 onward.

Figure 19 Collodio-chloride and gelatin-chloride papers gradually replaced albumen paper in the 1880s. Photographers double-toned these papers, first with gold and then with platinum, as in the above print to enhance permanence. The effect was a warm, neutral-toned image. Courtesy International Museum of Photography at George Eastman House.

Tests to Help in the Identification of Artifacts

To further aid in identification, there are tests that can be performed.

There is a simple spot test that can be used to distinguish between albumen, collodion, and gelatin processes. It involves placing a very small drop of water or alcohol on the edge of a non-image area of the print, waiting 60 seconds, and blotting it carefully with a clean blotter. Alcohol will not affect albumen or gelatin and leaves no aftermark. It does dissolve collodion. When water is used, neither collodion nor albumen is affected but gelatin is. If the gelatin is in good condition, a slight swelling may be observed on the prints by viewing it at an oblique angle; if the gelatin is very soft, it will lift off on the blotter. Collodion dissolves in alcohol; gelatin swells in water; and albumen is unaffected by either.

For situations in which positive identification is necessary, there is a chemical test that distinguishes unmistakably between gelatin and albumen. Gelatin contains hydroxproline which is not present in albumen and which can be readily identified. The procedure involves a simplified testtube colorimetric method based on the use of Ehrlich's reagent. This test is known as the Tri-Test Paper Spot Test and it is available in kit form from W. J. Barrow Laboratory in Richmond, VA.[3] The reference noted should be carefully read and further literature studied before these tests can be applied responsibly. The foregoing information provides only minimum details, more complete instruction on the use of these tests is required.

Figure 20 The configuration of the grains in developing-out paper makes it more susceptible to deterioration than printing-out paper. The above print on gelatin developing-out emulsion paper shows various degrees of discoloration.

#10 Cirkut Camera
Manufactured by the Folmer-Schwing Division
Eastman Kodak Company, circa 1905.

The design of this camera is unusual in that both the camera and the film move during exposure because of a clockworks mechanism. This mechanism rotates the camera in a 360° circle producing photographs that could be as long as 15 feet.

Chapter IV The Structure of Photographic Materials as it Pertains to Image Stability

In the previous chapter the earliest of the photographic processes were described including the materials used in them and the methods of identifying the artifacts made from them. The gelatin-silver bromide dry plates and gelatin-silver bromide or chloride papers in use by the end of the nineteenth century were essentially the same as the black-and-white materials manufactured today. Consequently, most of the photographs with which the custodian of a photographic collection has to deal are made with these kinds of materials. The properties of the modern materials and how they react under conditions of long-term keeping are as significant to the conservation of photographs as those of the earlier processes described in Chapter III.

The basic structure of most modern photographic materials consists of a support upon which an emulsion layer is coated. The support material may be glass or a film base made of cellulose nitrate, cellulose acetate, or polyester. Or it may be paper. Paper has been used as a support for both negatives and prints over the course of photographic history. The emulsion layer consists of gelatin and light-sensitive silver salts. Emulsions have also been coated on black leather, oil cloth, synthetic ivory, fabric, wood, stone, china, enamelled porcelain and linen for special purposes.[4] The preservation of the image and its support is the primary subject of this book.

Figure 21 Silver ingots. Silver bullion almost 100% pure is converted to pure silver nitrate crystals required in emulsion making. Each bar is individually identified (the black marks) and the weight of each is indicated. Jerry Antos.

The Emulsion Layer

Silver. Highly purified silver ingots are treated with nitric acid to produce highly purified crystalline silver nitrate ($AgNO_3$). This salt is then dissolved in water for use in making the photographic emulsion. Because pure silver can be chemically attacked by atmospheric contaminants, it can in itself be a contributing factor to the deterioration of photographic artifacts.

Gelatin. Photographic gelatin is highly purified animal protein that is a very stable material as long as it is kept dry. Gelatin is an important component in the manufacture of the photographic emulsion and it also influences the chemical processing of the emulsion layer. It is used because of its particular combination of chemical and physical properties: it keeps the silver halide particles uniformly dispersed; it has no adverse effect on the silver halide in the coated emulsion; it is permeable enough to permit the diffusion of processing chemicals through its structure without destroying its toughness or permanence; it can be handled simply and in a reproducible manner; when dry it is stable for long periods of time. This property yields products that are reasonably stable both before and after processing.

Figure 22 Gelatin keeps silver chloride, bromide , or iodide uniformly dispersed (right). Without gelatin, the silver halide settles to the bottom (left). Jerry Antos.

Gelatin can withstand a considerable amount of dry heat for a reasonable period, but heat in the presence of moisture gradually degrades it until it becomes sticky and soluble. Gelatin is quite resistant to chemical attack by atmospheric contaminants. It is degraded by strong acids such as are formed by the deterioration of cellulose nitrate support. Since gelatin is a protein, it readily promotes the growth of microorganisms under sustained conditions of high relative humidity. This biological growth (bacteria and fungi) is the principal cause of gelatin deterioration.

It is generally believed that gelatin, if it is properly stored and protected from agents that degrade it, is stable enough to last as long as acetate and polyester film supports upon which it is coated.

Conventional Emulsion Making. Salts such as potassium chloride (KCl), potassium bromide (KBr), and potassium iodide (KI) are known as "halide" salts. One or more of these salts are reacted with a silver nitrate solution in the presence of a dilute gelatin solution to form exceedingly fine *silver halide* crystals. These light-sensitive crystals are uniformly dispersed or suspended in the gelatin. A typical reaction is expressed chemically as:

$$AgNO_3 + KCl = AgCl + KNO_3$$

silver nitrate potassium chloride silver chloride potassium nitrate

The potassium nitrate is soluble and is usually washed out thereby having no effect. The silver chloride is one of the silver halides and provides the light sensitive agent. Of course, many other treatments are involved in manufacturing the great variety of film and paper emulsions available today.

The Support

Glass. As an inert transparent material, glass is an ideal support for negative and positive emulsions, but its physical disadvantages of weight, bulk, and fragility make it an impractical material for general photography. Glass plates are still manufactured for certain technical applications in which dimensional stability is very important.

There are numerous glass plates in storage today, but generally they are a problem for custodians because of the space they occupy, their tendency to break and the danger the sharp edges of broken glass presents to the user. Glass is brittle when manufactured and becomes more brittle with age so the older the plate, the more carefully it must be handled. In addition, the smooth surface of glass allows the material carrying the photographic image to separate. Unfortunately, a great deal of valuable historical material has been inadvertently lost because of these characteristics. When possible, glass negatives should be cleaned and duplicated on film to eliminate these problems. See "Preservation Through Photographic Reproduction," on page 110 and "Restoration of Glass Plate Negatives" on page 134.

Paper. It was recognized early in the development of the photographic process that there was a relationship between the stability of the processed photographic image and that of the paper on which it was formed. For this reason, the paper used in printing photographs and the material that comes in contact with them such as mounting board, negative enclosures, interleaving paper, etc, must be of the appropriate content and quality. Photographic paper support must be as durable and stable as possible. It cannot adversely affect the silver halide emulsion coated upon it and it must be resistant physically and chemically to the chemical processing required to produce the silver image. The record obtained should keep a long time if properly processed and then stored under optimum conditions. This has been a concern of the industry from the earliest days to the present. Some knowledge of the history of photographic paper making will be helpful to the photographic conservator in caring for early and contemporary photographic artifacts.

FIBER-BASE PAPER. Early in the nineteenth century, all paper was manufactured from linen and cotton rags. Because of impurities such as dyes, pigments, and other materials, it became necessary to bleach the rags in a strong acid solution of calcium hypochloride which weakened the fibers causing more rapid degradation of the finished paper. Then rosin was added as a sizing to prevent the penetration of liquids such as the emulsion or the processing solutions. Natural rosin oxidizes rapidly and turns yellow. It was deposited on the fibers by the use of papermaker's alum which increased the acidity and accelerated the degradation of fibers and finished paper. About 1840, groundwood pulp containing resins, pitch, and lignin was used to make paper. This paper turned yellow rapidly and became brittle. In 1867, the sulfite process was employed to rid groundwood pulp of the resins and lignin. Mixtures of groundwood and sulfite pulps made papers that had very poor stability.

From 1839 on, early photographic print processes utilized the highest quality rag paper available. Plain salted paper prints, at first, had no binder; then arrowroot starch was used as a binder and this produced paper that permitted improved photographic quality. Despite the fact that different kinds of sizing materials and only the best possible rag stock paper were used, many old photographs have shown yellowing even when good processing was performed.

The best possible rag stock papers were imported by Eastman Kodak Company until 1914 when the company decided to manufacture its own paper. In 1918 Kodak installed the first production paper machines using wood cellulose after it was found that paper made from rag stock and rosin binder did not meet the purity standards required for photographic use. An extensive research program in cooperation with pulp manufacturers has resulted in a product made from wood pulp that proved to be as good or better than the best quality rag stock.[5][6][7]

By 1926 papers containing 50 percent rag and 50 percent purified wood pulp were manufactured. Since then a series of improvements have been made including: replacement of rosin in 1926–27 by an improved, more stable sodium stearate binder; development of paper that was manufactured 100 percent from wood pulp in 1929; the addition of a chemical—melamine formaldehyde—in 1943 to improve the wet strength of the paper; the use of aluminum chloride instead of papermaker's alum to deposit the stearate sizing agent onto the paper fibers; and in 1965 the use of other resins to improve the dry strength of the paper.

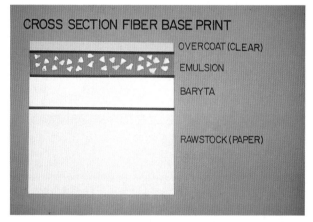

Figure 23 Above a cross section of a fiber-base print showing its construction.

Historically fiber-base papers have been baryta coated to obtain a smoother, whiter surface. Baryta, or barium sulfate is dispersed in water containing a small amount of a binder such as gelatin and small amounts of colorant. The surface of the raw paper is coated with the baryta and then calendered.

Prior to 1906 baryta coated paper was imported from Europe; at that time Kodak began coating in their own facilities. Most photographic paper was baryta coated until the advent of polyethylene resin coating in the late 1960s.

Current fiber-base papers particularly appropriate for the applications discussed in this publication include such papers as KODAK EKTALURE Paper, KODAK POLYFIBER™ Paper, and KODAK ELITE Fine-Art Paper. The latter two are new black-and-white papers that offer improved image quality and stability in finished prints. KODAK ELITE Paper, on the basis of ac-

celerated tests, possesses the most stable silver image of all black-and-white papers currently made by Eastman Kodak Company. The image stability is the result of incorporating into the emulsion the most advanced technology relating to silver image stabilization. Notwithstanding this progress, images on KODAK ELITE paper should be toned for long-term preservation (see page 57).

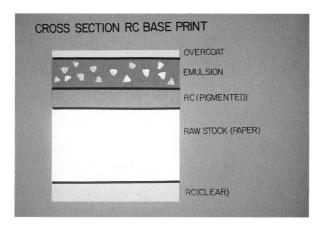

Figure 24 Cross section of a print on water-resistant resin-coated base paper. A titanium dioxide pigmented polyethylene layer replaces the baryta layer that is in fiber-base paper. A clear polyethylene layer is coated on the nonemulsion side of the paper support.

WATER-RESISTANT (RESIN-COATED) BASE PAPER. Extended fixing and washing times, limpness of paper in photographic solutions, and the prolonged drying times required for prints are the direct result of paper's affinity for moisture. Significant and disproportionate changes in the length and width of paper caused by wetting or changes in humidity, roughening of surfaces, and annoying problems with ferrotyping are additional concerns with fiber-based prints. Differences in moisture absorption between the paper base and the emulsion layer, and differences in shrinkage of these layers in dry air, create the additional problems of curl and cockle. Efforts to manufacture a paper that would provide reduced fixing, washing, and drying times, that is, more rapid processing, resulted in the introduction of water-resistant or resin-coated (RC) base papers. These are standard photographic papers coated on both sides with a plastic layer. The earliest versions of water-resistant paper were coated with baryta and then overcoated with a cellulose ester in a solvent. Known as KODAK RESISTO and RESISTO RAPID, these papers served the Armed Forces well in the 1940s. Contemporary RC papers are coated on both sides with polyethylene.

The unique properties of polyethylene make it particularly suitable for waterproofing photographic papers. It exhibits excellent coatability by extrusion, is inert to most chemicals and solvents, is impermeable to water, and is quite flexible. Polyethylene can be made to adhere well to paper and photographic emulsion layers can be made to adhere to it. In addition, the resin thickness balance provides a good means for controlling curl. Through this combination of advantageous properties, polyethylene provided for the first time a water-resistant paper support for general photographic use. The resin coating on the emulsion side of this paper is pigmented with various additives to provide reflective whiteness in highlight areas of the print and image sharpness. Figures 23 and 24 diagram the basic structure of fiber-base and RC papers. Resin-coated or RC papers, such as KODAK POLYPRINT RC Paper, KODAK POLYCONTRAST Rapid II RC Paper, and KODABROME II RC Paper, have these general characteristics: Faster processing, more rapid drying, less curl, improved stiffness for ease of handling while wet, greater resistance to tearing in machine processing, greater dimensional stability, and easier handling.

Basic Structure of Fiber-Base and Resin-Coated Papers	
Fiber-base	Resin-Coated
Emulsion	Emulsion
Baryta Layer	Pigmented Polyethylene
Paper	Paper
	Clear Polyethylene

Since resin-coated papers are a comparatively recent development, reliable long-term keeping data are not yet available. From incubation studies made, it appears that when black-and-white prints are stored in the dark, with only occasional viewing, and when storage conditions are uniformly maintained near 21°C (70°F) and 50 percent relative humidity (RH), the useful life of RC prints can be equal to the life of prints on conventional paper base. Displayed black-and-white photographic prints on early versions of RC paper base, that were subjected to active oxidants at low concentration could, over a period of time, develop colloidal silver spots. This phenomenon can also occur on fiber-based papers. For some time, Kodak black-and-white papers on RC paper base have incorporated a stabilizer in the paper stock which prolongs the life of prints under display conditions. Nonetheless, treatment with toners is recommended to further extend the life of all black-and-white photographic prints.

Figure 25 Emulsion or mosaic cracking on a fiber-base print at the left and on a resin-coated print at the right.

EMULSION CRACKING OR MOSAIC CRACKING. This effect may occur on either fiber-base or RC prints under adverse display and/or storage conditions. The emulsion layer is free to lose moisture in low humidity and to absorb moisture rapidly under high humidity conditions. In either case stress develops in the emulsion layer. Stress can also develop in the paper base under similar conditions. Intense levels of illumination, severe humidity cycling (20–70% RH) and high temperature will increase the chance of cracking. Long periods of exposure to room light, display in direct sunlight, framing under glass, or storage in a container in an uncontrolled, hostile environment are practical situations that also contribute to cracking.

AVAILABILITY OF FIBER-BASE BLACK-AND-WHITE PAPERS. Recently there has been concern over the continued availability of these papers. Concurrent with the manufacture of black-and-white RC papers, Kodak supplies a number of fiber-base products such as KODAK ELITE Fine-Art Paper, KODAK POLYFIBER Paper, KODABROMIDE, and EKTAMATIC Papers and will continue to provide the best products for photographic conservation purposes for as long as they are needed. Fiber-base papers are preferred for aesthetic reasons among many users of photographic papers.

Film. The term film is used to designate a wide variety of flexible, transparent materials used as photographic supports. These materials may consist of cellulose nitrate, cellulose acetate, or polyester.

NITRATE FILM BASE. The earliest flexible films were made of cellulose nitrate in 1889. Cellulose nitrate film base is chemically similar to guncotton, but is not as highly nitrated. It releases oxidants and acidic gases as it decomposes which destroy the image. Large quantities of this material constitute a fire hazard, it is highly flammable but not explosive. Materials with cellulose nitrate supports should never be stored with other types of photographs. The deterioration and safe handling of negatives on cellulose nitrate film base are discussed in detail in the chapter on deterioration.

ACETATE FILM BASE. Because of the chemical instability and the dangerously flammable nature of cellulose nitrate film base, Eastman Kodak Company commenced an extensive program of research into other cellulose derivatives after World War I. By 1923 a substitute for nitrate base had been developed. This substitute was a slow-burning film known as cellulose diacetate, or safety film. Amateur movie film was manufactured on this new support.

Cellulose diacetate was not an entirely satisfactory replacement as a support for some photographic purposes. While it was safer in use than nitrate base, its physical properties of strength and toughness were not adequate for use in motion picture film. In addition, its tolerance to heat and water absorption were not as good as desired. Continued research on cellulose derivatives resulted in the mixed esters of cellulose known as cellulose acetate propionate and cellulose acetate buty-

rate. The production of x-ray films was transferred from cellulose nitrate to a cellulose mixed ester base, thus removing the fire hazard from hospitals and other places where large quantities of the film were used. Finally, cellulose triacetate was developed and, up to a few years ago, used as the support for most Kodak films. During World War II nitrate base film was manufactured in France when Kodak-Pathé was seized and operated by occupying forces. During this time, aerial film was manufactured in the Kodak plant and was coated on nitrate film base. It was also manufactured during this time in England. By 1951 Kodak had discontinued the use of cellulose nitrate as a support for any film product, except the skin of a stripping film used in the graphic arts. Since the changeover from one kind of film base to the other was gradual, the date that a particular negative was made will not indicate whether the base is nitrate or acetate, but a simple test can be made to distinguish one base from another. See the section "Identifying Nitrate Base," on page 89.

The well-known instability of cellulose nitrate film base naturally raises a question about the stability of acetate bases. Kodak testing of the early acetate films from the period of World War I to 1930 indicated excellent keeping quality. During the early 1930s, the U.S. National Bureau of Standards conducted an investigation into the long-term stability of acetate film base. The tests were similar to those used to establish the permanence and durability of paper. The Bureau of Standards reported that, "On the basis of the test data, the cellulose acetate type of safety film appears to be very stable . . . While it is not possible to predict the life of acetate film from these results, the data show that the chemical stability of the film with respect to accelerated aging is greater than that of papers of maximum purity designed for permanent records."[7][8][9] In addition, accelerated aging tests in the laboratory, as well as some 60 years of observation, indicate that cellulose acetate has good stability and should provide satisfactory keeping properties for many centuries if stored under proper conditions. All amateur films in short rolls are manufactured either on acetate or polyester base.

POLYESTER FILM BASE. Polymers of the polyester type are currently being used to replace triacetate base in a number of film products. Kodak's ESTAR Base— the chemical name of which is polyethylene terephthalate—is such a base. Where permanence is concerned, accelerated aging tests and experience to date indicate that polyester film base is equal to or better than acetate materials[8]. Moreover, it is less brittle, has greater mechanical strength, higher dimensional stability, and greater resistance to changes when subjected to extremes of temperature than does acetate base film. Such films as those used in x-ray applications, business systems applications, the graphic arts industry, and other professional uses requiring sheet form or long rolls are manufactured on a polyester base.

LONG-TERM KEEPING CHARACTERISTICS OF FILM BASE. Both cellulose acetates and polyester film bases have excellent keeping properties when stored under proper conditions of temperature and humidity. Archival keeping is dependent upon adhesion of the emulsion layer to the film base as well as upon the chemical stability of the component layers. Extremes of temperature, relative humidity, and cycling humidities should be avoided. The greater the exposure to such extreme conditions during aging, the greater the possibility of physical and/or chemical deterioration of the adhesive layer and the film base—changes that may cause emulsion peeling, lifting, flaking, wrinkling, or cracking.

Emulsion distortion can also occur due to changes in the subcoat or adhesive layer that holds the emulsion to the support, when stored under severe conditions of temperature and humidity. At low humidities the emulsion layer exerts a compressive force on the adhesive sub layer which may cause creep or flow. Depending upon the characteristics of the emulsion layer, the adhesive layer, the bonding between layers, and the severity of the storage conditions, the creep may be excessive and the adhesive layer and emulsion may rupture giving rise to fine cracks.

It is also possible for film base to change chemically under very extreme conditions of temperature and humidity. Cellulose ester base films in long-time storage under severe conditions may release the smell of acetic acid—an indication of chemical change in an acetate film.

An important property of films is dimensional stability: polyester films have the best dimensional stability, cellulose esters such as triacetate are completely satisfactory for many applications, and the early diacetate films considerably less so. The early diacetate films sometimes exhibited serious chemical degradation of the base when stored under adverse conditions. This resulted in a very high shrinkage and subsequent wrinkling of the emulsion. This is encountered on diacetate negatives. See page 135 for possible restoration techniques.

More recent studies[9] of physical property changes of processed emulsion-coated film supports after high temperature incubation have indicated acceptable physical properties for at least 300 years for cellulose triacetate films and several times that for polyester-base films. These time periods were predicted by use of a modified Arrhenius relationship (see page 65). Laboratory measurements after normal storage conditions for at least 25 years support these predictions.

Chapter V Technical Standards for
Photographic Materials

During the late 1920s and early 1930s, the National Bureau of Standards in Washington, D.C. began the study of the durability and permanence of paper used in the production of books and other printed material. Later the Library of Congress joined and supported the effort. These government agencies along with the National Archives studied the stability of photographic paper and film supports, the processing of photographic materials, and the storage of processed films and prints.

Coincident with these investigations, the activities of the American Standards Association (ASA) were initiated between 1938 and 1939. The objective of some of its subcommittees was to establish industry–wide technical standards for photographic materials and their use. The name of the parent organization was subsequently changed to the American National Standards Institute (ANSI).

The American National Standards Institute

Currently, this organization is responsible through its various committees for establishing specifications for photographic products, the processing of these products, and the protection requirements for their keeping. The committees consist of representatives from photographic manufacturers, government agencies, various consumer groups such as commercial processing laboratories, and even foreign government agencies which serve as a liaison to promote international agreement. This coordinated research effort arrives at specifications that are practical for the consumer. None of the specifications are mandatory but serve as a guide to good practice in the manufacturing and utilization of photographic products.

Accelerated Test Procedures. Much of the data used to determine many of the ANSI recommendations is obtained by using test procedures designed to produce results in a short time compared to natural keeping and use tests. These are known as accelerated test procedures. The problem of predicting in this manner is well described in the foreword to ANSI PH1.41-1981.

"The problem of predicting the probable life of any material, particularly a new material, is

very difficult. Some people question the validity of accelerated aging tests. However, scientists have a high level of confidence in accelerated aging tests provided they are properly selected for the material and purpose in question. Such tests are essential because the alternative of waiting for many decades of natural aging is not a practical solution."

The terminology used in specifications with respect to the keeping properties of photographic records should be clearly understood. Conservators and custodians should have copies of the complete ANSI Standards, most of which contain excellent technical information in their preambles. They may be purchased by writing to the American National Standards Institute, Sales Department, 1430 Broadway, New York, New York 10018 and requesting a copy of their catalog of photographic standards.

Figure 26 Some typical covers of ANSI Standards for photographic film and paper products.

Some ANSI Photographic Standards. Listed below are some of the ANSI standards for photographic film and paper products.

Film Products

ANSI PH1.28-1981 Specifications for Photographic Film for Archival Records, silver–gelatin type, on cellulose ester base.

ANSI PH1.41-1981	Specifications for Photographic Film for Archival Records, silver-gelatin type, on polyester base.
	These two standards cover black–and–white film emulsions coated on cellulose acetate and polyester type supports and include processing requirements for residual processing chemicals and a test for image stability. There is no corresponding standard for color products.
ANSI PH1.31-1973	Method for Determining the Brittleness of Photographic Film.
ANSI PH1.42-1969(R)*	Method for Comparing the Color Stabilities of Photographs.
ANSI PH1.43-1983	Photography (Film)—Storage of Processed Safety Film.
ANSI PH1.45-1981	Practice for Storage of Processed Photographic Plates.
ANSI PH1.53-1984	Photography (Processing) —Processed Films, Plates, and Paper—Filing Enclosures and Containers for Storage.

Paper Products

ANSI PH1.48-1982	Photography (Film and Slides)—Black–and–White Photographic Paper Prints —Practice for Storage.
ANSI PH4.8-1984	Photography (Chemicals)— Determination and Measurement of Residual Thiosulfate and Other Chemicals in Films, Plates, and Papers.
ANSI PH4.10-1977	Requirements for Photographic Grade Blotters.
ANSI PH4.21-1979(R)*	Specification for Thermally-Activated Dry-Mounting Tissue for Mounting Photographs.
ANSI PH4.32-1980	Method for Evaluating the Processing of Black-and-White Photographic Papers with Respect to the Stability of the Resultant Image.

*R indicates standard in revision process.

The International Organization for Standardization (ISO)

This organization promotes and promulgates photographic standards on a worldwide basis. It was formed in London in 1946 and began to function officially on February 23, 1947. The 25 countries involved at that time agreed that the objective of the organization would be "to facilitate the international coordination and unification of industrial standards." ISO at present comprises the national standards bodies of 89 countries including the American National Standards Institute. Like ANSI it conducts its technical work through technical committees whose efforts are published in international standards.

The National Archives

There are different standards for the longevity of film in storage depending upon the requirements of the user. Currently, archivists and others concerned with the keeping properties of photographic materials are working with three classifications: medium-term film, long-term film, and archival or permanent film.

Medium- and long-term films are defined as those capable of a useful storage life of either 10 or 100 years, respectively. The shorter storage time requires reasonably good processing and storage while permanent or archival films require the most complete processing and more stringent storage conditions.

The National Archives have the ultimate authority for determining what is meant by permanent or archival film in the United States.

The Archivist of the United States has determined that the words permanent and archival mean the same: forever. He has stated that it is the intention of the National Archives to keep forever records which have been appraised as being of permanent or archival value. He further states in a preamble to ANSI Standard PH1.60-1979 that "whatever material is approved for permanent record filming must be equal to or better than the present materials that have been certified for permanent use." Permanent or archival record film can be defined as any film that is equal to or better than silver film as specified in ANSI specifications ANSI PH1.28-1981 and ANSI PH1.41-1981. The archivist continues "We realize that equating other film types to silver may not be the best criteria but at this time it is the only standard that we have. Silver has been around long enough to establish credence to its stability as an archival material, yet if newer materials can be qualified they too should be considered for certification."

The general philosophy among those concerned with archival records such as the Library of Congress and the National Archives is that an archival record should never be available for use but rather, that copies or duplicates should serve as the research or service object.

Chapter VI Processing for Black-and-White Stability

A fundamental conservation principle maintains that the prevention of damage is easier and more economical to achieve than repairing damage already done. The careful processing of the artifact is the first step in its preservation. This includes developing and fixing of the image and washing and drying of the print or negative so that maximum stability is obtained. Art galleries and museums are becoming increasingly involved in photographic processing as they respond to community interests and needs and as they recognize the advantages in copying and duplicating valuable artifacts. Even though the conservation program of some museums and galleries may not require involvement in actual photographic processing, knowledge of the procedures which should be used to obtain maximum stability will be helpful to them in working with processing laboratories. It will also provide a better understanding of the deterioration of images caused by improper processing.

Processing to produce image stability is not difficult when the underlying principles are understood. The manufacturer of photographic materials usually recommends the best processing possible and publishes detailed instructions for its accomplishment. The photographer and the processor have a joint responsibility to see that the processing is done as recommended by the manufacturer. Deviation from recommended procedures can result in the deterioration of the image by both internal and external contaminants. The final responsibility rests with the holder of the artifact—whether it be an institutional conservator or a private individual—who displays or stores the finished negatives, transparencies or prints.

In Chapter IV it was seen how the structure of photographic image materials contributes to the stability of the image. In this chapter extended processing techniques that will help to produce photographic records having good long-term keeping properties will be outlined. While there may be technical and economic reasons to consider less careful procedures than those detailed here, it is desirable, in most cases, to process all materials to a high standard of stability. It is not very rewarding at some later date to select a negative or print from a file or storage only to find it unusable. General processing techniques are not discussed in this publication since it is concerned only with those factors impinging on the long-term keeping properties of photographs. Further general information on processing and Kodak chemicals and formulas is contained in the publication *Photographic Chemistry in Black-and-White and Color Photography*, and J-1, *Processing Chemicals and Formulas*.

Methods of Processing for Stability

There are various ways to process photographic materials depending on the quantity of material to be processed and the urgency with which it is needed.

Manual Processing. Negatives and prints can be processed manually in shallow trays or by the rack-and-tank method. This method of normal processing is used most often when the volume is low. Good image stability can be achieved with this method if the prints are handled one at a time, with constant agitation, and with the trays or tanks immersed in a sink or water bath to maintain the processing temperature. Tank development is highly recommended for small quantities of roll films, film packs, sheet films, and plates. The use of a tank enables the operator to produce clean, evenly developed negatives, and at the same time permits accurate control of development factors. Except in the case of large quantities, tank development is the most practical method of processing 35 mm films.

Figure 27 Manual processing using a tray setup. Note trays are set on a slatted wooden support that is placed in the sink to provide an elevated support for more comfort. Jerry Antos.

Figure 30 KODAK ROYALPRINT Processor, Model 417. The design of this machine processor is based on the roller-transport principle. It is intended for the rapid processing of certain Kodak black-and-white photographic papers that are resin-coated and developer-incorporated. Incorporation of the developing agent in the RC base facilitates very rapid processing. Fully processed, dried, and excellent-quality prints are produced. NOTE: These prints, however, are not recommended for archival storage.

Figure 28 Manual processing using a rack- and- tank setup. This often consists of a 3-gallon, hard-rubber tank and racks to hold sheet film sizes up to 8 x 10 inches. Jerry Antos.

Figure 29 Manual processing using a roll-film processing tank. A loaded film reel is placed in the tank and the cover is put in place. Developer at the proper temperature is poured into the tank and the light-tight cover cap positioned. All of this is done in the dark. Jerry Antos.

Machine Processing. Early in this century processing was mechanized in order to gain the advantages of semiautomatic or fully automatic large volume production in applications such as motion pictures, x-ray films (radiographs), and photofinishing roll films and prints. The trend was toward more compact machines to process 8, 16, 35 and 70 mm films in large quantities. Then the development of the roller-transport principle led to very compact, rapid automatic processors for sheet films of all kinds and sizes and for continuous processing of photographic papers. Mechanization meant that large quantities of films or papers could be processed daily or that negatives could be processed in a minimum of time as is required in newspaper work. It has provided more rapid and more uniform processing.

Consequently, specifications are now available from manufacturers for achieving optimum processing in various processors for a wide range of photographic materials. In every instance the specifications had to be worked out taking into consideration the film or paper to be used, the processing chemistry involved, and the specific processor to be used. The processing laboratory must follow these specifications and use test strips and chemical tests (as described in this chapter) to be certain of good control.

Processing solutions can be mixed from separate chemicals as described in published formulas, or they can be made from packaged chemicals prepared by photographic manufacturers. It is absolutely necessary to use mixing equipment that provides accurate measurement of volumes. Processing solutions should not be mixed in a tank or tray in which the final volume cannot be accurately determined.

Techniques to Achieve Long-Term Image Stability

Developing the Image. Development is controlled by the use of times and temperatures recommended for films and papers in the instruction sheets enclosed with the sensitized product. This data is obtained by carefully controlled testing procedures that yield the relationship between increasing exposure and the increased density formed under the conditions of development. This relationship expressed as a graph produces the "characteristic curve" which is characteristic of sensitized materials.

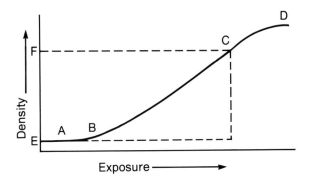

A-B is the "toe" of the curve; C-D the "shoulder"; B-C "the straight line portion." The slope or gradient of B-C indicates development contrast and is known as "gamma." F-E is the density range.

An important derivation of the characteristic curve is the density range which is a significant measurement in the photographic preservation of discolored, stained, and faded originals. It is the difference in density between the lightest and darkest areas in a print or negative.

The manufacturer's instructions and conditions for developing the image should be followed to assure image stability. In addition, there are specific precautions that can be taken to assure optimum image stability at this stage. A developer that has been overused or allowed to oxidize will turn brown and cause brownish stains on the image. An oxidized developer is the result of exposure to air; for this reason the developer solution should be kept covered. Contamination of the developer with fixing bath must be avoided. Fixer splashing into the developer solution during processing will result in silver and dichroic fog stains. Developer tanks should be cleaned regularly. Dirty developer tanks that are rarely cleaned may contain bacteria and if the situation is severe enough the bacteria will produce sulfide stains. Stains are discussed further in the chapter on deterioration.

Images developed for the finest grain tend to be subject to attack by sulfiding and oxidizing agents to a greater degree than those developed for normal grain size. Images that are greatly overexposed and underdeveloped suffer from the same tendency.

Stopping the Development Action. In processing for long-term keeping or maximum image stability it is advisable to use an acid stop bath such as KODAK Stop Bath SB-1 or KODAK Indicator Stop Bath. Prints should remain in the stop bath for 30 seconds with agitation.

The purposes of a stop bath are to stop development by neutralizing the developer alkali, to prevent stain, to reduce emulsion swelling, and to maintain fixing bath acidity by minimizing the carry-over of developer solution.

The strength of the stop bath should not exceed that recommended for two reasons: (1) excess acetic acid can affect the physical condition of some types of photographic paper support, causing it to become brittle during drying and storage; (2) excess acetic acid can react with the sodium carbonate in some developers to produce carbon dioxide gas, which can cause blisters in film emulsions or gas bubbles to become trapped within the paper structure of the prints. In the latter case, hypo and silver compounds trapped in the pockets of the paper are difficult to wash out, and as a result, small brown spots appear on the print after a period of keeping (or immediately if the print is sulfide-toned).

The acidity of an acetic acid stop bath is about pH 3.5 when fresh and pH 5.5 at exhaustion. Some proprietary stop baths, such as KODAK Indicator Stop Bath, help in determining when a stop bath is fresh and when it is exhausted. These baths contain a dye indicator which produces a yellow-colored solution when the bath is fresh and a purple-colored solution when it is exhausted. A stop bath that does not contain an indicator dye—for example, KODAK Stop Bath SB-1 can be tested for its effectiveness. It is difficult to state a capacity for a stop bath because of the variety of developers and techniques used in processing. For this reason, it is preferable to test the stop bath as described in the following section.

Figure 31 This scale permits, with the use of a pH meter, the determination of the number of times the acidity or alkalinity of a solution exceeds that of pure water. The successive numbers in the scale are related to each other by a factor of 10. For example, in the acid range the concentration of acid increases as the pH value becomes smaller. A solution at pH = 5.0 contains 10 times more acid than one at pH = 6.0. Similarly, a solution at pH 10 contains 100 times the alkali in a solution at pH 8.

TESTING A PRINT STOP BATH. Fill a clean 30 mL (1-fluidounce) vial about three-quarters full with the stop bath. To this add 2 drops of KODAK Stop Bath Test Solution STB-1. An acid stop bath that is still useful will remain yellow. When the acid has been neutralized, the bath will turn purple, and should be replaced. Under a KODAK OC Safelight Filter (light amber) the yellow color is not noticeable, but the purple color appears dark.

Figure 32 If a small amount of stop bath in a vial remains yellow (as shown on the left) upon the addition of a few drops of KODAK Stop Bath Test Solution SBT-1, the acidity of the stop bath is being maintained. If the same stop bath turns purple (as shown on the right) upon the addition of the test solution, the bath has been neutralized and should be replaced.

Replenishment of an exhausted *film* stop bath with 28 percent acetic acid is possible and for this reason film stop baths usually are not tested. However, replenishment of a *print* stop bath should be avoided because reaction products accumulating during use may cause a variety of mottle patterns if the print is subsequently toned.

Stereoscopic viewing cabinet Invented and manufactured by Alexander Beekers, 1859.

This device holds fifty pairs of stereo cards on a band. By rotating the knob, the pictures are changed.

Fixing the Image. The latent image formed during exposure is processed in a photographic developer to produce a visible image. A stop bath is used to control the degree of development. At this stage in processing, unexposed and undeveloped silver halides still remain in the emulsion. These salts, if allowed to remain, will darken with exposure to light. It is the function of the fixing bath to remove these salts from the emulsion without affecting the developed image. Two conditions must be met: (1) All of the unexposed and undeveloped silver halides in the emulsion must be dissolved by the fixing solution so that the soluble silver compounds thus formed can be removed from the material by washing, (2) Both the fixing chemicals and the soluble silver compounds must be removed from the emulsion and its support by washing. The materials must then be tested for the proper level of residual chemicals and posttreated as described on pages 57 and 58.

A single sheet of film or paper fixes in a relatively short time in a fresh fixing bath, because fresh solution is in contact with the whole surface of the material throughout the immersion time. When a batch of prints or negatives are fixed together in a tray, a different situation exists. The sheets of material may adhere to one another, and so prevent access of fresh solution to the surfaces. For this reason, photographic materials *must be agitated and separated constantly throughout the fixing time.* The effect of lack of agitation is often seen later as a discolored patch in the center of the negative or print, indicating that solution reached the edges of the material but failed to reach the center of the sheets. Bunching of negatives or prints during fixing is one of the most common causes of deterioration.

Most manufacturers publish the times for which their products should be fixed in the data and instruction sheets accompanying their photographic products. The recommendations for fixing time accompanying Kodak products includes a safety factor that helps to compensate for the difficulties in fixing material in batches and for the slowdown of the fixing reaction by a buildup of silver compounds in the fixing solution. Recommended fixing times should not be exceeded, particularly in the case of paper prints. Fixing times longer than those recommended tend to reduce the silver im-

age by removing silver from the image and perhaps changing its characteristics. Loss of fine detail is often the result. This is particularly true when the fixing agent is ammonium thiosulfate or a rapid fixer. In addition, prolonged fixation of prints also causes hypo and silver-hypo compounds to be retained in the paper fibers making thorough washing more difficult. Underfixing, on the other hand, allows silver-halide salts to remain in the emulsion. Under certain storage conditions, these salts will migrate to the surface of the emulsion layer and show up as a shiny black or multicolored deposit in the negative or print. Specific information on fixing times for negatives and prints is included in the sections entitled "Fixing Negatives" and "Fixing Prints."

A system of silver recovery can be used in situations where there is a sufficient volume of photographic processing. The silver is recovered from the fixing bath in black-and-white processing after the fixer has been used to the recommended limit. More information on this procedure can be obtained from the KODAK Publication J-10, *Recovering Silver from Photographic Materials.*

Figure 33 The above photo illustrates negatives clearing. This is called the "clearing time" and is the time required for the milky-appearing emulsion on a piece of preconditioned film to disappear completely. Jerry Antos.

FIXING NEGATIVES. A few negatives can be fixed in a tray if they are separated and handled carefully. In batch processing, the best method is to use suitable film hangers suspended in a tank. In this way, the films are always properly separated and there is a minimum of handling and potential damage.

In the case of film negative processing, a single fixing bath is usually adequate although a two-bath procedure may produce economic advantages if the volume of film to be processed is high. Approximately twenty-six 20.3 x 25.4 cm (8 x 10-inch) films can be fixed per litre (twenty-five 8x10-inch films per quart) of fixing solution. If the number of films processed is uncertain, the condition of the fixing bath should be checked frequently for its efficiency. This is described in the section, "Exhaustion of a Film Fixing Bath" later in this chapter.

The time required to fix a film negative can be determined by observing how long it takes a preconditioned unexposed piece of film to lose its milky appearance and become transparent. This is achieved by immersing a piece of raw film in water at the temperature of the fixer for one or two minutes. This is referred to as the "clearing time" and it is the result of the fixer dissolving the silver halides in the emulsion. This "clearing time" is controlled by several factors: the grain size and thickness of the emulsion, the concentration and type of thiosulfate, the amount of silver which collects in the bath from the film, and the fixing technique. Based on these factors, twice the time it takes to clear the emulsion is the recommended time to allow for fixing negatives.

FIXING PRINTS. Prints are usually fixed in a tray and often in batches which vary in the number of prints depending upon print size. Some technicians can handle several prints at a time up to the 16 x 20-inch size; some prefer to do one print at a time. In either case, accurately timed constant agitation is required to produce uniform quality from print to print. When processing multiple prints, a carefully timed rotation technique should be employed in which the bottom print is moved to the top of the batch in a continuous cycle for the recommended time of fixing. The time interval can be determined in advance. For example, with small-size prints requiring three minutes fixing, divide the 180 seconds (3 minutes) by the time required to interleave or move each print for fixing. This time will vary with each technician but the time between moves and the number of changes should be the same for each print. The development and stop bath operation must be compatible with the fixation technique used.

There are at least five general procedures to choose from as shown in the table opposite. For this purpose the procedures for a single print and a batch of five prints are outlined. Both single- and two-bath fixing techniques are included. Two-bath fixing is discussed at the end of this section and is recommended as preferred practice.

Procedures for Use of Fixing Baths

No. of Prints	Develop	Stop Bath	#1 Fixer	Water Bath	#2 Fixer	Wash
Single	1	1	1			
Batch of 5	5R*	5R	5R			
Batch of 5	5R	hold† 5RA**	1			
Batch of 5	5R	hold 5RA	1		1	
Batch of 5	5R	hold 5RA	1	hold# 5RA	5R	

R* = rotation as discussed above

RA** = rotation as above but keep in stop bath or rinse until batch has been fixed one-at-a-time.

Hold† = keep batch in stop bath while prints are fixed successively one-at-a-time

Hold# = Keep batch in water bath while prints are fixed successively one-at-a-time

Figure 34 Good agitation by rotating prints is important in the fixing step. The bottom print is taken out and placed on top in a continuous cycle. The prints are either counted or they can be turned over in each cycle. Jerry Antos.

Figure 35 The irregular staining in this print is the result of poor processing technique. Residual hypo has caused image discoloration and silver-hypo complexes have caused background stain.

Always use trays or tanks that are large enough to permit easy handling of the prints. For example, not more than twelve 20.3 x 25.4 cm (8 x 10-inch) prints can be fixed properly in an ordinary 41 x 51cm (16 x 20-inch) processing tray.

Prints may be placed face upward or downward in the fixer solution but they should not be left unattended for any length of time. Bubbles form under a print that floats face downward; consequently, some areas are only partially fixed. The effect may not be apparent in a straight black-and-white print, but it will be seen as circular purplish stains in a print toned by one of the sulfide processes. A print that floats face upward exhibits the same effect, but the purplish stains are irregular in shape.

As with negatives, the objective in fixing prints is to clear the emulsion of silver halide salts. The recommended fixing time for prints on fiber-base papers is 5 to 10 minutes. Times in excess of 10 minutes permit the fixing solution, and the silver compounds it bears, to penetrate the paper fibers, as well as the spaces between the fibers. Paper in this condition is difficult to free from residual chemicals by washing. After a period of keeping, the effect can be seen as an overall yellow stain that extends through the paper base. It may become apparent immediately if the print is toned by one of the sulfide processes.

Prints on resin-coated papers can be fixed in a shorter length of time than those on regular fiber-base papers. It is important not to exceed the recommended time for fixing these papers. Prolonged fixing can result in the fixing bath penetrating the uncoated edge of the prints making it extremely difficult to wash out the

silver compounds. Thus, a major advantage of the water-resistant base—the short fixing and washing times—is lost. Even with extended washing there is danger of subsequent stain formation on the edges of the prints.

As successive sheets of paper are fixed in the solution, the quantity of silver in the solution builds up. When prints are fixed, a critical concentration of silver is reached after comparatively few sheets of paper have been fixed. The recommended number of 20.3 x 25.4 cm (8 x 10-inch) prints that can be fixed successfully per litre of solution is about 25 for normal processing. However, if prints with the minimum tendency to deterioration (stain) are required, the bath should be discarded after eight 20.3 x 25.4 cm (8 x 10-inch) sheets of paper per litre have been processed. These figures give only an approximate estimate of the condition of a fixing bath because the amount of silver compounds added to the solution by a print depends on how much of the silver halide in the emulsion was developed to metallic image silver. Less silver halide is left in a very dark print than in a light one. A more definitive method of testing the capacity of a fixing bath when processing prints is described in the section entitled "Exhaustion of a Print Fixing Bath."

TWO-BATH FIXING OF PRINTS. The use of a two-bath fixing technique is recommended in processing prints for stability. This method provides increased capacity of the fixer and helps to maintain a final fixing bath that is low in silver content. Because of this it is more efficient and more economical than the single-bath method.

Fiber-base prints should be fixed for 3 to 5 minutes in each bath. The major part of the silver halide is dissolved in the first bath, and the remainder is dissolved or rendered soluble by the second bath. When fixing with two baths, the following procedure should be used:

1. Mix two fresh fixing baths and place them side by side.

2. Fix the prints for 3 to 5 minutes in each bath. *Do not turn on roomlights until prints are in the second fixer.*

3. Discard the first bath when fifty-three 20.3 x 25.4 cm prints per litre (fifty 8 x 10-inch prints per quart) of solution have been fixed.

4. Substitute the second bath for the one just discarded; the second bath has now become the first one.

5. Mix a fresh bath and place it beside the first one.

6. Repeat the above cycle four times.

7. After five cycles, mix fresh solution for both baths.

8. If five cycles are not used in one week, mix fresh solution for each bath at the beginning of the second week.

In the complete cycle of five changes, two hundred and sixty 20.3 x 25.4 cm prints will be processed in 6 litres of fixer for an average of 43 prints per litre (forty-two 8 x 10-inch prints per quart) compared to twenty-six 20.3 x 25.4 cm prints per litre (twenty-five 8 x 10-inch prints per quart) if only a single bath is used. This increases the effective capacity of the two-bath fixing solution by 68 percent at least and by a greater percentage if the increased image stability that is obtained is considered.

Resin-coated prints should be fixed for 1 minute in each bath and then drained for 5 seconds between baths. The first bath should be discarded when ninety-two 20.3 x 25.4 cm prints per litre (eighty-seven 8 x 10-inch prints per quart) of solution have been fixed. Both baths should be discarded after four cycles or after one week, whichever is sooner.

CAPACITY OF THE FIXING BATH SOLUTION. As more and more film or paper is fixed, more silver is accumulated in the fixing bath in the form of complex silver compounds. The result is a gradual weakening of the fixer solution which means a slower-working fixer and a longer time to clear an emulsion. The useful life of a fixing bath is determined by the quantity of undeveloped silver dissolved in the bath. The concentration of silver that is dissolved in the bath is related to the time it takes for negative and print emulsions to clear. When the silver concentration exceeds a certain level as described below insoluble silver-hypo compounds or complexes are formed that are not removed from the material during washing. The fixing bath should be discarded before it reaches this point: it is "exhausted." Simple tests to determine when fixing baths are exhausted are described in the following text.

Exhaustion of a Film Fixing Bath. When film is being processed, the best way to determine the efficiency of the fixing bath is the length of time it takes for the emulsion to clear. To determine this, use a small unexposed strip of the same type of film as is being processed and soak it for at least one minute in water at the temperature of the fixing bath. Then immerse the strip in the fixer or in a small volume of the fixer in a test tube. Record the time required for the opalescence or milkiness of the emulsion to disappear. This is one-half the time required to fix the film and is best observed against a dark background such as a piece of dark paper or a dark wall. When a film requires twice the time to clear that is necessary in a fresh bath, the fixing solution should be discarded. The maximum amount of

silver that can be contained in an effective film bath is approximately 6.0 grams per litre of a sodium thiosulfate fixer or 13.0 grams per litre of an ammonium thiosulfate fixer. The silver ammonium compounds wash out more readily than the silver sodium components.

Exhaustion of a Print Fixing Bath. The useful life of a fixing bath for fiber-base prints is shorter than one for negatives. There are two reasons for this: (1) Paper, because of its nature, absorbs the silver compounds from the fixing solution whereas film base does not; (2) there is more carry-over of stop bath or rinse water to the fixer in print processing than in film processing, thus diluting the fixing solution and reducing its working strength. This situation cannot be corrected by increasing the fixing time because there is a significant relationship between fixing time and washing time in print processing. Consequently, when processing prints, the fixing solution should be checked more often.

A print fixing bath cannot tolerate more than 2.0 grams of silver per litre. When it reaches this concentration silver compounds cannot be removed easily and staining will occur. The bath should be replaced. The efficiency of a print fixing bath is not as easily measured by using a sample print as it is with a sample negative. This is due to the opacity of paper and the inability to observe the clearing time when the paper print is immersed in the fixing solution. However, there are several ways that print fixing baths can be tested. The same clearing test as is used for negatives can be approximated with prints by making the test on a strip of motion picture positive film or microfilm. The physical and chemical characteristics of these materials are quite similar to those for a paper emulsion. In addition, KODAK Fixer Test Solution FT-1 will provide a rapid and positive indication that the silver concentration in the fixing bath has reached the limit beyond which prints cannot be fixed satisfactorily. If a single fixing bath is being used, it should be tested frequently with Solution FT-1. If the two-bath method is being used, the second bath needs to be tested only occasionally. Usually, in the case of the two-bath method, the test is negative but if optimum stability is important, the test is worthwhile.

Test for Single-Bath Fixer. To 5 drops of KODAK Fixer Test Solution FT-1, add 5 drops of the fixing bath to be tested and 5 drops of water. Discard the fixer if a yellow-white precipitate forms instantly. Any slight milkiness should be disregarded.

Two-Bath Fixer. First Bath. Test as described above for a single-bath fixer.

Second Bath. To 5 drops of KODAK Fixer Test Solution FT-1, add 5 drops of the fixing bath to be tested and 15 drops of water. If both tests result in a yellow-white precipitate, replace both baths with fresh fixing baths. If only the first bath forms a precipitate, replace the first bath with the second bath, and the second bath with a fresh bath.

See the bibliography for a test procedure on unexposed paper described in the book *Darkroom Techniques*.

Washing Processed Photographic Materials.
After all of the undeveloped silver halide has been converted in the fixing bath, the layers of the photographic material are still saturated with fixing bath chemicals and dissolved silver compounds. If these are not removed by washing, the image may subsequently discolor or fade or stains may appear on the surface. This can be especially serious when processing for long term image stability. Good washing is as important to image stability as is the careful adherence to the previously discussed techniques.

WASHING APPARATUS. The equipment that prints and films are washed in should be kept clean by frequent wiping and rinsing. Dirty washers are a source of print stains that may be difficult to account for later on. A 5 percent solution of sodium hypochlorite, commonly available as a bleach sold for laundry use, is helpful in removing the slime that tends to accumulate in washers that are not cleaned frequently. The washer should be flushed thoroughly with clean water after using any chemical. Small amounts of a chemical left in a washer may bleach the silver image; large amounts may remove the gelatin emulsion from film or paper support.

WATER SUPPLY. The water in any tray or tank used for washing photographic materials should flow at a rate sufficient to fill the vessel in 5 minutes or to provide a complete change of the volume of water once in every five minutes. This rate should be achieved without excessive turbulence, which can damage the film or prints, and without splashing adjacent walls or floors. The stream of water should be generous enough so that the turbulence and replacement occur equally throughout the washing vessel permitting each print or negative to be washed completely, wherever it is located in the vessel.

A test to determine the rate of change of water in a washer can be made quite simply. Add a small quantity of concentrated liquid food coloring or potassium permanganate solution to the water in the tray or tank and observe the time the color takes to disappear. If the flow of water is sufficient, the color should disappear in five minutes. Before making this test, be sure that the washer or trays are free from any slimy deposit that might retain the coloring material. If potassium permanganate is used, be sure that the wash water is not contaminated by fixing agent because a weak permanganate solution is made colorless by these chemicals.

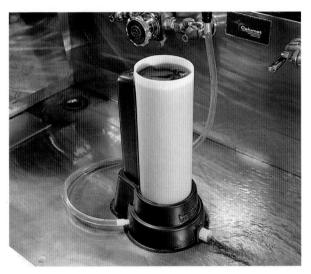

Figure 36 Adding potassium permanganate solution to the washing tank and measuring the time required for the color to disappear is one way of checking if the flow of water is sufficient for thorough washing. Potassium permanganate is purple and if the flow of water is sufficient, the color should clear in five minutes.

A plentiful supply of pure water is desirable in processing photographic materials for permanence. Municipal water supplies are generally satisfactory for washing negatives and prints. Water may be either hard or soft according to the amount of calcium or magnesium salts dissolved in it. The degree of hardness usually has little effect on stability, although very soft water permits gelatin to swell excessively, especially water that has been treated in softeners to remove salts; this may be troublesome in some processes.

Water from a well or other untreated source may contain sulfides or dissolved vegetable matter. The presence of sulfides can be detected by an odor of hydrogen sulfide (like rotten eggs) when the water is heated. A greenish color in the water or turbidity may indicate dissolved vegetable matter. These impurities can be removed by suitable filtration or treatment.

Generally, it is safe to assume that water is satisfactory for photographic washing if it is clear and colorless, and does not have a sulfide odor on being heated.

WASH-WATER TEMPERATURE. The temperature of the wash water has a definite effect on the rate of removal of fixing chemicals and silver complexes from both films and prints. Residual chemicals are washed out with increasing difficulty at temperatures below 16°C (60°F). When practical considerations as well as the physical characteristics of film and paper are taken into account the most suitable range of temperature for washing by the tank or tray method in a sink is 18 to 24°C (65 to 74°F).

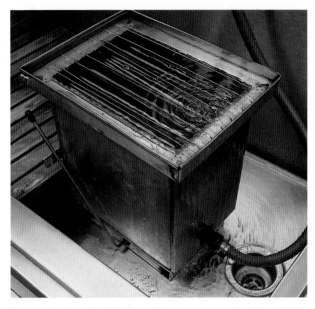

Figure 37 For efficient film washing, running water should enter the tank at the bottom and overflow at the top as shown in the diagram below. Photo shows negatives suspended in hangers and washed in a tank. Jerry Antos.

Figure 38 For efficient circulation of wash water, the inlet should be located not at the top of the tank but at a bottom corner as illustrated.

WASHING NEGATIVES. A small batch of films or plates can be washed in a tray but excessive turbulence should be avoided because these materials tend to scratch one another if allowed to move about too rapidly.

Batches of negatives should be suspended in hangers and washed in a tank. With suitable hangers, both films and plates can be washed in this way. For good water circulation, the inlet should be positioned at one corner of the bottom of the tank. Allow the water to overflow at the top edges of the tank rather than using a single outlet at the top. Such an outlet tends to produce a pattern of currents that may leave certain areas in the tank comparatively stagnant, and so reduce the rate of complete water change. Film negatives can be washed quite efficiently following standard procedures within 20 to 30 minutes because chemicals are not absorbed by the base. Use a timer to determine the exact amount of time being used.

If small air bubbles tend to form on the film, insert an aspirator (filter pump) in the wash-water line and adjust it to permit a steady flow of air into the water. The resulting larger air bubbles will not cling to the film. Water can be conserved and the cost of washing reduced by limiting the washing to the recommended time, by not using an unnecessarily high rate of water flow and by not washing negatives in a tank bigger than is needed to accommodate the size and quantity being washed.

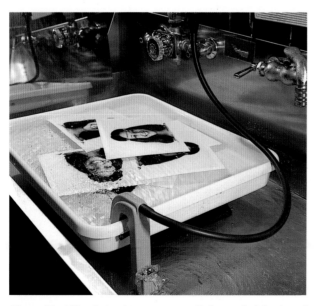

Figure 39 This photo shows proper agitation and siphoning of prints being washed in a tray. Efficient washing of prints involves thorough agitation and removal of the hypo-laden water from the bottom of the tray.

WASHING PRINTS. Prints can be washed in a tank or a tray selected according to the quantity and size of the prints to be processed. The KODAK Automatic Tray Siphon will convert any ordinary tray into an efficient print washer. Commercial washers are also available from photographic dealers and other manufacturers. The washing apparatus should be designed so that the water can reach every part of each print throughout the washing time. A well-designed washer can do this automatically with prints up to 12.7 x 17.8 cm (5 x 7 inches); larger prints need frequent handling to keep them separated unless they are in individual compartments. Some print washers tumble the prints in a rotating bin so that each print is agitated separately. Other washers agitate the prints with water while they are kept separated with perforated plastic sheets in individual compartments. Still others use the force of a directed flow of water to keep the prints swirling in the wash. It is not possible to suggest the exact procedure for efficient washing in all of the types of washers that are available in the marketplace. In addition, the use of washers, advertised as archival print washers may because of design flaws or improper operation result in inadequate washing. For these reasons, the control tests described later in this section should be used to determine the amount of residual chemicals and silver in the prints or negatives after all of the washing has been completed. These tests will indicate whether the water flow rate, the time, and the washing procedure have been effective. If the conservation of water is important, three trays or shallow tanks can be arranged in series to permit countercurrent movement (cascade) of the prints. Each tank is placed at a higher level than its predecessor, with fresh water coming into the final and highest tank. Prints are moved at regular intervals from the lowest tank—where the bulk of the fixing chemicals are removed—to the intermediate tank and then to the upper tank, where washing is completed by the action of the incoming fresh water.

Prints on resin-coated papers wash more rapidly than prints on conventional-base papers. This is because the fixing chemicals are absorbed only by the emulsion and the edges of resin-coated papers—not by the base. Consequently, these prints can be satisfactorily washed within a relatively few minutes. On the other hand, washing prints on fiber-base paper takes longer because chemicals are absorbed by the base. Generally, a thorough washing of these papers usually takes from one-half hour to one hour if the proper procedures are used and depending on the weight of the paper base, that is, whether it is single or double weight. Prints can be processed more rapidly as suggested by some other manufacturers but control *tests* must be used to be certain the processing is satisfactory for good image stability. Fiber-base papers that contain fluorescent brighteners should not be subject to excessive "wet" time and should be washed and dried without a long delay. Brighteners may leach out of the paper while soaking in a chemical solution or in water over a long period of time. Most Kodak resin-coated papers have fluorescent

brighteners incorporated in the paper base but because of the RC layers the wet time is not as critical. As in the case of negatives, a timer should be used to determine the exact length of time of the washing operation—the actual time being determined by testing the effectiveness of the washing with tests described in the following section.

TESTING FOR EFFECTIVE WASHING. The last step remaining in processing for maximum image stability is to test the processed photographic material for residual fixing chemicals and silver after all of the washing has been completed. Tests on samples of the negative or print are the only way to be sure if the washing has been uniform and effective, particularly in the case of fiber-based prints where the paper support retains hypo in its fiber structure.

Testing for Hypo. As stated in the introduction to this chapter the discussion of processing "is concerned only with those factors impinging on the long-term keeping properties of photographs." The removal of hypo and silver-hypo complexes by washing is an important factor. The only purpose of removing these chemicals from processed prints, negatives, and plates is to enhance the stability of the processed materials.

Images that are essentially free from residual hypo and silver complexes are generally very stable to external contaminants and are suitable for long-term keeping if properly stored. Images produced for long-term keeping should be well-washed, tested for residual chemicals and finally treated with a dilute solution of one of the recommended Kodak toners [10][11]. Treatment in a diluted, recommended Kodak toner generally improves image stability.

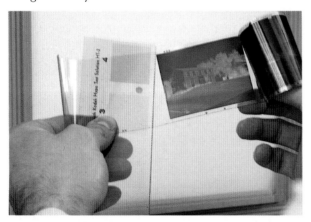

Figure 40 The same materials can be used to test for hypo residue in films. A drop of KODAK Hypo Test Solution HT-2 placed on a film that is dry in an area that has no photographic value will show the amount of fixer left in the film. The comparison should be made with the hypo eliminator in its sleeve crossed over the spot on the test film so that both the test film and the comparison spot are viewed through the thickness of the two film bases. Note that the test spot is on the unexposed but processed end of the roll film.

Either the KODAK Hypo Test Kit, sold by photo dealers, or KODAK Hypo Test Solution HT-2 can be used to test for remaining fixing chemicals. The solution should be stored in a screw-cap or glass-stoppered brown bottle, away from strong light. At 18 to 24°C (65 to 75°F), it will keep for about 6 months. The solution should not be allowed to come in contact with hands, clothing, negatives, prints, or undeveloped photographic material: it will stain them black. To determine whether prints are effectively free from hypo, wipe the excess water from the face (emulsion side) of an unexposed piece of the paper that is being processed, or from the non-image, margin area of one of the prints. Place one drop of the test solution on the face of the processed paper sample. Allow the solution to stand on the sample for two minutes, rinse it to remove the excess reagent, and compare the stain with the tints shown in the *KODAK Hypo Estimator*, Publication J-11, or the *KODAK Professional Photoguide*, Publication R-28. The *KODAK Hypo Estimator* is an aid for determining the thoroughness of washing and like the *Photoguide is* available from photo dealers. Note that this test gives a qualitative rather than quantitative estimate of the degree of washing; quantitative testing for residual hypo in prints and films is discussed later in this section. For fiber-base prints the stain should be between the 1 and 2 patches on the Hypo Estimator. The test results are significantly different for prints on fiber-based and water-resistant paper base: the levels of hypo in fiber-based papers is higher than in resin-coated papers because of the natural tendency of fiber-based paper to retain hypo.

Prints on resin-coated papers should show very little or no discoloration with the HT-2 test, with an acceptable spot density of Patch 1 or below; those testing similar to Patch 3 contain objectionably high hypo levels. To test films for residual fixing chemicals, cut off a small strip from the clear margin of the film and immerse a portion of it in a small volume of the test solution for about three minutes. Well-washed films that are essentially free of hypo should show very little or no discoloration. This technique is very useful in testing dry films but it should not be used on wet films because of the danger of spreading the reagent.

Quantitative Test for Hypo in Prints. The amount of fixing chemicals in fiber-base (non-resin coated) photographic papers can be determined quantitatively by the first procedure described in ANSI PH4.8-1984 Photography (Chemicals)—Determination and Measurement of Residual Thiosulfate and Other Chemicals in Films, Plates, and Papers. The second procedure, which is simpler to perform, measures not only thiosulfate but also polythionates and other residual sulfur-containing chemicals. In this method, acidified silver

nitrate is applied to an unexposed part of the processed print, or to a blank print that has been processed with the exposed prints. Excess silver nitrate is removed with sodium chloride solution to convert the silver salt to silver chloride, which is then dissolved out in hypo. This step is necessary because the excess silver nitrate would darken in light and yield a false analysis. To determine whether the hypo has been removed uniformly, an entire blank sheet or print can be treated in this manner.

Any thiosulfate present will react with silver nitrate to produce a stain. The densities of the stained and unstained areas before and after treatment with the silver nitrate solution are read on a densitometer equipped to measure Status A blue density. The difference between these density readings indicates the amount of hypo in the material.

Residual hypo and especially silver-hypo complexes must be at a very low level because any subsequent stain that forms will show prominently in the highlight and non-image areas. The proper use of the fixing bath is most important in this regard. An exhausted fixer will produce insoluble silver-hypo complexes that are very difficult to remove by washing.

Neither of the ANSI tests cited above accurately measure residual hypo quantitatively in RC prints containing incorporated developing agents. A colorimetric determination of residual thiosulfate in processed photographic paper has been described in Imaging Technology (formerly the Journal of Applied Photographic Engineering), Vol. 9, No. 2, April 1983 pp 66-70. This iodine amylose method has been adopted by the Accredited Standards Committee, PH4, as a standard method for determining the residual thiosulfate in RC papers.

Quantitative Test for Hypo in Films. The residual fixing chemical left in processed film can also be determined quantitatively by the techniques described in the same ANSI Standard PH4.8-1984. Hypo limits are given in the American National Standard Specifications for Photographic Films for Archival Records, Silver-Gelatin Type, on Cellulose Ester Base, ANSI PH1.28-1981, and on Polyester Base, ANSI PH1.41-1981. Fine-grain films have tighter residual hypo levels than medium- and coarse-grain films. Table VI-1 taken from the ANSI Standards indicates the maximum concentration of residual hypo that can be permitted for archival stability assuming that archival storage conditions exist.

Table VI-1*
Limits for Thiosulfate Concentration

Classification of Films According to Graininess of Developed Image	Maximum Permissible Concentration of Thiosulfate Ion, $S_2O_3^{--}$ in Micrograms per cm^2 (See Note 1)	Grams Per M^2
Class 1 Fine-grain copying, duplicating, and printing films (includes ordinary microfilms) (See Note 2)	0.7	0.007
Class 2 Medium-grain continuous-tone camera films (negative and reversal) and coarse-grain x-ray films	2	0.02

*ANSI STANDARD PH1.28-1981 (see page 42).

NOTE 1: For films having photographic layers on both sides, or a noncurl backing layer, values are for each side of the film.

NOTE 2: For films having finer grain structure than those types covered by Class 1 (that is, high-resolution films), it is desirable to have a residual thiosulfate ion concentration less than 0.7μ g/cm^2 (0.007 g/m^2).

NOTE: Not all of the practical recommendations given in this text fall within the scope of *current* ANSI specifications. The ANSI standards do not prevent anyone from using products or processes not conforming to the standards.

Testing for Silver. As discussed in the section "Capacity of the Fixing Bath Solution," an overworked fixing bath contains complex silver thiosulfate compounds that are retained by the films or prints and cannot be removed completely by washing. These salts lead to stains that may not become evident for a period of time. Since the quantity of silver compounds necessary to cause an overall yellow stain on a print or negative is extremely small, there is no simple quantitative method available for its determination. However, the stain that might be visible after a period of keeping can be simulated by the following test: Place a drop of KODAK Residual Silver Test Solution ST-1 on an unexposed part of the processed negative or print and blot off the surplus solution with a piece of clean white blotting paper or absorbent tissue.

Any yellowing of the test spot, other than a barely visible cream tint, indicates the presence of silver. If the test is positive, residual silver can be removed by refixing the print or negative in fresh hypo and rewashing for the recommended time. Prints toned in a sulfide toner or selenium toner will not yield to this treatment because the residual silver in the image has been toned.

AIDS TO HYPO ELIMINATION AND REDUCED WASHING.

The washing of negatives, plates, and prints, especially on fiber-base paper, is the most time-consuming operation in processing. Many suggestions and recommendations have been made through the years to remove hypo more rapidly than by washing alone. Several chemical solutions have been developed for use as aids to the washing process and are applicable under certain circumstances.

As stated earlier the only purpose in removing hypo and silver-hypo complexes is to enhance the stability of the processed material. Newly reported evidence on the stabilizing effect on some silver images to attack by hydrogen peroxide produced by modest levels of retained hypo has been cited.[10][11][12][13][14] It is therefore important to review the recommendations for the use of KODAK Hypo Eliminator HE-1 and KODAK Hypo Clearing Agent in the processing of black-and-white films, papers, and plates. The comments below relate only to the use of these washing aids in the production of long-term photographic records.

KODAK Hypo Eliminator. KODAK Hypo Eliminator *should never* be used on films or plates intended to be stored under long-term or archival conditions.[15][16] It *should* also *never* be used instead of a proper wash but only to remove the last traces of hypo from prints and *only* when these traces of hypo would create a problem in a subsequent toning process. For reasons still unknown, the adsorption of hypo by paper fibers can interfere with toning reactions. KODAK Hypo Eliminator is not intended to be used as a time saver.[17]

KODAK Hypo Clearing Agent. Hypo can be removed by conventional washing for a long period of time or by the use of a washing aid such as KODAK Hypo Clearing Agent. A shortened wash time is sometimes desirable to save time, to save water, or to avoid the unnecessary long time use of an unsuitable water supply. KODAK Hypo Clearing Agent can reduce hypo level to a point much lower than that attained by shortened wash time. It was designed specifically as a washing aid and was never meant to be, in itself, an image stabilizer. All prints, films, and plates whether washed with KODAK Hypo Clearing Agent or by thoroughly washing with water should be treated with appropriate diluted toners to obtain maximum image stability. See page 57.

When it is necessary to use KODAK Hypo Clearing Agent with films and plates, rinse them in fresh water for 30 seconds to remove excess hypo and then immerse them in KODAK Hypo Clearing Agent solution for 2 minutes with agitation. Wash them for 5 minutes in a tank in which the water changes completely in 5 minutes. To avoid streaks, drying marks, and the formation of water droplets on film surfaces, bathe films in KODAK PHOTO-FLO Solution for 30 seconds and then hang them up to dry.

When it is necessary to use KODAK Hypo Clearing Agent with papers, rinse the prints in fresh water for 1 minute to remove excess hypo. Treat single-weight papers for 2 minutes, with agitation, in KODAK Hypo Clearing Agent solution and then wash them for at least 10 minutes. Observe the normal recommendations concerning water flow. The prints must, of course, be agitated and separated throughout the washing time. Rinse double-weight papers for one minute in clean water; then immerse them in KODAK Hypo Clearing Agent solution for three minutes. Wash the prints for at least 20 minutes with normal flow and constant agitation. Prints can be transferred to the KODAK Hypo Clearing Agent solution directly from the fixer without an intermediate rinse. This practice, however, considerably reduces the capacity of the KODAK Hypo Clearing Agent solution. For the capacity of the solution with and without intermediate rinsing, see the reference chart. Because of the rapid washing characteristics of resin-coated papers, the use of KODAK Hypo Clearing Agent with these materials offers little advantage and is not recommended.

If the hypo estimator spot test described on page 54 is used after washing and if a washing aid other than KODAK Hypo Clearing Agent is employed, it may give misleading results. The face or emulsion side may show less stain than a print washed only in water, and yet the hypo content of the two prints may be equal. In such cases results obtained with KODAK Hypo Test Solution

HT-2 may be unreliable and it would be preferable to measure the density of the material after treatment with the silver nitrate test solution. See "Quantitative Test for Hypo in Prints," page 54.

KODAK Fixing Bath F-6. This fixing bath is also helpful in reducing the washing time necessary for photographic materials. In addition to hardening the gelatin in the emulsion to protect it and make it easier to handle, KODAK Fixer F-6 has properties that make it easier to wash out of gelatin than many other fixers such as F-5. These characteristics make it especially beneficial for processing when image stability is important. Most fixing baths recommended today are known as acid hardening fixers and usually have a pH of about 4.1 to 4.3; that is, they are quite acidic (see page 47). They are also "buffered" which means that such baths can tolerate a considerable addition of acid or alkali without a significant change in pH value. This means that the stop bath solution (acid) or developer solution (alkaline) which is "carried over" by the film or paper to the fixer does not affect the pH value very much. The F-6 fixer has a pH of about 5.0 and has the same advantages and use instructions as other acid hardening fixing baths. The use of an acid stop bath is mandatory when the F-6 fixing bath is employed.

Fixing baths and various other photographic processing solutions change the properties of the gelatin in a photographic emulsion. When the emulsion is fixed in a low pH fixer (4.1-4.3), the hypo is strongly held by the gelatin but when a higher pH fixer such as F-6 (5.0) is used, the hypo is not strongly held and is more readily removed during washing.

Other Aids. Other products and techniques have been recommended for rapid processing of prints. They should be carefully studied by the user if they are being considered for use in the processing of archival materials. Oftentimes their structure does not meet the requirements for archival processing nor are they cost effective from a time and labor standpoint.

Toning. Despite all of the recommended techniques to this point, the silver image is very subject to deterioration caused by numerous external contaminants and factors. Fiber-base and resin-coated prints as well as negatives can be affected by oxidizing gases in the environment, exposure to high levels of irradiation (light) for long periods of time, or adverse storage, display, or framing conditions. Many of these adverse effects can be substantially reduced by treatment with toners such as KODAK Rapid Selenium Toner, KODAK POLY-TONER, KODAK Sepia Toner, or KODAK Brown Toner (see the chapter on deterioration).

Figure 41 This comparison shows a fully processed print (right) that faded when subjected to hydrogen peroxide vapors in a test chamber. A second print (left) that had been posttreated in dilute KODAK Rapid Selenium Toner (1:19) was tested side by side in the same chamber at the same time and showed no sign of fading.

These toners are used at specified dilutions of 1:19 to 1:35 (1 part toning solution to 19 parts water, for example). For optimum stability no one dilution is equally applicable to all processed films, plates, and prints. However, until data for specific products becomes available a general recommendation suggests a 1:20 dilution of the selenium toner (i.e., 1 part selenium toner to 20 parts water).

Toners that change the metallic silver to sulfides or selenides significantly increase the life of print images. The use of toners that contain gold chloride and KODAK Gold Protective Solution GP-1 are slightly less effective than the toners mentioned above. Their use, however, does extend the life of untoned prints considerably. Other toners such as iron and copper should not be used for improving image stability because they, in fact, decrease image stability.[18]

Protection is given to the images by the recommended toners whether there is a color change or not. Apparently light and ultraviolet radiation have little effect on the longevity of black-and-white images that have been properly toned. The prints can be kept in the dark or displayed with no difference in stability.

For information relating to the use of Kodak toners for producing fully-toned images, see Kodak Publication G-23, *The ABC's of Toning*, and J-1, *Processing Chemicals and Formulas*.

Drying. The last step in processing for maximum image stability is the drying of the processed photographic materials. Meticulous operation and care must be followed through the drying stage to avoid contamination by chemicals as well as physical changes in the structure of the material. It is important to dry film or prints in a dust-free cabinet or room with filtered air or an air purifier if necessary. The drying air should be circulated and not allowed to become stagnant. Film should be dried by first rinsing it for a few brief seconds in KODAK PHOTO FLO Solution to prevent water spots. Then it should be allowed to dry in a chamber where the temperature is between 21-26.5°C (70–80°F) and the relative humidity (RH) is about 70 percent. When the RH is higher than 70 percent, the drying is retarded; when it is less than 70 pecent, there may be excessive spotting especially with hard water that contains various salts. A very high temperature can cause water spotting, buckling, or even melting of the film. Film should never be squeegeed: this can cause scratching in a soft emulsion. Squeegeeing may be necessary in some forms of mechanical processing.

Circulating air should be kept at low velocity to minimize film movement and prevent contact between the damp films. If films are allowed to touch each other, they may stick together. Alcohol can be used to accelerate drying by bathing the film in a solution containing

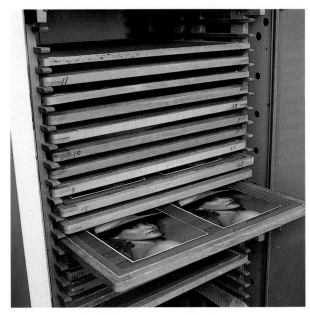

Figure 42 This dryer has a series of fiber-glass screens in a vertical arrangement with one slightly withdrawn to show the positioning of the prints. (In actual operation photographic blotters are used as well.) Removal of all the screens provides a drying chamber for roll films. Jerry Antos.

85–90 percent alcohol in water. The use of full strength alcohol can produce an opalescence in the film which is due to the crystallization of the gelatin—a change that can be reversed by rewashing the film and then drying it properly. A commercial, alcohol-based product may leave a light haze or residue on the film which can be removed with a film cleaner.

Natural air drying without heat is the best way to dry prints. Here, too, cleanliness in handling the material is of paramount importance. There are significant differences in the ways in which fiber-base and resin-coated prints should be dried but one important rule in both cases is to avoid mixing them with stabilized black-and-white or color prints. Contact between the two may introduce processing chemicals that can affect the image stability desired. If image stability is important, print-flattening solutions should be avoided because some contain hygroscopic chemicals which, if left in the print, attract moisture. Fiber-base prints can be air dried on fiber glass screens, between photographic blotters, or on heated drums. These screens must be kept immaculately clean; that is, they must be kept free of any residual chemicals from previous drying operations. Kodak photographic blotters should be replaced for each batch drying to avoid any possible contamination. In addition, cloth belts on dryers should be free of chemicals; they should be cleaned by washing them in hot water and a mild detergent and then by giving them a vigorous squeegeeing. Fiber-based prints usually cannot be dried by hanging because of curl. Resin-

coated prints, on the other hand, seldom show curling except in situations where there is very low humidity. They can, therefore, be hung up by the corners on a line to dry except in very dry situations (instances of low humidity). Alternatively, these prints can be spread out to dry on a clean, dust-free table or on clean toweling. Resin-coated prints should be squeegeed free of excess water on the backside only and should not be subjected to a belt dryer.

Summary of Processing for Long-Term Stability. The foregoing provides the details of optimum processing techniques and requirements. The use of control tests and exemplary techniques will produce protected silver images that will have excellent long-term stability especially when stored and used under the conditions described later in this book. When concerned about long-term stability, it is better to err in favor of solution usage that is below the recommended exhaustion level rather than to reach it or exceed it. In summary the important steps in processing to achieve long-term stability are:

1. develop according to instructions

2. use an acid stop bath

3. fix and wash to produce images that are essentially free of processing chemicals

4. use control tests to determine if hypo has been reduced to an adequate level

5. treat with diluted toner solution to protect the silver image against contaminants

6. dry in an environment that will avoid contamination by chemicals and physical changes.

Processing to produce image stability requires close adherence to the manufacturer's recommendations and the use of control tests to determine if the processing has been satisfactory. The artifact must then be stored in a proper enclosure in a recommended storage area environment. The procedure, though time-consuming, will produce images that will last a long, long time.

Chapter VII Color Photographic Images: Their Structure, Their Processing and Preservation for Stability

Color images have become an important part of photographic collections and, as in the case of black-and-white photographs, it is important that the conservator understand the basic structure of these materials, how to process them for long-term stability, and how to care for them to preserve the image. The keeping properties of color images have become very important to photographers, archivists, and others who must preserve them as historical, sentimental, or commercial records of value.

When exposed to light over a period of time or even when stored in the dark, color photographic dyes will change to a greater or lesser degree. As with the color dyes used in paints, inks, and fabrics, the dyes used in color photographic images will, in time, change also. But there is knowledge available and procedures that can be followed to reduce the rate of change in recent materials or to restore deterioration if it has already occurred in historical artifacts. Nevertheless, as illustrated in Figure 43, the image stability of many color photographs have remained good under normal keeping procedures over a period of time. The image stabil-

Figure 43 The above series of photos from a family album of Christmas cards were made on a variety of KODAK EKTACOLOR Papers. The album was stored in a typical home environment. These original photos show that the dark stability of prints made almost 30 years ago on EKTACOLOR Papers is such that they remain quite acceptable today. Kodak data indicate that current EKTACOLOR Papers such as EKTACOLOR Professional Paper and EKTACOLOR Plus Paper are even more stable and when properly processed and stored under normal conditions without extended exposure to light should remain acceptable for approximately a century. Courtesy Myron Kerney.

ity of a particular color photograph depends on the specific product used and how it is processed, stored, and displayed. Many color prints of historical significance were made by different processes and their stability is related to the dyes or pigments used in those processes. Eastman Kodak Company believes that color photographic slides, prints and movies made on today's Kodak products will retain good to excellent color for a long period of time if properly processed, stored, and displayed. In this chapter, the company sets forth the most recent information available on color images and their preservation. This includes an explanation of the structure of color photographic materials, their processing, stability, and care. Restoration is covered in a later chapter. The preservation of hand-colored photographs and those made by lesser-known processes are not included in this discussion. Rapid changes are taking place in color technology with the primary objective of improving color quality and the stability of the dyes. The trend toward increased color image stability will probably lead to different considerations of stability than those that are presently held.

a

b

Figure 44 The basic structure of black-and-white and color print materials is illustrated in these diagrams: (a) a simulated cutaway showing the paper support, the baryta layer, and the emulsion; and (b) the paper support and the three color layers.

Structure of Color Materials

Color negatives, slides, transparencies, and prints are much more complex in structure than black-and-white materials. Basically there are at least three separate emulsion layers designed to record images during exposure: the blue, green, and red primary colors of an original scene or object. These emulsion layers contain silver halides in gelatin and are coated on the same stable film or paper supports as in black-and-white photography. A silver image is formed in each layer during processing but each image is different from the other two. These color materials are known as *integral tripack color* systems which means that the three component colors of an original—blue, green, and red—can be recorded simultaneously.

The chart below illustrates the physical structure of this type of color film product. Silver halides are naturally sensitive to blue light but not to green and red light. Special chemicals known as spectral sensitizer dyes are added to the second and third emulsion layers: one dye to emulsion No. 2 to make the silver halide sensitive to green light and another dye to emulsion No. 3 to make

	Exposure	
No. 1	Blue Sensitive Layer	
No. 4	Yellow Filter Layer	
No. 2	Green Sensitive Layer	
No. 3	Red Sensitive Layer	
	Transparent Film Base	
No. 5	Antihalation Backing Layer	

the silver halide sensitive to red light. For color films, a coating of yellow Cary Lea silver (layer No. 4) and/or a yellow filter dye is included to absorb any blue light and prevent it from reaching layers No. 2 and No. 3. An antihalation layer, No. 5, is added to absorb any light that passes through the entire structure and to prevent it from being reflected back to the emulsions which would degrade the image quality, primarily its sharpness. Color photographic materials may have a variety of layer orders in addition to the conventional one shown above.

The image stability of a color film or paper can be influenced at the time of design and manufacture by the selection of dyes and other ingredients in the emulsion layers and the steps and ingredients of the recommended process. However, the manufacturer must take great care in selecting dyes so that they meet a number of objectives, only one of which is image stability.

Among the other factors that must be considered are the health hazards of the chemicals, the cost of the materials, the reactivity of the dye formers, the color of the dyes, the compatibility among dyes, the compatibility of dyes with the selected process, and the cost of that process. Nevertheless, Eastman Kodak Company strives to meet these objectives in such a way that its color products have good stability.

Color Processing

When a developer reacts with the exposed silver halide, a silver image is produced in each layer. At the same time, oxidation products of the developing agent are present in proportion to the silver formed. These oxidation products react with special organic compounds known as dye couplers or dye formers to produce a color image in each of the emulsion layers. Dye is formed in proportion to the developer oxidation products and the image silver and, therefore, in proportion to the exposure. The silver is then removed leaving a dye image.

There are several color processing systems by which color photographic materials can be processed depending on the particular product used: the reversal process, the negative-positive process, and the image-transfer process. These processes and their disposition to long-term keeping are described in the following text. There are several factors in manufacturing that affect the final image stability such as the pH of the emulsion, the developing agents, the coupler or dye formers, and the various treatments following the formation of the image dyes. Even though the manufacturer has formulated the best possible processing chemistry for each color product, processing of color images is very complex and very close tolerances in temperature, agitation, time of treatment, and techniques are necessary. Processors of color photographs can provide pictures having the best image stability of which the materials are capable by carefully following the manufacturer's processing recommendations. In some instances, failure to follow the processing recommendations can impair the image stability.

The Reversal Process. KODACHROME Films and EKTACHROME Films and Papers are Kodak color products that are processed by the reversal process. They yield transparencies and prints. The rather complicated processing chemistry produces the complementary colors of the primary colors blue, green, and red. These complementary dyes—yellow, magenta, and cyan—are formed for two reasons: (1) the original exposure provides records of the blue, green, and red components of the colored original, and (2) the final transparency or slide is viewed in white light (such as a projector or illuminator) and, to look like the original subject, should permit just the right amount of blue, green, and red to reach the eye. The chart opposite reflects this: the yellow dye absorbs blue in those areas where the subject did not reflect blue, the magenta absorbs green where there was no green, and the cyan absorbs red where there was no red.

 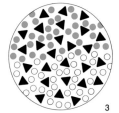

Figure 45a Color Reversal Film

(1) Each of the image-forming layers of a color film contains silver halide crystals and color-forming globules of couplers.

(2) Camera-exposed silver halide is reduced to metallic silver in the first developer, forming a black-and-white negative image. Unexposed silver halide is the source of silver for the positive image.

(3) The color developer (second) reduces the unexposed silver halides to silver and forms corresponding amounts of dye. The coupler globules that are not converted to dye remain colorless in the emulsion.

(4) All of the silver is bleached and fixed. The dyes remaining in the layers change white light used for viewing or projection to produce a full-color positive image of the original subject.

Yellow-Blue Absorbing
Magenta-Green Absorbing
Cyan-Red Absorbing
Film Support
Clear

However, the processes are quite different for KODACHROME and EKTACHROME Films. Exposed KODACHROME Film is processed in three separate dye-forming color developer solutions. Each of these processing solutions contains the developing agent and the dye coupler required to produce each dye. On the other hand, exposed EKTACHROME Film is processed in a single color developer solution because the couplers are incorporated in the emulsion layers during manufacture. Processing is relatively simple compared to that of KODACHROME Film.

The Negative-Positive Process. Kodak color products that are processed by the negative-positive process are: KODACOLOR VR Films, VERICOLOR II

Figure 45b Color Negative Film

(1) As in color reversal film, the image-forming layers of a color negative film contain silver halide crystals and color-forming globules of couplers. The red- and green-sensitive layers also contain lightly colored coupler globules that form positive color-correcting masks during processing.

(2) When the layers are color developed (first and only developer), dyes are formed in direct proportion to the amount of silver developed.

(3) The silver is bleached, then all of it is fixed out. The negative dye images remain as well as some residual couplers. That gives the color negative an overall orange-brown color.

and III Professional Films, and EKTACOLOR Papers. All of these products have couplers incorporated in the emulsion layers during manufacture. They yield color negatives which are then used to expose either paper or film to provide color prints or slides, respectively. The printing materials are also coated with a color negative emulsion. The complementary dyes—yellow, magenta, and cyan—are formed in both the negative and positive and when the exposure is correct, the final color positive will look like the original. Except for the more complex chemistry involved in color processing, the negative-positive process is similar to the black-and-white camera film negative used to make a black-and-white print on photographic paper.

Color Transfer Diffusion Systems. These processes are based on image transfer processing. This means simply that the positive or final color print is formed in a receiver sheet. The color-forming substances or dyes migrate or diffuse from the image-forming sheet to the receiver sheet. There are three Kodak photographic products that use this color transfer diffusion system: dye transfer, instant, and EKTAFLEX PCT Products.

In the dye transfer process an exposed unhardened silver halide layer is developed in a tanning developer which hardens the emulsion layer where image development occurs. The unexposed, unhardened emulsion is washed off leaving a relief image which is formed in proportion to the exposure and the development. The processed sheet is bathed in a dye solution which is imbibed by the relief image. Three such sheets are required, one for each dye. The imbibed dyes are then transferred by diffusion, one at a time, in register, to a single receiver sheet to give a full color print of high quality and excellent stability.

KODAK Instant Color Film / PR 144-10 and KODAK TRIMPRINT™ Instant Color Film are products used in instant photography. They use color diffusion transfer but the processing takes place in a self-contained package when a pod of chemicals is ruptured as the film is exited or discharged from the camera. In the case of the PR 144-10, all processing chemicals are retained in the finished print. Image stability is very good if the prints are kept clean, dry, cool, and preferably in the dark when not being viewed. On the other hand, the TRIMPRINT film yields a color print that has been separated from the image-forming sheet by peeling the two layers apart. The resulting TRIMPRINT picture is more stable than the print from PR-10 film because most of the residual processing chemicals have been removed. As with all instant prints, careful storage is advisable when it is not being viewed.

When using KODAK EKTAFLEX PCT Products to produce color prints direct copying of color negatives or transparencies results. The image-forming dyes are transferred automatically from the exposed and processed sheet to a receiver sheet in a processing device specially designed for the system. These prints also have good image stability when they are kept clean, dry, and cool.

Chemical Deterioration of Color Images

The fading of dyes in color images usually results in changes in density or color or both. It results from complex chemical reactions that accelerate under high temperature, high relative humidity, atmospheric pollution, or a combination of these factors. These reactions can occur in the dark or in the light. Under actual use conditions color materials undergo constantly varying combinations of temperature, relative humidity, and illumination and these vary widely from user to user. Different films and papers fade at different rates and even individual layers in a color film or paper fade at different rates. Some early color papers show high yellow stain even after proper processing. Examples of changes that can occur in color images include the following:

Stain	refers to changes in minimum density which occur in the dark
Print-Out	in color theory refers to increases in minimum density which occur in the light
Density Change	the amount of change in an image as measured with a densitometer, spectrophotometer, or similar device
Dye Change	the amount of dye formed or destroyed as measured by chemical analysis or some other quantitative analytical technique
Color Shift	a change in color brought about by 1) a differential fade rate (for example, in a red, the magenta dye fades faster than the yellow dye making the red shift orange, 2) generation of an unwanted colored species in an image area (for example, putting yellow in cyan sky making it turn green).

Estimating the Image Stability of Color Photographic Products

To understand the interrelationships of all possible reactions that contribute to changes in color images is a complex matter. Therefore, in the following text an explanation is given of how Eastman Kodak Company investigates the stability of its color products and how these studies can provide the consumer with some idea of the useful life of a color image. This information is applicable to the wide range of Kodak color products. Even though modern technology provides some color images that are more stable than their predecessors it is not possible to wait a number of years to see how good the stability of a product may be. It is necessary to utilize accelerated test procedures to try to predict an anticipated image life when the image is kept under optimum conditions. These tests are run under extreme conditions of controlled temperature and humidity in the dark and light and they provide a prediction of color image stability. By using standardized experimental keeping conditions in these tests the amount of dye that will be lost and how fast it will be lost can be forecast. Dark-keeping tests are made at varying temperatures with a fixed relative humidity. Light-keeping tests are made under illumination from specific light sources at specific intensities with a fixed temperature and relative humidity.

Estimation of Dark-Keeping Stability. A rather complex data manipulation is involved once the practical tests have been completed. This involves the use of the Arrhenius equation which has been used by others to predict the aging characteristics of materials. It has been used here to predict the dark-storage dye stability of color and black-and-white photographic products[19]. Where the predicted fading rates can be compared to the actual fading rates under long-time conditions, the equation has worked. This method is a considerable improvement over previous methods for predicting the stability of color photographs to long-term storage at various temperatures. See ANSI Standard PH1.42 (1969) Method for Comparing the Color Stabilities of Photographs.

Nevertheless it must be kept in mind that this method of prediction does not consider the effects of other factors on the rate of fading. Humidity, for example, has a substantial effect on dark-keeping dye stability particularly in the yellow dye layer. Some humidity effects are shown in Table VII-1.

Table VII-1.

Effect of Humidity on Dye Stability in Dark-Keeping Conditions

Relative Humidity	Relative Fading Rate	Relative Storage Time
60%	2	1/2
40%	1	1
15%	1/2	2

A relative humidity of 40 percent was considered the reference point in this test (a fading rate of unity was assigned) and relative fading rates were determined at other relative humidities. At 60 percent RH fading occurs twice as fast and, therefore, the dye stability is only 1/2 the normal. On the other hand, at 15 percent RH the fading occurs more slowly and the dye stability is twice the normal time. Storage at 15 percent RH makes the emulsion too dry and brittle. Therefore an RH of 25-30 percent is recommended for best storage.

The Arrhenius equation method is used to predict expected changes for dark storage at various temperatures. Predicted keeping times for low temperatures can be determined in the same manner as the prediction from high temperatures to room temperature. Table VII-2 summarizes the predicted fading rates and storage times relative to the normal room condition of 24°C (75°F) at 40 percent relative humidity.

Table VII-2.

Effect of Storage Temperature on Dye Stability in Dark-Keeping Conditions

Storage Temperature	Relative Fading Rate	Relative Storage Time
30°C (86°F)	2	1/2
24°C (75°F)	1	1
19°C (66°F)	1/2	2
12°C (54°F)	1/5	5
7°C (45°F)	1/10	10
−10°C (14°F)	1/100	100
−26°C (−15°F)	1/1000	1000

A room temperature of 24°C (75°F) and a relative humidity of 40 percent were selected as the reference point. The table shows the relationship of temperature to dye loss at 40 percent RH. At −26°C (−15°F) the relative fading rate is 1/1000 as fast. This means that a film stored at −26°C (−15°F) will not fade in 1000 years any more than it did at an average room temperature of 24°C (75°F) in one year.

Estimation of Light-Keeping Stability.

The prediction of light-keeping stability is also based on the results of accelerated tests. The samples of color products are illuminated with a selected high intensity light source while being kept under controlled conditions of temperature and humidity. The choice of illuminant and total illumination time are related to the typical use of the product. The data are plotted on a graph showing density versus time in days. In each case the type of illuminant, the intensity level, and the time interval are given with this data format. A typical result for the fading of the cyan, magenta, and yellow dyes in a test sample is shown in Figure 47.

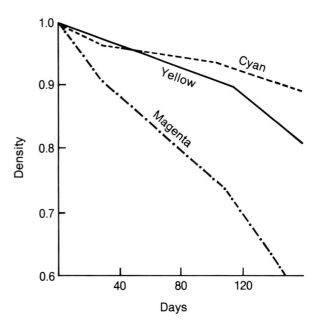

Figure 47 The above diagram illustrates the accelerated light-keeping stability of dyes showing density related to time.

This test method can be used to estimate expected changes *only* for conditions of use similar to the test conditions or to compare products in a general way. Under practical use and display situations the kind and intensity of illumination are important. (See Chapter IX Storage and Display of Photographic Artifacts.) Average intensities in typical locations are stated to be 270 to 1075 lux (25 to 100 footcandles) in the office, 54 lux (5 footcandles) in the home, and 54,000 lux (5000 footcandles) in sunlight. The concentration of ultraviolet radiation is significant in sources such as fluorescent lamps and daylight which comes through window glass.

The Effect of Post-Processing Treatments on Color Image Stability

The effect of post-processing treatments on the stability of the dyes in color images should be understood by individuals responsible for photographic collections. A great deal of research has been conducted on this subject but testing is very complex and time consuming. Consequently, the following discussion relates specifically to KODAK EKTACOLOR Paper and the effects of post-processing treatments such as lacquering, laminating, texturing, retouching, mounting, and framing on this product. The effects discussed here are not necessarily the same for color images on other products although testing of post-processing treatments on these products continues. For additional information on the effect of post-processing treatments on the stability of color prints contact the Customer Technical Services Department at Eastman Kodak Company, Rochester, New York.

The highest level of dye stability of a color print on KODAK EKTACOLOR Paper is attained when the print is first dried following recommended processing. Post-processing treatments generally will not improve the dye stability of prints on this product; in fact, certain treatments and the manner in which they are used can reduce the stability of color images or even accelerate dye fading.

Lacquering. A large percentage of professional color portrait prints are lacquered. The technique is commonly used to enhance the print's visual appearance, to protect the print from physical degradation such as soiling, scratching or abrading, or to provide a surface with tooth when retouching is required. Vintage prints should never be lacquered. A lacquer mixture consists mainly of solvents in which an organic polymer is dissolved. Cellulose derivatives and acrylates are commonly used and have proven to be satisfactory. Phthalate esters are often used as plasticizers and are harmless to the print. The most critical component in a lacquer is the solvent of which there are three classes to consider: (A) those that penetrate moist gelatin; (B) those that are capable of producing peroxides; and (C) those that do not penetrate moist gelatin.

The solvents that comprise Class A include alcohols, esters, ketones, and carbitols. Some typical ones include butyl alcohol, ethyl acetate, and methyl isobutyl ketone. All of these substances may produce defects identified as blue print, cyan spots, or red print. Blue print is a predominance of blue color in the major area of the print and is the result of markedly reduced yellow dye stability. It is caused by lacquer solvents that can penetrate dry or moist gelatin (Class A above). The effect is more pronounced when the print is sprayed with lacquer in a very humid environment or when the print is not thoroughly dry before spraying. Cyan spots are bluish-green spots and are caused by the same Class A lacquer solvents. The penetration of the solvent is limited to the emulsion layer that contains an ultraviolet absorber and does not reach the yellow layer as in the blue print effect. Local areas of the UV absorber have crystallized and these areas reflect light striking the print to produce cyan spots. Red print is manifested by brownish-red stains over the image. It involves the same solvents but in this case the solvent penetrates the top-most emulsion layer only, the cyan layer. A dark-fading reaction occurs between the cyan dye and the unused dye former or coupler.

Class B include esters and ketones which are capable of producing peroxides upon oxidation such as ethers and methyl isobutyl ketone and carbitols. These peroxides cause the formation of yellow dyes in the magenta layer. This effect is known as yellow print and usually occurs when the print is kept in a confined space as is often the case with albums or glass-covered frames. It is noticeable as a yellow effect on the image. In such instances neither the solvent nor the peroxide can evaporate. Class C solvents include the hydrocarbons such as toluene or hexane and the chlorinated hydrocarbons such as methyl chloroform. Methyl chloroform is 1,1,1-trichlorethane and is commonly used as a film cleaner. These solvents do not produce the problems that can result with the first two groups.

> **NOTE:** Shellac and polyurethane varnish are not lacquers but are sometimes used for print coating. Both tend to yellow with age. Shellac is a natural resin that should not affect dye stability but it does absorb moisture and become sticky. Polyurethane varnish has no known adverse effect on dye stability.

LACQUERING TECHNIQUE. It is important to preserve the original dye stability of a color print when applying lacquer. For this reason, the following guidelines should be carefully observed:

1. Prints should be thoroughly dry prior to lacquering and the lacquer should be applied immediately after processing. Otherwise the print should be re-

dried using a heated dry mounting press or a hair dryer.

*2. Only lacquers with solvents that do not penetrate dry or moist gelatin such as toluene, hexane, and methyl chloroform (Class C above) should be used.

3. Multiple light coats of lacquer rather than a single thick coating should be applied.

4. Lacquering should be done in a dust-free, well-ventilated environment where the relative humidity is 50 percent or lower.

5. Lacquered prints should not be allowed to come into contact with the glass in a frame or to be tightly sealed in any enclosure if peroxide-forming solvents are involved. (Photographic prints should not be allowed to come into contact with the glass because of the possibility of sticking.)

REMOVAL OF LACQUER. Lacquer can be removed with solvents.

Solvents that can penetrate the gelatin emulsion layer such as those mentioned in Classes A and B above should also be avoided. The preferred solvents recommended for the removal of lacquer are hexane, toluene, and methyl chloroform. Denatured alcohol, acetone, or methyl ethyl ketone can also be used.

Laminating.
When this treatment is used, a much thicker polymer layer (than is used in lacquering) of a transparent sheet material such as polyester or cellulose ester is applied to the surface of a photograph. Usually an appropriately safe adhesive provides the bond between the laminating material and the photograph. Laminates provide excellent protection against fungus and bacterial attack, moisture, dirt, and objectionable gases in the air. Because of ultraviolet absorbers that may be incorporated in the laminate, they can also provide excellent protection against ultraviolet radiation. The laminate adhesive is important; it should not contain any ingredients harmful to the print or the laminate. Gelatin is a very safe adhesive.

Texturing.
The embossed pattern or lack of pattern on the surface of a photographic paper is described as its texture. The smoothness or roughness of the surface is created at the time of manufacture and varies from no texture or pattern to one that is coarsely textured or patterned. Similarly, the surface of processed photographic prints can be varied by producing an embossed pattern in the lacquer layer or the laminate or by pro-

viding a surface texture by canvas mounting. Texturing other than that produced in the manufacture of the paper can cause print degradation if the pressure rollers or plates used to provide the texture cut too deeply into the emulsion layers so that they are actually cracked. The recommendations given for applying lacquer are equally appropriate for using texturing lacquers. Before applying a texture lacquer by spray or brush, spray the surface of the print with one or two light coats of the selected lacquer.

Retouching.
If retouching is required on a colored print, the retouching dyes used should have the following important characteristics: their light absorption characteristics should match those of the dyes in the print; they should have the same light and dark-keeping stability characteristics as those in the print; they should respond in the same way that dyes in the print do to other post-processing treatments.

These requirements are difficult to meet and have been achieved only with Kodak dye transfer materials. Most retouching dyes do not have dark and light-keeping stability properties identical to those of the dyes formed in the print emulsion. Because of this, the retouched areas of a color print will gradually become visible as a print ages. When used according to instructions, Kodak retouching dyes will not adversely affect image stability. These retouching dyes are water-soluble organic dyes that are related chemically to the dyes used to make dye transfer prints. Their dark and light-keeping stability properties are also similar to those for dye-transfer prints. They are very stable in the dark and have light stabilities, comparable to the image dyes. Kodak retouching dyes are available in both wet and dry form: KODAK Retouching Colors (dry) and KODAK Liquid Retouching Color Set (wet).

Of course retouching of color paper products other than EKTACOLOR Paper is possible. There are no serious problems retouching dye-transfer prints because the retouching dyes are the same as those used to make the print. The retouching dyes mentioned above for use with prints on EKTACOLOR Paper can also be used with color negatives. EKTACHROME Film transparencies (Process E-6) and prints on EKTACHROME Paper can be retouched with KODAK E-6 Transparency Retouching Dyes but it is advisable to work on a duplicate rather than on a camera-original transparency. KODAK Liquid Retouching Colors should not be used on EKTACHROME Film transparencies.

Mounting.
Prints are mounted on almost every type of solid support known. Some commonly used supports include plastics, metals, wood, glass, paper, textiles, ceramics, and composite materials. Of these materials, clean glass is inert with respect to conservation pur-

*Since some chemicals of this type are potentially hazardous, they should be used only in well-ventilated areas and in strict compliance with manufacturer's recommended safety procedures.

poses. Unbuffered, so-called archival board made from high quality paper is used by conservators for this purpose. Metals, textiles, woods, and plastics may or may not affect image stability. If plastics such as polyethylene, polystyrene, cellulose esters (KODACEL) and polyesters (MYLAR® and ESTAR) are used, care should be taken to be sure that they are inert. That is, they should have no overcoat or addends that could affect the image. Other materials require testing. Attachment of the print to a support involves the use of an adhesive. These adhesives are available in sheet form such as dry-mounting tissue and cold-mount laminates or in liquid form that can be applied by brushing or spraying. However, since images can be attacked through the base side of the print the solvents and techniques used to adhere prints to supports need evaluation before general recommendations can be made. For conservation applications, KODAK Dry Mounting Tissue, Type 2 has proven to be satisfactory and produces no adverse effects on the dye stability of prints made on EKTACOLOR Paper.

Display and Storage of Color Photographic Images

The stability of processed color images can be greatly affected by the manner in which they are used and stored. It is a fact that a user can select use and storage conditions for photographic materials that will assure long-term keeping equal to or better than that of any other artifact. Information in the following section discusses how light, temperature, and humidity affect the storage and use of color images and how the user can control these factors. In addition, much of the information in the chapters entitled "Storage and Display of Photographic Artifacts" in this publication is applicable to the conservation of color images.

After color prints have been processed, they may be exhibited in a frame in a lighted room or stored in an album in the dark. There are certain dangers inherent in this. If an unlacquered print is allowed to come into contact with the glass in a picture frame, sticking is apt to occur. A simple overlay mat is adequate to prevent sticking. A glass-covered framed print should never be lacquered because trapped vapors cannot escape and may cause the print to change color. In addition, the glass of the picture frame should also be cleaned carefully with an appropriate detergent, rinsed thoroughly, and dried completely before inserting a print into the frame. Albums are quite satisfactory for print storage from a dye stability standpoint except in cases where lacquered prints are stored in albums that are tightly sealed. This is not recommended because these prints may change color due to peroxide-forming solvents present in the lacquer. When lacquered prints are

stored in albums, the albums should be opened several times a year to allow vapors to escape. The adhesives used to glue the prints onto the album page may cause dye fading. The objectionable ingredients in these adhesives are the same as those that are in lacquer solvents. See also the section on print enclosures in the chapter, "Storage and Display of Photographic Artifacts" for information on the composition of these materials.

Exposure to Light. Color images are displayed, examined and used in a great variety of ways, and so are exposed to many different light sources and light intensities. Often they are displayed in homes at illumination levels lower than 54 lux (5 footcandles). In offices and similar locations, color prints are normally displayed at illumination levels between 270 and 1075 lux (25 and 100 footcandles). Occasionally, prints are subjected to illumination levels of 54,000 lux (5000 footcandles) in direct sunlight. Movie and slide films, when projected, are exposed to very high levels of illumination but for very short intervals; exposure may be frequent or seldom. Sheet-film transparencies may be used as originals for reproduction and receive very little exposure to light, or they may be displayed using a wide variety of illuminants at varying intensities. In each case, higher illumination levels, more frequent or prolonged exposure, or the presence of ultraviolet radiation will accelerate fading of color materials. Those

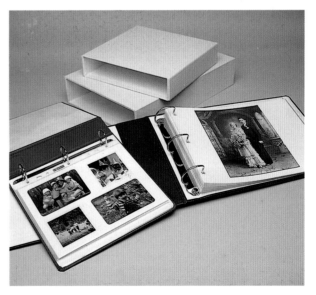

Figure 48 Archival print albums are available for keeping both black-and-white and color prints. Those shown above, from *Light Impressions. Rochester, NY* are covered in buckram, lined in TYVEK, and have polypropylene protective cover sheets. They are constructed with specially made acid-free pages and come with or without Wheat slipcases. Two sizes are shown: the smaller is most often used for family purposes, the larger one by museums. Jerry Antos.

who are interested in preserving color images for a long time should avoid these conditions.

The best general rule for preserving color images is to keep them in the dark, keep them dry, and especially keep them cold. However, this is not always practical so some general guidelines for viewing or displaying color images have been devised. Intensity levels of illumination for transparencies and prints should be no higher than necessary for the intended viewing conditions. All evidence points to glare-free incandescent lighting between 54 and 160 lux (five and fifteen footcandles) as being the safest for museum or home display of color photographic images. Tungsten illumination is preferred. Prints should not be displayed for long periods of time in direct sunlight or under sources rich in ultraviolet radiation such as fluorescent lights. If there is no alternative to fluorescent lighting, ultraviolet filter sleeves or absorbing diffusers are available that will reduce the amount of ultraviolet radiation to satisfactory levels. Color prints can also be protected from ultraviolet radiation by covering them with a sheet of Rohm and Haas PLEXIGLAS UF-3. This material has a slight yellow tint but it is not sufficient to significantly alter the appearance of the color image. The yellowish tint can be eliminated by using PLEXIGLAS UF-4 but it does not offer quite as much protection as the former. Color negatives should not be subjected to light other than the normal exposure received during printing and enlarging operations. Needless exposure to ambient lighting and abnormal illuminating conditions should also be avoided; for example, color slides or color negatives should not be exposed for long periods of time on an illuminator. High temperatures will increase the rate of light fading. Good air circulation and heat-absorbing filters in projectors will minimize light fading from high temperatures. Where necessary, display illuminators should be air cooled to keep transparencies at the same temperature as the ambient room temperature.

A special display situation involves the projection of color slides. Projection times should not exceed one minute per slide. Original and duplicate slides made on Kodak color films can be projected many times before changes in the dye are noticeable. The dye images most stable to light are those in slides made on KODAK EKTACOLOR Slide Film 5028, KODAK EKTACHROME Slide Duplicating Film 5071 (Process E-6), KODAK EKTACHROME Films and EASTMAN Color Print Film. Slides made on KODACHROME Films are somewhat less stable, but may be expected to withstand 250 to 500 15-second projections in non-arc projectors before significant dye fading results.

If *valuable* color pictures are to be displayed or projected frequently, the best preservation technique that can be used is to make duplicate prints or transparencies and display the duplicates. The originals, then, can be kept under the best storage conditions while being exposed only to the minimum amount of radiation necessary to make the duplicates. For information on this technique see the chapter entitled, "Preservation Through Photographic Reproduction" in this publication.

Cold Storage of Color Images. Refrigeration, in the long run, is a far less expensive and more reliable technique for long-term keeping than any other published method even if occasional temporary rewarming for various periods of time occurs as a part of normal use. Virtually no dye changes occur with this kind of usage. However, even if the unit is frost-free or a room has been specially equipped for color film storage *moisture-proof packaging is recommended*. Storage envelopes made of laminated polyethylene, aluminum, and paper such as KODAK Storage Envelopes for Processed Film can provide suitable protection against humidity. These Kodak envelopes can be used for either black-and-white or color materials but dissimilar materials should not be stored together in the same envelope. These envelopes can be heat-sealed at low relative humidity to exclude moisture. An alternative is to use three wraps of household aluminum foil with the seams and folds taped with a moisture-proof tape, such as plastic electrical tape. The effectiveness of both of these methods depends, of course, on the integrity of the seals. Before sealing the packages, the separated films, interleaving material, all enclosures, and the storage envelopes must be preconditioned until fully equilibrated in a small room or chamber at a temperature of about 21°C (70°F) with a relative humidity between 25 and 30 percent.[20] It is important to note that one or more refrigeration-type dehumidifiers may be needed to achieve the necessary low humidity. The insertion of the films in the envelopes and the sealing operation should be performed in the same air-conditioned chamber. The packages can then be placed under refrigeration.

Care must also be taken in removing packages from cold storage. To prevent moisture condensation on material taken from a refrigerator or freezer, the package must be allowed to reach equilibrium with the room temperature before being opened. The *warm-up time* required depends on the temperature differential between the photographs and the ambient air, the dew point of the air, the quantity of photographs, and the size and insulation of the packaging.

Since warm-up time recommendations cannot be given for all the different conditions that might be encountered, practical experience is required by the user for the particular conditions. Moisture condensation is not only harmful in itself, but also might lead to subse-

quent return of the photographs to storage in a high-moisture condition. Photographs should be resealed in equilibrium with low RH before being replaced in cold storage. Taped metal cans are satisfactory for high relative humidity storage but all packages in high-humidity storage must be examined periodically for deteriorated tapes or seals.

Alternatives to taped containers or packages are the use of a controlled-humidity, low-temperature room or the use of a frost-free, low-humidity refrigerator or freezer. These methods are preferred. Between 20,000 and 100,000 original negatives, slides, or transparencies—depending on their size—can be stored in a 20-cubic-foot, frost-free, household refrigerator/freezer. This allows for storage in KODAK Storage Envelopes. The first commerically available low-temperature vault for storage at −18°C (0°F) and 30 percent RH was introduced by Advanced Media Archives. This equipment is still available from this firm. The use of frost-free, low-humidity refrigerators or freezers is described in the chapter on storage.

Black-and-White Separation Masters

An alternative solution to the problem of preserving color images for extended periods is to make black-and-white separation masters—either positive or negative—depending on the form of the original. Since these separations are records in silver of each of the dye layers of a color original, they can be expected to last as long as a properly processed black-and-white negative stored in the best possible manner. If a color reproduction is required from the separations at some later date, it can be made by a dye imbibition method or by tricolor exposures onto a color photographic material.

Before undertaking the production of many separation sets, several factors should be considered: (1) The process entails skilled photographic work because the density and contrast of each master must be matched carefully by exposure and development to produce a good color reproduction and (2) the process is expensive. The only way to be quite sure of good color reproduction is to make a sample reproduction in color; the cost of this is high. At a minimum, good sensitometric records should be kept if a satisfactory reproduction is to be available at some much later date. If the colors in the original are thought to be unnecessary, consideration should be given to making a simple black-and-white negative from the original color picture. This is a far less costly procedure than making separation masters and the work is well within the competence of most photographic workers.

Recent Advances in Color Technology

Most of the material in this book deals with preserving photographs already in existence. However, many modern color materials, notably KODAK EKTACHROME Films (Process E-6) now have better keeping characteristics than earlier films of the same type. In fact, transparencies made on these films should retain excellent color fidelity for generations under easily attainable *dark* storage conditions. These conditions are 70°F (21°C) or lower coupled with about 40 percent relative humidity. The implication here is that with successive duplication at long intervals, color images can be made to last indefinitely. See the Chapter entitled "Preservation Through Photographic Reproduction" in this publication.

Custodians, conservators, archivists, and others concerned with the conservation and preservation of color images should keep informed of new advances in color technology and the image stability of Kodak color products.

Chapter VIII Deterioration

Even with the best processing and preservation practices, photographic images may deteriorate. It is not unusual for photographic collections to contain artifacts that have deteriorated or are in the process of deteriorating. For these reasons, it is important for photographic conservators to understand the changes that can take place in a photographic image, to be able to identify the changes, and to recognize the causes. More important, they should be aware of the procedures that can be taken to prevent deterioration. This chapter describes the physical and chemical deterioration of black-and-white photographic artifacts and explains how it can be prevented. Restoration of some of these deteriorated artifacts is discussed in the last chapter of the book. The chemical deterioration or changes that occur in color images is discussed in Chapter VII: Color Photographic Images. The same information on physical deterioration of black-and-white images that is given in this chapter can be applied to color images.

Description of Deteriorated Artifacts

Deterioration is any physical or chemical change in the condition, appearance, or appeal of the original. These changes are the result of poor processing, adverse environmental or storage conditions, or mishandling of the artifact. Usually the conditions that precipitated the changes occurred prior to the receipt of the collection by the conservator.

Physical Changes. These changes usually occur because of adverse environmental or storage conditions and/or careless handling of the artifact. They include a variety of defects. Blisters and frilling of emulsions are a result of poor storage conditions and can result in emulsion lifting and flaking. These defects can occur with emulsions that are coated on film, metal, paper or glass supports. Dry storage can cause curling of both films and prints. An emulsion that has become wet from being in damp storage and is then subjected to rapid temperature changes can produce stresses in the gelatin and cause an irregularity of the surface gelatin. Spots, holes, and scratches usually result from the abrasion of one material against another.

Artifacts will often have cracks in the emulsion and/or support because they have become brittle due to dry

storage conditions. A "crazed" emulsion has many very small cracks. Often a collection will contain brittle unmounted and mounted prints or broken glass plates. Some artifacts may have shiny areas on them which are due to the emulsion sticking to a smooth, warm surface. This condition may result in the deformation of the image or in the actual fusing together of materials.

STABILIZATION. Physical defects such as those mentioned above require special attention and temporary storage until further conservation measures can be employed. These preliminary preservation techniques are known as "stabilization procedures." They are a means of protecting the artifact temporarily from further damage until more complete procedures can be

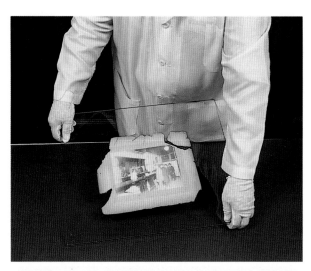

Figure 49 A damaged, aged mount with intact faded print is carefully placed on a rigid auxiliary support before any preservation steps are taken. Jerry Antos.

accomplished. Many of the procedures described in the following text are the result of pioneering work in this field by the Canadian Conservation Institute and their conservator, Siegfried Rempel. The procedure involves using an auxiliary support to provide a more rigid surface. Separate pieces of the broken artifact are put on the auxiliary support and then carefully wrapped and stored. Intact artifacts on auxiliary supports are often sandwiched between appropriate sizes of buffered 4-ply mattboard, then wrapped or stored in a safe position depending on the nature of the deterioration. The en-

closures are carefully removed after transcribing the data on them to another record. When this procedure is used, the artifact often becomes isolated: the image is no longer in easy view or touch of the conservator. For this reason it is advisable to duplicate negatives and copy prints before stabilizing them so that they can be kept easily accessible and in mind. This procedure is more fully described in the chapter entitled "Preservation Through Photographic Reproduction." A few of the more commonly encountered damaged artifacts and the manner in which they can be stabilized are described below.

Broken Glass Plate Negatives. A limp enclosure indicates potential breakage. A rigid enclosure indicates that the material is whole or unbroken. Clean each piece of broken glass and transfer it from the first auxiliary support to a second auxiliary support. Be careful not to tear or abrade any loose pieces of emulsion hanging over the edge of the break. Do not attempt to assemble the pieces and do not allow contact between the separate pieces. Each piece should then be wrapped in acid-free paper and transferred to a document envelope of the appropriate size that has been labelled. It is important to label the envelope before anything is put in it to avoid marking the emulsion and so the contents are known and recorded.

Cracked Glass Plate Negatives. This damaged plate usually differs from the broken plate in that the glass support may be cracked while the emulsion layer is intact. In this case a piece of 4-ply matt board should be cut to the same size as the glass plate and placed on top of the emulsion layer to provide additional rigidity. Then, the auxiliary support, the cracked plate, and the matt board should be taped together, labelled, and stored for future conservation.

Lifting Emulsion Layers. This condition is treated in much the same manner as the cracked glass plate negative except that the emulsion may have to be laid down immediately on the matt board. It may be necessary to advance the matt board slowly, laying down the emulsion immediately in front of the board. The two should then be taped together, and put into a paper enclosure, labelled, and stored.

Flaking Emulsion Layers and Brittle Prints. After carefully removing the artifact from any enclosure, cut two stabilizing supports of 4-ply matt board slightly larger in size than the artifact. Hinge one side with the artifact between the two supports, carefully check the position of any dislodged pieces, and then tape the opposite side and label.

Figure 50 The above photo shows a deteriorated glass plate negative in which the emulsion layers have lifted. There is also staining and discoloration in the right-hand area.

Cellulose Diacetate Negatives. Keep as dry and cool as possible. Do not store in sealed protective envelopes. Package loosely with good quality interleaf paper. Loose packaging allows any acetic acid to evaporate and interleaving paper absorbs the acetic acid.

Mounted Prints. Do not attempt to remove a print from its mount even when a lifted corner indicates the possibility of doing so. The mount may be brittle and if broken could remove a piece of the print. If the mounted print is flat, insert it between two pieces of matt board, label it, and store the material flat.

Figure 51 The concertina fold illustrated above provides safe, pressure-free storage for strongly bowed or curved mounted prints.

If the mounted print is strongly bowed or curved, place it between two pieces of matt board with a concertina fold. This will allow the artifact to be stored without being pressed flat. Do not allow these items to pile up one on the other because if pressed, the artifact may break.

Strongly Curled Prints. These are often large size prints that have been rolled for storage and no effort should be made to flatten them. The preferred stabilization procedure is to wrap the print around a mailing tube that is one inch longer at each end than the print and has a diameter close to that of the curled print. After one wrap around the tube, interleave the print with acid-free tissue. Then wrap the assembly in tissue, label, and store. Slightly curled prints usually can be unrolled without cracking or breaking and gradually flattened by covering with a blotter that is held in place by weights.

Albums. Albums that are dirty or whose contents show signs of deterioration should be cleaned on the outside and then wrapped in acid-free tissue. Photographs should not be removed from them but each page should be interleaved with acid-free tissue that has been cut to size.

After these preliminary preservation techniques have been completed, the stabilized artifact should then be placed in a soft, clean storage container until such time as further treatment is possible.

Chemical Changes.
These deviations in the original artifact are usually the result of poor initial processing or adverse environmental and storage conditions. They can appear in the image or the non-image area of the photograph. Until now there has not been any definitive terminology for describing these changes in appearance. Terms such as yellowing, stain, fading, and tarnish have been used to describe changes in the

image itself and the same terms have been used to describe changes in the background area. The language has been ambiguous and confusing and this has made it difficult to explain or interpret observations under study. In an attempt to clarify the terminology and to arrive at some universal definitions, the following classifications have been developed to describe various forms of chemical degradation of processed photographic material. These classifications were derived by experts in the field of photographic conservation* and were proposed for standardization and international use to the classification committee of the International Federation of Documentation. They were approved by that body and are the basis for the following descriptive terminology.

*D. F. McLaen and W. E. Lee, Photo Technology Division, Eastman Kodak Company, Rochester, NY, and Diane Hopkins and Klaus B. Hendriks, Picture Conservation Section, Public Archives of Canada, Ottawa, Canada.

FORMS OF CHEMICAL DEGRADATION

Image Discoloration: any change in the tone or color of the image that may involve a change to a cold, blue-black tone, a warm brown tone or any other tone change.

Stain: any change in the appearance of the background area. A stain can be any deposit on a negative or print that will absorb light and is therefore capable of producing an image during the printing of a negative or the copying of prints. The background area may also contain very low levels of silver as a result of processing chemicals left on the materials.

Image Fading: disappearance of the visible image without a change in the non-image area.

The following table indicates the causes and origins of image discoloration and fading and the causes and origins of background stains.

Megalithoscope
Circa 1870s, invented by Carlo Ponti

A viewer for photographs that have been hand painted. When viewed by different lighting, the picture appears first as in daylight and then as at night.

Table VIII-1

Visible Signs of Discoloration, Fading, and Stains
in Black-and-White Photographic Materials:
An Explanation and Possible Causes

IMAGE DISCOLORATION

Visible Signs	Explanation	Cause
Image browning	Thin silver filaments recrystallized to form larger, thicker filaments	Occurs during storage under very moist conditions
Image yellowing and formation of microspots (often yellow and red) or redox blemishes by incident light (often silver mirrors)	Image oxidation, overall conversion of the image to yellow color. Formation of spots resulting from localized discoloration of the image	Exposure to oxidizing gases
Image yellowish-brown	Chemical reaction of residual hypo with image silver	Poor processing
Image often appears slightly brown and the surface of the silver image is very shiny often resembling a mirror	Acidic gases such as hydrogen sulfide reacting with silver image—image oxidation	Improper storage
Purplish image tone	Ferrotyping on a heated drum	Excessive heat while drying

NON-IMAGE STAINS

Visible Signs	Explanation	Cause
Amber to brownish color	Gelatin of the emulsion, negative backing coat and paper support colored. Aerial oxidation of developing agents	Incomplete removal of developing agents and their oxidation products from the emulsion
Yellowish-brown color in negatives	Stain evenly formed by pyro oxidation by-products	Pyro developer
	Decomposition of silver complexes to silver sulfide	Poor processing
Any color change foreign to the normally expected appearance seen following post-treatment	Chemical stain	Post-processing treatments such as lacquering, retouching, etc.
A non-image stain yellow by transmitted light and grayish by reflected light	Chemical fog. Reduction of free silver ions in solution	Dichroic silver produced by contamination of the developer with fixer and/or fixer with the developer
Appearance of a metallic sheen of various colors. Usually bluish to brownish and often called tarnish. May also be a yellowish-brown color.	Silver stain resulting from oxidation of the silver in the non-image area	Incomplete removal of silver complex

IMAGE FADING

Visible Signs	Explanation	Cause
Image disappearance without tone change. Old photographs often show an almost complete loss of visible image without a change in the non-image area	Generally the result of an oxidation process that occurred in an acidic atmosphere	Acid gaseous contamination
Image disappearance with tone changes to yellow image discoloration	Eventual conversion of silver sulfide to soluble silver sulfate	Excessive residual hypo together with excessively high RH and temperature over a long period of time

SPECIFIC STAINS. Some specific stains represented by the categories in the preceding table are discussed in the following section. These are stains that might be encountered on both nineteenth and twentieth century artifacts.

Stains on black-and-white artifacts are generally the result of faulty processing techniques and not the manufacturing process (see the section on chemical deterioration of color images in Chapter VII for information on stains on color materials). Photographic processing can be quite well done today if the information published by manufacturers is carefully followed. Prior to the availability of this data, photographers mixed their own chemicals, made their own variations of procedures, and experimented with processes. Consequently, some stains appeared on negatives or prints following complete drying and others during storage under adverse conditions. Generally, negatives and prints from the early part of this century show more stains than do contemporary ones. Most of these stains are the result of: (1) overuse of solutions; (2) excessively high solution temperature; (3) lack of adequate agitation and uniformity of treatment; (4) excessive carry-over of one solution into another; (5) poor quality of local water supplies; (6) any or all of these conditions in combination and (7) oxidation by-products of pyro developing agent. These stains are readily identified by their appearance and color or by simple solubility spot tests. (For information on the removal of these stains see the chapter on restoration.)

1. **Calcium sulfite.** This stain is formed by the reaction of sodium sulfite in a developer with the calcium present in gelatin and/or hard water. It is soluble in acid and normally is dissolved by either an acid stop bath or an acid fixing bath during pro-

cessing. It is often seen on dry negatives as a white scum and sometimes duplicates the pattern of fingerprints. After drying it is insoluble in an alkaline solution and is not dissolved by exhausted, low acidity stop or fixing baths.

2. **Aluminum Sludges**

(a) aluminum sulfite is formed when the acidity of a hardening-fixing bath falls below a certain critical value. This occurs when there is excessive carry-over of alkaline developer into the fixing bath. The fixer becomes milky and the white sludge settles on the surface of films or prints. The fixer sometimes remains clear but the aluminum salt may form when there is insufficient immediate agitation. It is soluble in both alkalis and acids.

(b) aluminum phosphate is formed when phosphate-containing developers are used with alum fixing baths that are nearing exhaustion. It is soluble in both alkalis and acids.

(c) aluminum hydroxide forms when some alum fixing baths hydrolyze at a critical dilution. At this point the sludge forms in the wash water and then adheres to the surface of negatives, prints, and processing equipment.

(d) many surfactants or wetting agents are precipitated by alum in the fixing solution that is carried over in the emulsion or in the paper support to the final rinse in a wetting agent soluton. KODAK PHOTO-FLO Solution is a wetting agent that does not precipitate under these conditions.

75

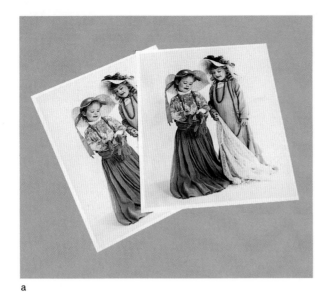

a

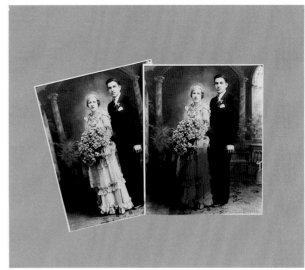

d

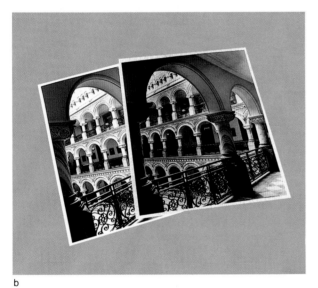

b

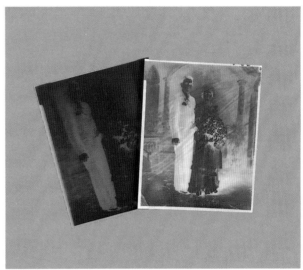

e

c

Figure 52 Some typical stains described in the text. In each case, the control print or negative is on the left. Dennis Thompson, Eastman Kodak Company Photo Laboratories.

(a) Aluminum sulfite sludge on the print on the right.

(b) Print on the right shows selenium toner stain.

(c) Oxidized developer stain on a print. Surface scum caused by developer is on the upper left-hand corner of the stained print.

(d) Blue ink stain on a black-and-white print.

(e) Surface scum on a negative caused by improper care of processing solutions.

(f) Brownish stain on a negative caused by iron impurities in the wash water or processing solution. Rust usually produces brown specks rather than a uniform stain.

(g) Opalescence caused by sulfur precipitation in the emulsion as the result of an overused fixer at an elevated temperature.

f

g

3. Opalescence. This is usually visible only on a negative or transparency and gives the appearance of having been made on opal glass. There are two kinds of opalescence:

(a) yellowish opalescence is caused by finely divided or colloidal sulfur produced when there is too much acid or too little sulfite in the fixer or when the fixing bath is too warm. It is insoluble in water, acids and sodium carbonate solution.

(b) silvery-white opalescence is formed when negatives and transparencies are dried by means of full strength denatured or wood alcohol especially when drying is hastened by heat.

4. Developer Oxidation Stain. These stains may be yellow or amber in color and they are usually transparent. They are caused by the oxidation products of the developing agent. They may be local or general (see the section on causes of deterioration in this chapter and the chapter on restoration).

(a) local irregularly shaped stains are the result of local oxidation of developer by air because of incomplete immersion in either the developer, stop bath, or fixing bath or by use of an alkaline fixer.

(b) general stain over the entire surface of the emulsion can be caused by old or discolored developer or by use of an alkaline fixer. Negatives developed in pyro developer always show a general stain. This stain has no effect except to require an increase in the printing exposure.

In the case of prints, a general yellow stain is produced if development takes place in a warm developer, if it occurs in a dirty tray, if the print is rinsed too long before fixing, or if it is not agitated when first immersed in the fixing bath.

5. Yellowish-Brown Stains from Colored Vegetable Extracts. This type of stain, usually occurring in the highlights of prints, can be caused by the presence of dissolved extracts from decayed vegetable matter and the bark of trees in the wash water.

6. Brown Rust Stains. These dark brown stains are often caused by the offsetting of rust from corroded metal clips used to hold film. They often appear as brown spots.

7. Bluish-Green Stains. These are sometimes seen on matt paper and are caused when an exhausted chrome alum rinse bath has been used or if it has been used at high temperature. The stain is usually a bluish-green scum of chromium hydroxide. Chrome alum hardening baths were more common in the early 20th century.

8. Brownish-Red Stains. These stains may be formed when a mercury intensifier such as KODAK In-1 is used. Photographic reduction and intensification were common practices that were used to provide improved printing characteristics when negatives were overexposed, underexposed, overdeveloped, or underdeveloped. The stains are caused by insufficient washing after bathing negatives in such solutions as KODAK Special Hardener SH-1 or KODAK Mercury Intensifier In-1. The latter is a mercuric chloride bleaching bath. Whenever these two solutions are used, negatives must be thoroughly washed to avoid the formation of stains as a result of the treatment.

9. **Blue and Brown Iron Stains.** These stains may be uniform but more often are seen as colored specks on prints. Iron rust in wash water or traces of iron in processing chemicals react with ferro- or ferricyanides in solutions such as Farmer's Reducer to produce prussian blue or brown stains.

10. **Stains on Selenium-Toned Prints.** Red and yellowish stains are caused by the precipitation of elemental selenium by hypo or by the acid left in a print which has not been washed sufficiently before toning. These stains can be prevented by removing the last traces of hypo with KODAK Hypo Eliminator, HE-1. See the section on KODAK Hypo Eliminator in the chapter on Processing For Black-and-White Stability.

11. **Water-Soluble Residues.** These include: salts from hard water which show frequently in the form of water spots or as a white scum, hypo residue which forms because of poor washing, and wetting agent residues which form from the use of highly concentrated solutions and/or inappropriate compounds.

12. **Dye and Ink Stains.** These stains may form because traces of sensitizing dyes were not removed in processing and with time the color returned. They may be pink or blue but are transparent and harmless photographically. Traces of antihalation dyes are generally harmless because they do not absorb printing light. In some instances, however, the color is not uniform but spot-like because of the action of fungus which causes the dye color to reappear. Stains due to indelible inks and red or black writing inks may be removed photographically by copying.

13. **Yellow (Iodide) Stains on Glossy Prints.** These stains appear as a deep lemon-yellow color on old glossy prints that were probably developed in a solution containing potassium iodide. Although seldom used today, potassium iodide was sometimes added to developers to help prevent abrasion on glossy prints. Potassium iodide converts the surface layer of a silver bromide emulsion to silver iodide, which is deep lemon-yellow in color. The silver iodide fixes much more slowly than silver bromide and when not completely fixed retains its yellow color because it darkens slowly on exposure to light.

14. **Surface Scum.** Under some improper processing conditions, scums form on the surface of processing solutions including washing apparatus. Usually the scum consists of organic matter such as gelatinous slime that has accumulated on tank walls and dislodged to the surface. Vegetable matter, bark extracts, diatoms, etc. present in water supplies may contribute to the mass and the whole may be colored by developer oxidation products. The scum then adheres to the surfaces of negatives and prints in uneven swirls and patterns.

15. **Wash Water.** At different times of the year, wash water may vary in its composition. Water finishing treatments often change with the season, the amount of rainfall, and local conditions such as the amount of soluble salts that are contained in the water supply.

Causes and Impedance of Deterioration

It was stated in the introduction to this publication that the chemicals from which photographic material are derived are unstable by nature. Because of this, photographic artifacts are extremely sensitive to their environment and to elements in the environment which may have a deteriorating effect. They vary in their resistance to time, temperature, humidity, contamination, handling, even the presence of humans. They may tarnish, stain, fade, discolor, grow fungus, or be attacked by insects and gases. The support may become degraded and affect the image by physical or chemical distortion. Even some enclosures intended to protect images may lead to their deterioration.

Temperature, moisture, light, and atmospheric contaminants are probably the primary causes of deterioration. Chemical reactions are accelerated at elevated temperatures, particularly in the presence of moisture. The intensity and duration of exposure to light, especially in display situations, has a very significant effect on color images. Atmospheric contaminants react with the image silver and accelerate other reactions.

In the past, many photographic collections were stored in unsuitable places, and the damaging effects of excessive heat and extreme dampness often went unrecognized until irreversible damage had occurred. Moreover, most photographs were and still are, made without regard to their possible historic value. Very often, when files of negatives become inactive they are relegated to damp basements, hot attics, or other equally unsuitable storage locations, and then the ravages of extremes of temperature and relative humidity may go unobserved and unchecked. High humidity is particularly detrimental to photographs. Its effects include

negatives sticking together, mold growth, "foxing" of pages, chemical degradation of the support and rusting of metal cans. Deterioration such as this may result in the loss of important photographs or in the need for special restorative techniques that would otherwise be unnecessary.

Figure 53 An albumen print in carte dé visite format (late 1860s) showing the brownish stains known as "foxing." Courtesy James Reilly.

Figure 54 The effects of a sustained high relative humidity are shown in this photo. The print and mount have both yellowed. The flow marks probably developed from adhesive used on the upper corners or the decomposition products of the print paper support.

Relative Humidity. The moisture content of air must always be considered in relation to its temperature. The higher the temperature the greater the weight of water air can hold. At any particular temperature, the amount of water in the air, described as a percentage of the maximum that the air will hold at that temperature, is the relative humidity (RH). Absolute humidity is simply the weight of water per unit volume. Relative humidity is the important factor, NOT absolute humidity. For example, on a warm sunny day when the temperature is about 29°C (85°F) and the RH is about 50 percent, air of the same absolute humidity that is cooled in a basement to 20°C (68°F) would be very damp, having a RH of 83 percent.

A similar situation exists in a room cooled by an ordinary air conditioner, although an air conditioner extracts some moisture from the air by condensing water vapor on the cooling coils. For reasons associated with the operation of many types of air conditioners, the extraction of moisture may not be sufficient to keep the RH in a storeroom at a safe level. Dehumidifiers for home use are designed to reduce the relative humidity and are especially effective in cool, damp basements. See the sections on air conditioning and humidification in the chapter on storage.

Gelatin coatings, photographic paper, and film base absorb moisture from the air to a greater or lesser extent, depending on the nature of the material. A negative or a print surrounded by dry air will give up moisture to the air, while one surrounded by damp air will absorb moisture until a balance, or equilibrium, is reached. The quantity of moisture held by a photographic material at equilibrium depends on the RH of the surrounding air. At a high RH—60 percent or more—the moisture content of a material reaches the upper limit of safety if physical damage and biological attack are to be avoided.

RECOMMENDED LEVELS OF RELATIVE HUMIDITY. Limits of relative humidity for the storage of photographic films, plates and papers have been specified by the American National Standards Institute as being between 30 and 50% RH.

Changing or cycling relative humidity should be avoided because short-term cycling may cause adhesion defects on polyester base and cellulose ester base such as edge peeling, flaking, or emulsion cracking. These conditions are covered in ANSI Standards PH 1.43-1983.

Extremes in relative humidity should be avoided. The dampness caused by high RH is much more damaging than the drying effect of low RH. The former can result in complete destruction of records. Dampness, or high RH, accelerates the effect of any residual processing chemicals that happen to be in the material and

Figure 55 An albumen print that has faded and has also developed a crazed emulsion. Courtesy Thomas T. Hill.

causes gelatin to become soft—sometimes to the point where it sticks to envelopes or anything else that it comes in contact with. High RH may cause irreversible size change, a particularly important concern in the storage of motion-picture films and black-and-white separation sets from color originals. Early safety base films made of cellulose diacetate often changed in dimensions because of degradation brought on by high humidity, causing emulsions to buckle. RH values above 60 to 65 percent will cause fungus spores in the air to germinate and the fungus will spread. For more information on this see the section on fungus in this chapter. In a humid atmosphere, gelatin in contact with very smooth material, such as plastic negative enclosures, becomes glazed (see the section entitled "Cellulose Acetate Sleeves" in the chapter on storage). Dampness may eventually destroy paper, mounting board, and packaging material used in storage.

The effects of dryness, or low RH, are not very serious unless the condition prevails for several weeks at a time. RH below 25 percent may result in brittleness of film and paper, as well as excessive curl. Acetate film will shrink markedly if stored in a dry environment. However, these effects are usually reversible, and the property may be recovered with rehumidifying. Gelatin contracts in very dry conditions and this may cause adhesion problems with old glass plates. Also, mounting boards tend to curl under conditions of low RH. Emulsion cracking in varying degrees may result from the large dimensional changes that take place under conditions of extreme humidity and temperature, especially when severe cycling of RH and temperature occurs.

For details about humidification and dehumidification of air, see the section on atmospheric conditions in the archival area in the chapter on storage.

USING A DESICCANT. When a small quantity of photographic material is to be kept for a short time in a humid area—in transit, for example, it can be placed in a closed, sealed container with a desiccant, such as silica gel. This substance resembles coarse white sand in appearance; each grain is porous, and like a sponge, it absorbs moisture in considerable quantity. Silica gel is odorless and nonreactive with most common materials. It is sold in bulk by a number of chemical supply houses. Forms of the product that cause dust should be avoided. Prepared drying units, such as Davison Silica Gel Air Dryers, are available. These units are perforated metal containers holding approximately 42.5 g (1 1/2 ounces) of silica gel, with a color indicator that turns from blue to pink when the desiccant needs reactivation. The dryers are convenient for holding a limited number of packaged negatives or other material in a closed container. One Davison Air Dryer is sufficient to keep relative humidity at a suitable level in a sealed cubic space that is about 30 centimetres (1 foot) long on each side. Silica gel lasts indefinitely and can be reactivated by heating to a temperature between 149 and 204°C (300 and 400°F) in a vented oven or over a fire. In this temperature range, 1 to 3 hours is sufficient to reactivate approximately 40 grams. To prevent reabsorption of moisture, allow the hot silica gel to cool in a closed metal container. Then, if the desiccant is not to be used immediately, seal the container. Silica gel can be obtained in a colored form with an indicator dye that changes from deep blue to pink when saturated with moisture. It is reactivated by heat when the color returns to blue.

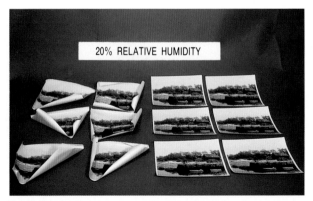

Figure 56 Curl in paper prints made on fiber-base paper and subjected to storage at 20% relative humidity is shown in the photo at the left. The prints at the right are on resin-coated paper and show no sign of curling.

Temperature. Temperature is not as critical a factor in the deterioration of photographic materials as relative humidity but the two conditions must be considered together in relation to one another. The recommendations for the storage temperature of films, plates, and prints is a temperature of 21°C (70°F). Cycling of temperature should not exceed 4°C (7°F).

Conditions which are the most damaging to photographic materials are those where the temperature exceeds 24°C (75°F) coupled with relative humidity that is greater than 60 percent.

Temperatures higher than 120°C can be tolerated for a considerable time if the RH remains less than 40 percent. *The foregoing remarks do not apply to the storage of films on cellulose nitrate base, because the rate of decomposition of this material approximately doubles with each 6°C (10°F) increase in temperature.* The deterioration of negatives on cellulose nitrate base is discussed in a section at the end of this chapter.

Low temperature is not damaging in itself; in fact a storage temperature of 10°C (50°F) is preferable to one of 21°C (70°F) if the relative humidity can be controlled in a simple way. Unfortunately, it rarely can be controlled without using special air-conditioning equipment. A dehumidifier can be installed, in a small storeroom, but a daily check on the RH is necessary to be sure that the condition is within proper tolerances.

Processing. The importance of proper processing to the stability of photographic images has been stressed throughout this publication. It is explained in detail in the chapter entitled "Processing for Black-and-White Stability." In this section, the effects of incorrect processing are described. One of the most important steps in the processing procedure is the removal of processing chemicals from the photographic materials by proper fixing and washing. When thiosulfate (hypo) and/or silver-thiosulfate complexes are retained in a negative or print, the chemicals may react to form yellow to yellowish-brown image discoloration and/or non-image stain. This will occur particularly if the materials are left under poor storage conditions. Hypo will react with the image silver to form silver sulfide and if subjected to very poor conditions for a long time will convert the silver sulfide to silver sulfate which is colorless and soluble. When this occurs, the image or part of it will disappear. The low density or highlight areas of an image show these effects first. If a relatively large residue of chemicals is present, the stain will be much heavier. The silver-thiosulfate complexes, under poor storage conditions, will decompose to form a yellowish-brown stain of silver sulfide.

Deterioration can also occur if the chemicals in the processing procedure are not used correctly. An overused developer will often turn a dark brown color. This color is the result of the aerial oxidation of some developing agents to form brown oxidation products. Negatives and prints then assume a brownish, transparent to translucent overall stain which cannot be removed by subsequent processing steps. The developer can also become contaminated with fixing bath which will cause dichroic fog—a non-image stain which is yellow by transmitted light and grayish by reflected light. Dirty developer tanks that are rarely cleaned may contain bacteria and if the bacteria is severe enough they will produce sulfide stains. If an acid stop bath or rinse is not used, each negative or print will carry alkaline developer into the fixer. In such instances, the pH of the fixer will become too high and the bath will become exhausted. The developing agents carried into the fixer

Figure 57 The effects of residual hypo and silver-hypo complexes on the photographic image are shown in these photos. Residual hypo from poor washing has discolored (sulfided) the image on the left similar to the way silverware tarnishes. The photo on the right shows the effect of hypo complexes on the highlights (the flower) or light-colored backgrounds of prints. The right half of the right-hand image is normal because of complete fixing and washing. Courtesy George Eaton.

reduce free silver ions (Ag+) giving rise to dichroic fog. This type of stain is seen frequently on sheet film negatives and prints. The stain may be "blotchy" or uniform and show a variety of colors.

Prints, films, and plates known to have had proper processing have lasted under normal conditions for more than 100 years if temperature and relative humidity are kept within the prescribed limits during storage. This is true provided that any mounting boards, interleaving sheets, album leaves, envelopes, and storage cabinets that are used with the prints are free from injurious constituents (see the chapter on storage).

Air Contamination. Pure air oxidizes paper, acetate film, and other photographic materials at a very slow rate if the temperature and relative humidity are normal. On the other hand, impurities in the materials themselves or in the surrounding air may accelerate the oxidation process in proportion to the amount of such impurities that are present. One of the serious problems in preservation is the relatively large quantity of oxidizing gases in the atmosphere in certain areas.

The problem is most acute in densely populated areas where traffic is heavy and industry is concentrated. Coal-burning industry, gasoline and diesel engines, oil- and gas-burning heating systems, and industries employing chemical processes all contribute to general air pollution. High pollution also exists in areas where paints, printing inks, lacquers, enamels, varnishes, and cosmetics are being used as in automobile body shops, furniture factories, and beauty shops. If possible, the storage area should be situated as far from the sources of pollution as possible. Otherwise, an air-conditioning

Figure 58 Print showing image discoloration, general staining resulting from poor processing, and the formulation of tarnish (sulfiding) around the edge. The tarnish is the result of atmospheric contaminants. Note the outline of the print frame or holder. Courtesy Thomas T. Hill.

system incorporating an air-purification device should be installed if the records are to be kept in good condition for as long as possible.

Near the seacoast, very small amounts of airborne salts may migrate into storage areas and onto photographs. The salts are hygroscopic and tend to establish a high level of moisture, which not only accelerates localized chemical activity but also encourages the growth of microorganisms.

Figure 59 This photograph by William Henry Jackson shows deterioration caused by poor framing, poor matting, and environmental overexposure. The paper has expanded from moisture, and peroxide and lignin have caused both fading of the image and discoloration of the paper. Photo taken at IMP by Don Buck, Eastman Kodak Company, Photographic Illustrations Department.

Since the effects of oxidation on a silver image are similar to those of contaminants, it is difficult to determine in any particular case to what extent atmospheric conditions are responsible for the deterioration. In most cases, there is no single cause; the effect is usually due to a combination of several factors. The unprotected silver image is subject to attack by a host of contaminants that may be present in the air and/or the storage area in high or low concentrations. These include: gases such as hydrogen sulfide, sulfur dioxide, nitrogen oxides, hydrogen peroxide, and ozone; the fumes from auto exhausts, freshly manufactured plastics, oil or gas heating, stains and varnishes, formaldehyde, acids, paints; or items such as cosmetics, rubber bands, and enclosures. The action of these various contaminants is not fully understood in all cases but there is sufficient evidence to indicate that the deterioration produced in photographic images may be initiated early without visible evidence; that temperature and humidity accelerate the reactions; and that residual processing chemicals contribute greatly to their deterioration.

The visible signs of deterioration by atmospheric contaminants may appear in several ways. Oxidizing gases usually cause a yellowing of the silver image or the entire surface of a print. Lines and blotches may appear in the image area. They may also degrade and stain the paper base of a print. A brownish-yellow stain around the edges of a print that has been stored in an album is a sign of atmospheric deterioration. Acidic gases that are often present in the air tend to degrade gelatin, the paper base of prints, and the film base of negatives. Another sign of deterioration caused by oxidizing gases is the appearance of orange-red spots on photographic prints, microfilm records, and astronomical plates. Similar spots have occurred on Autochrome plates—which are most visible at a low angle of illumination. These spots sometimes appear to be silver mirrors.

A simple test method using colloidal-silver coated test strips has been used to determine the presence of gases in a storage area[21]. Layers of yellow colloidal silver having a grain size less than 30 nm underwent a dark discoloration in the presence of very small amounts of oxidizing gases. The strips are considered to be ten to twenty times more sensitive than photographs. This test method is not practical because the test strips are not generally available and the discoloration is also influenced by humidity. In addition, inasmuch as the concentration of oxidizing gases is usually quite small, considerable time is required for any reaction to occur. However, this testing method did indicate positive reactions from plastic packaging materials, automobile exhaust fumes, nitric oxides, index cards made of phenol-formaldehyde, and the ozone gas given off by some copying machines.

a

b

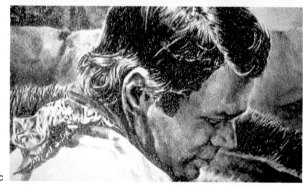

c

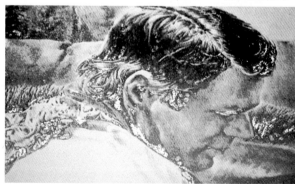

d

Figure 60 Redox blemishes (microspots or red spots) are caused by paint fumes. Shown above:

a) blemishes on microfilm-leader end of a processed roll.

b) one red spot greatly magnified to show structure.

c) red spots formed on a print.

d) red spots which sometimes appear as mirrors when observed at a low angle of view.

Atmospheric contaminants may affect photographic images in ways other than microspot formation. Figure 61 shows a 1952 Athena print that had been kept in a freshly painted room. The deterioration prompted a practical test of paints and their effect on photographs. Hydrogen peroxide is generated during the curing of certain paints[22].

Figure 61 Atmospheric contaminants can affect the image in other ways than microspots. Photo at right shows an image on KODAK ATHENA Paper (fiber-base) circa 1952 that has discolored due to atmospheric contaminants.

Thirty-two different paints from several manufacturers were tested including 19 alkyd (oil base) and 18 latex (water base) paints. Using an experimental test chamber it was found that the latex paints had no effect while all of the alkyd paints showed varying degrees of activity. Practical tests in which photographic materials were placed in newly painted rooms confirmed the experimental results. Properly fixed and washed fiber-base and RC prints were placed in a room about five hours after the painting was completed. The following results were noted: the prints showed discoloration within seven days; the paint fumes continued their discoloration activity up to four weeks after completion of the painting, only 24 hours or less of exposure to the paint fumes was required to initiate discoloration that eventually appeared on the prints after they had been removed and stored elsewhere. It was confirmed that hydrogen peroxide was the active species formed during the curing of the alkyd paint and that the active oxidant concentration never exceeded 30 parts per billion.

Protective treatments described earlier (see the chapter on processing for black-and-white stability) involving the use of certain toners were found to be very effective in preventing the oxidation of the image silver by hydrogen peroxide from alkyd paints. Test results from a peroxide fuming chamber correlated well with the tests conducted in newly painted rooms. Both fiber-base and RC paper prints were treated, after processing, in KODAK Rapid Selenium Toner, KODAK POLY-TONER and KODAK Sepia Toner. None of the toner-protected prints showed yellowing while all of the untoned prints yellowed. Not all toners are effective.

Light. Small amounts of light that might reach black-and-white materials in storage are not a factor in deterioration (see the chapter on storage). Light has no significant effect upon the silver of an image in ordinary circumstances. However, light can reduce silver ions to metallic silver after oxidizing gases and moisture have acted upon the image as described above.

Constant exposure to light can cause gelatin to turn yellow and tends to make it brittle. Paper also yellows with exposure especially papers used in photographs prior to 1926. Any considerable discoloration is more likely to be caused by oxidation or by the decomposition of residual processing chemicals than by light.

Valuable prints that are placed on display should not be exposed to strong daylight for any length of time. Tungsten light is preferable to most types of fluorescent light for display purposes.

Light is a very significant factor in the stability of color images in view of the fact that image dyes do fade. For more information on this subject see the chapter on color images.

Fungus*. Often called mold or mildew, fungus growth is another form of deterioration that can be damaging to negatives, transparencies, and prints. It is the result of high relative humidity —60 percent or more—that often prevails in tropical countries and in the United States during the warm summer. Fungus spores and bacteria are in the air regardless of temperature and humidity. Moisture is important to their growth even when the temperature is as low as 4.5°C (40°F) as is often the case in damp basements. They thrive in darkness, in stagnant air, and they spread to other materials. They feed on dead organic matter such as leather, cloth, wood, paper, and gelatin. Particular care should be taken to avoid fingerprints on films and prints because the oil from the skin will nurture these fungus spores. If fungus can gain access to packaged film or paper it will damage unexposed film. It readily attacks processed materials and if nurtured through lack of care by the custodian may eventually destroy the gelatin coatings. A blue coloration on the back of processed films indicates the presence of fungus—the

*For more information, see KODAK Publication AE-22 *Prevention and Removal of Fungus on Prints and Films*, and KODAK Publication C-24 *Notes on Tropical Photography.*

Figure 62 Antihalation dyes on the back of negative film are generally destroyed during processing. In some cases the dye may be converted to its leuco or invisible form. During storage, acid caused by fungus can convert the leuco base to the blue dye as in this illustration. Courtesy Thomas T. Hill.

acid generated by fungus regenerates the blue antihalation dye from a colorless form which was not destroyed during processing. Fungus growth may also etch or distort images. Damage to the image is usually not immediate. If the growth is discovered in time, steps can be taken to remove it and to prevent recurrence. Continued growth causes permanent damage and destruction of the gelatin. The effect on color materials is more serious because the growth may liberate substances which affect the dyes. Uncontrolled fungus growth will also attack the enclosures in which processed negatives and prints may be stored and cause some disintegration. This includes envelopes, file folders, boxes with interleaving sheets, albums, and mounting board used for storage or display. Even enclosures satisfying the specifications of ANSI PH1.53-1984 (see Chapter V on technical standards for photographic materials) will not withstand extensive fungus growth. In the case of mounted prints, hygroscopic pastes and gums accelerate possible fungus attack because of the moisture absorbed by the adhesive.

The best preventive against fungus attack is to keep negatives, transparencies, and prints dry; that is, at a relative humidity between 30-50 percent. Air conditioning with controlled relative humidity, an electric dehumidifier, heated cabinets or metal boxes with the use of a desiccant such as silica gel will protect photographic materials. Silica gel or other desiccants provide only a temporary solution to the control of relative humidity. There is also evidence that hypo-alum toning provides prints less susceptible to attack by fungus. For more information see KODAK publication J-1, *Processing Chemicals and Formulas*. If controlled storage is not possible, then the materials should be inspected regularly to make certain fungus growth is not in progress. When there is evidence of fungus it should be removed, if possible, and all enclosures should be replaced. Infected areas may be more readily detected during examination by use of an ultraviolet light. The growths fluoresce as bright blue-white areas. *Do not look into the light source. Direct exposure can affect the eyes.* This test may not be useful when photographic papers containing "brighteners" are tested. The brightener compounds fluoresce in ultraviolet light and it may be difficult to detect fungus.

Black-and-white negatives and prints can be treated against fungus with fungicides.

In the case of black-and-white prints, immerse them for three to five minutes in a one percent solution of diisobutyl-cresoxy-ethoxy-ethyl-dimethyl benzylammonium chloride. This chemical is supplied as HYAMINE 1622 by Rohm and Haas Company. The temperature of the solution should not be lower than 21°C (70°F). This treatment may produce

Figure 63 Black-and-white prints can be treated similarly with a solution of Hyamine I622. On the left before treatment; on the right after.

Figure 64 A film negative on the left that has been attacked by fungus and on the right after treatment in a solution of sodium fluosilicate.

some discoloration which is not serious with most papers. It cannot be used on color prints because the fungicide causes dye fading.

Color prints, color negatives, color transparencies and black-and-white negatives can be treated against fungus, after proper processing, by bathing them in a one percent solution of zinc fluosilicate and water and drying them without wiping. To promote uniform drying, add one part of KODAK PHOTO-FLO Solution to 200 parts of zinc fluosilicate solution. Any residue that remains on the base side of unbacked films can be removed with a damp sponge. The sponge should then be discarded.

DANGER: This procedure must be used with extreme care. Zinc fluosilicate is a highly toxic chemical; its use as described above should be confined to photographic workrooms. It can be fatal if swallowed, even in a dilute solution. Protective gloves should be worn in the preparation and use of the solution. Wash thoroughly after use. Place clearly recognizable poison labels on all containers of the chemical. Zinc fluosilicate, or negatives that have been treated with it should never be stored in areas where children may have access to them.

For more information on fungus removal see the section entitled "Removal of Fungus" in the chapter on restoration.

Insects and Rodents. Photographic materials contain ingredients—such as the gelatin and cellulose in paper—that are very attractive to insects and rodents. In temperate latitudes the best preventive is to follow ordinary good housekeeping practices. This means that no food, drinking, or smoking should be permitted in the storeroom. Any windows that might be open should have screening to protect against insects; they are attracted to fungus and may damage the emulsion layer. Certain chemicals present in insect excretion can fade or bleach the image in localized areas. Insects will actually chew away pieces of prints and even containers especially when they are moist.

The principal method for treating insect infestation is fumigation. There are several chemicals commonly used as fumigants but based upon actual tests and a knowledge of the chemistry of image degradation, only sulfuryl fluoride is recommended as a fumigant for both black-and-white and color photographs.

Several other methods have been considered for treating photographic materials that show fungus or insect attack. One is the use of gamma (x-ray) radiation from cobalt 60. This is effective, but not convenient; and at the dosage level required to kill all the microorganisms present, some damage may be done to the image or the gelatin. Another method is the use of ultraviolet radiation. Here again, image degradation can be a serious problem at levels that will kill the microorganisms. A third method is the use of vacuum. This will kill insects and some microorganisms and will not adversely affect the photographic materials. However, it will not kill fungal spores, which will grow into full-fledged fungal colonies upon being put back into a high humidity condition. Nonetheless, if the biological deterioration problem is the result of insect attack, this could well be a very effective technique and preferred over the use of fumigants. A final method of protecting processed photographic materials from biological attack is to seal them in envelopes such as the KODAK Storage Envelopes for Processed Film. Use of these envelopes is discussed in the chapter on storage.

Water Damage. Water from any source can cause severe damage to photographic materials. Some examples of possible sources of water damage are: floods, sprinkler systems, overflowing sinks, burst pipes, melting ice or snow, backed-up sewers and particularly water used to extinguish fires. Careful attention should be given to the location of the storage area and to the protection of the files and collections to avoid this type of damage.

Resistance to wet immersion depends upon the type of photographic record, whether or not it was hardened during processing, the time of immersion, and the water temperature. A recent study [23] of the effect of water on contemporary black-and-white negatives and prints including color materials and artifacts representing most of the nineteenth-century processes was made. Prints were processed in both hardening and non-hardening fixers and then immersed for 72 hours in water at room temperatures. Several drying techniques were tested on the water-soaked materials: air drying (without freezing); freezing-thawing-air drying; freezing and drying in a vacuum chamber; and freezing-thawing-vacuum drying.

Figure 65 Insects and rodents can damage photographic artifacts. The above illustration shows a print that has been eaten by a mouse. Courtesy James Reilly.

Figure 66 A print of Niagara Falls showing typical water damage: mold has grown out of it, the print has curled and become brittle. Courtesy International Museum of Photography at George Eastman House.

The results indicated some interesting facts: (a) black-and-white materials were generally more stable than color; (b) contemporary black-and-white silver gelatin prints hardened in processing showed barely perceptible changes; (c) silver gelatin prints not hardened in processing were destroyed with the emulsion layer separating from the support; (d) salt prints, albumen prints, and collodio-chloride prints survived immersion surprisingly well after air drying; (e) collodion wet plate negatives, ambrotyes and tintypes cannot withstand water immersion, and if immersed, should never be frozen; (f) black-and-white prints showed the least dimensional change and the least loss of reflection density after air drying; and (g) no confirmation was found for the often-claimed formation of ice crystals in silver gelatin materials that had been water-soaked and frozen. It was also indicated that freezing retards further deterioration but should not be used if recovery efforts can be made immediately. The last technique showed blocking or sticking of the gelatin layers and therefore should not be used. Otherwise, the order of drying as listed by the three remaining techniques is recommended.

CARE OF WET FILMS AND PLATES. Photographic materials that have accidentally been soaked with water need immediate attention. If the films are still wet, or even damp, keep them wet. Never allow the materials to dry before attempting to salvage them. Do not separate enclosures. If rewashing is not possible within a few days, the immersed films and/or prints should be frozen to retard further deterioration. The wet materials should be put into plastic containers— plastic garbage cans work very well. Water-soaked negatives, slides, and prints should then be immersed in an alkaline solution of formalin and sodium sulfate. The latter prevents swelling of the gelatin; formalin is a much more effective gelatin hardening agent at an alkaline pH. A suggested formula is given below. After the material has been treated in this solution it should be washed in tap water for ten minutes at 21°C (70°F).

Quadrafos®*	0.6 gram per litre
$NaHSO_4$ (Sodium Acid Sulfate)	7.0 grams per litre
$Na_2B_4O_7/10H_2O$ (Sodium Tetraborate-Borax)	15.0 grams per litre
Na_2SO_4 (Sodium Sulfate)	195.0 grams per litre
Formalin (37.5% sol)	20.0 mL
Solution pH = 8.0 at 80°F	

*Quadrafos is a registered trademark of Monsanto for sodium hexametaphosphate.

This procedure is only a temporary measure. The materials must have further treatment at the earliest possible moment because wet gelatin will disintegrate in a matter of days even under the above condition. Negatives on nitrate base may have soft gelatin and hence are particularly vulnerable. If the collection contains nitrate-base negatives, these should be cleaned and air-dried first. See the end of this chapter for more information on this subject.

After removing wet envelopes or other packaging material, wash the negatives, for one half-hour, to remove any traces of mud, silt, paper, etc. Where necessary, *gently* swab the surfaces under water to remove grit. Prolonged washing is not advisable, particularly if the temperature of the water supply is above 18°C (65°F). *Never* use warm water for washing, because it may cause frilling or even melting particularly if the gelatin is already soft. Glass plates are often found in boxes of a dozen without envelopes or interleaving of any kind. If this is the case, it may not be possible to separate the negatives without transferring parts of the gelatin film from one plate to another. Black-and-white negatives should receive a final rinse in KODAK PHOTO-FLO Solution, diluted as directed on the label, and then they should be hung up to dry naturally. Color films should be treated in the same way, but if their original processing called for a final stabilization step, they should be bathed again in a suitable stabilizer before drying.

If the facilities and the manpower to perform the above work are not available, the materials should be kept wet until they can be taken to a professional photo laboratory. This should be done as quickly as possible. Since not all laboratories are equipped to handle water-damaged films, it is best to inquire if this expertise is available. Regardless of who does the work, the most valuable photographs should be segregated and cared for first. Salvaging water-damaged films by professionals can be expensive and it may be necessary to discard ones of lesser value. If there is a special problem requiring further advice on handling water-damaged films, call the nearest Kodak Processing Lab or the Customer Technical Services Department at Eastman Kodak Company in Rochester.

CARE OF WET PRINTS. Water damaged prints can be treated by the same methods described above. If possible, they should be stored flat in trays of water until they can be properly washed and dried. Only those prints for which negatives are not available and those prints that are not badly discolored should be salvaged. Prints for which negatives are available can be replaced at a later date. Color prints may prove very difficult to salvage, especially if the emulsion surfaces

have had an opportunity to dry and stick to other surfaces. They should be treated in a final stabilizing bath if one was required in the original process.

It is important to observe good hygiene and sanitary practices when working with film and prints contaminated with sewage. The use of rubber or plastic gloves is recommended as well as the use of procedures which are usually followed when handling contaminated materials.

Nitrate Base Supports. Cellulose nitrate film base can present a major deterioration problem for photographic conservators. It is inherently unstable, and in a large quantity constitutes a fire hazard. It is chemically similar to guncotton, but nitrated to a lower level. It is not explosive but it is highly flammable. In addition, some of the products of deteriorating nitrate film are powerful oxidizing agents. These agents attack other materials such as acetate-base negatives and prints that might come in contact with or be in the immediate vicinity of the decomposing film.[24] They cause yellowing and fading of the silver image as well as softening of the gelatin. For these reasons, photographic conservators should examine new collections or artifacts immediately after their receipt to determine if materials on this film base are present. If nitrate-base negatives are found to be in a collection they should be segregated from other materials as soon as possible and stored under the best conditions available until they can be duplicated and the originals destroyed.

IDENTIFYING NITRATE BASE. Unless some deterioration has set in, it may not be readily apparent whether film is on nitrate or acetate base. Generally speaking, any negatives that were made before 1950 are suspect, although many negatives were made on film with an acetate base long before that time. Kodak sheet films made of acetate are readily identifiable by the words "KODAK Safety Film" printed along one edge near the code notch, but many films of other manufacturers bear no such identification. This identification is not altogether proof positive that a safety base duplicate is involved because the possibility exists that a safety base film could have been duplicated onto a nitrate-base film. The following table shows when Kodak films of various types, originally on nitrate base, were changed over to acetate base. Note that 16 mm and 8 mm movie films were never made on the nitrate base.

Types of Film	Year of Last Nitrate Film Manufactured by Kodak in the U.S.*
X-ray films	1933
Roll films in size 135	1938
Portrait and commercial sheet films	1939
Aerial films	1942
Film packs	1949
Roll films in sizes 616, 620, etc	1950
Professional 35 mm motion picture films	1951

*Certain products manufactured in France during World War II were made on nitrate film base by occupation forces.

One indication of the presence of cellulose nitrate is a characteristic pungent odor which should not be confused with the smell of acetic acid (vinegar) which is characteristic of the decomposition of some cellulose-acetate film bases. Another indication of nitrate base is a brownish yellow discoloration of the film base. Other indications of both nitrate and safety base include stickiness of the gelatin, extreme brittleness of the base, and shrinkage and buckling of the negative. To determine if there is color change in the base, cut a small strip from the edge of the negative and soak it in water. When the emulsion has softened scrape it off gently to see the base color—if the color is yellowish or amber it is nitrate base.

Figure 67 The top photo illustrates the scraping test to identify nitrate-base film. After soaking and scraping of the emulsion layer, a yellowish-brown color as shown in the bottom photo indicates possible nitrate base. Photo service at Kodak Research Laboratory.

A negative which is not edge-marked "safety" should be assumed to be on nitrate base unless positive identification to the contrary is established. Nitrate film was first used for roll films in 1889 and for commercial motion pictures in 1895. Nitrate film base can also be identified by the tests described below. *They should be conducted very carefully and interpreted with caution. Eastman Kodak Company does not recommend or guarantee the results of any test.*

Float Test. To distinguish nitrate-base film from any of the acetate bases, take a 6 mm (1/4 inch) square piece of dry film and place it in a test tube containing trichloroethylene. Shake the tube to make sure that the film sample is completely wetted. If the sample sinks, it is cellulose nitrate; if it floats, it is acetate or polyester. Although trichloroethylene is not flammable, it is volatile and its vapors should not be inhaled. In addition, it should be used only in a well-ventilated area. Trichloroethylene is obtainable from most suppliers of laboratory chemicals and recommended safety precautions should be followed carefully.

Burning Test. Nitrate and safety film can be distinguished by their burning properties but this test must be made carefully because safety film does burn and a small piece of nitrate film burns much less vigorously than a large piece. A piece of film approximately 3 mm x 2.54 cm (1/8 x 1 inch) should be trimmed from the edge of the negative. It should be held vertically with tongs or pliers at the lower end over an ash tray (at some distance from other films). The piece of film should then be ignited with a match at the top. If the film is nitrate, it will burn rapidly and vigorously downward with a bright yellow flame until completely burned; if the film is safety, it will ignite only with difficulty and the flame will usually go out shortly after the match is removed. If ignited from below, safety film may burn completely. *Unless one is experienced, this test should be tried first on nitrate and safety film of known identity so that the behavior of both types will be understood.*

Polarization Test. Acetate film base and polyester film base can be distinguished by this test. A strip of film or a color slide should be placed between a pair of "crossed" polarizing filters. First look through the two filters at a fairly strong light and turn one filter until the least light passes; then put the strip of film between them. There is no change with acetate. With polyester there are changing fringes of rainbow lights and the darkening due to polarization is partially lessened.

PREDICTION OF NITRATE-BASE CONDITION. Two tests have been described for predicting the future condition of nitrate film already in storage. They are called the Alizarin Red Heat Test and the Micro-Crucible Test. These tests require a chemical setup—they are not simple drop tests—but they indicate whether or not the nitrate film should be destroyed then and the

Figure 68 When film is placed between polarizing filters, no change is evident if it is a triacetate base (left). A polyester-base film will manifest a color spectrum (right). This effect of polarized light on each film is characteristic of each material. The polyester has a greater birefringence than acetate thus the color in the polyester. Photo service at Kodak Research Laboratory.

number of months or years before the test should be repeated. For further details consult the Journal of the Society of Motion Picture and Television Engineers 54, 381-383, March 1950[25].

DETERIORATION OF NITRATE-BASE SUP-PORTS.
Nitrate film base decomposes slowly under ordinary conditions, but the rate of decomposition is accelerated by increasing temperature and relative humidity. The products of decomposition—nitric oxide, nitrogen dioxide, and other gases—hasten the process unless the gases are allowed to escape from the cans, boxes, and other packages that contain the film.

The actual life of nitrate-base films has varied widely; examples 50 or even 60 years old are still in a fair state of preservation, while others have deteriorated seriously in a much shorter time. Such wide differences in the rate of decomposition cannot be fully explained. However, rapid decomposition is most likely to have been caused by high temperature coupled with high relative humidity and by lack of ventilation. There seems to be little relationship between the rate of decomposition of nitrate base and the amount of residual processing chemicals—hypo and silver complexes—present in the material. Observations of old negatives on nitrate base show that, aside from the adverse effects of excessive heat and humidity, the quantity of cellulose nitrate present in a container and the ability of the products of decomposition to escape have a definite bearing on the rate of decomposition. For example, rolls of motion picture film, which represent a considerable bulk of cellulose nitrate film base in existence today, when stored in a sealed can, deteriorate fairly rapidly. This situation is one extreme. The other extreme is one in which a number of small negatives, approximately 5.7 x 8.3 cm (2 1/4 x 3 1/4 inches), were kept in open-sided negative enclosures that met the correct standards for long-term keeping. Negatives on thin-base material stored in this way have remained in very good condition. A situation intermediate between the two just mentioned exists where a number of large negatives, 20.3 x 25.4 cm (8 x 10 inches), for example, are stored in the original cardboard film box. Since sheet-film negatives have a thick base, there is a considerable amount of nitrate material present, and the products of decomposition are able to escape only with difficulty and very slowly. Under these conditions, the negatives deteriorate more quickly than they do in the open-sided enclosures or in a similar package. The archivist should, therefore, check the contents of enclosed packages of large negatives first of all. Then any nitrate negatives should be removed and stored in a location away from other photographic materials.

Figure 69 Nitrate-base sheet film in various stages of deterioration: On the bottom the occurrence of bubbles on the emulsion side of this 4 x 5-inch negative indicates the initial stage of deterioration; on the top an 8 x 10-inch negative in which the base deterioration is well advanced. Bottom photo courtesy Thomas T. Hill.

If negatives on nitrate base are present in a collection, it does not mean that they are all on the verge of total loss. If they are properly cared for, they can be expected to last for a considerable number of years.

It is important, however, to recognize the early signs of decomposition. First, the film base becomes yellowish and then amber. At this stage the base is brittle and it breaks easily on being bent double. Also, the gelatin is soft enough to melt readily if the negative is wetted. To make a simple test, a small strip should be cut from the clear margin of a nitrate-base negative, folded to check for brittleness, then soaked for approximately one minute in water. The gelatin should then be scraped from the surface. The degree of discoloration of the film base should be observed by placing the strip on a sheet of white paper. Any discoloration will indicate some degree of nitrate base decomposition. This scraping test to reveal the film base is important because many old negatives appear to be slightly yellow due to the sulfiding action of traces of silver in the emulsion and to the yellowing of the gelatin itself.

Negatives in the process of decomposition must be handled with care and kept dry. Also, they should be duplicated as soon as is convenient. In the later stages of decomposition, the gelatin buckles and becomes sticky and duplication becomes much more difficult. See the section on nitrate base negatives in the chapter on photographic reproduction.

Spontaneous Combustion. In the days when motion pictures were made on nitrate-base film, many fires occurred due to spontaneous ignition of this material. So far as is known, fire has not been caused by cellulose nitrate in good condition; in the advanced stages of decomposition, however, self-ignition can take place at temperatures greater than 38°C (100°F) if they are sustained for a considerable time. The conditions under which still-picture negatives on nitrate base would ignite spontaneously are rare, but the possibility does exist. Generally, self-ignition of the material has been caused by sustained high temperature coupled with low relative humidity, and by heat generated by the process of decomposition that was unable to escape. Moreover, a considerable amount of material would need to be in a closed container to make spontaneous ignition possible. Tests have shown that a 1000-foot roll of decomposing motion picture film ignited only after being subjected to a temperature of 41°C (106°F) for 17 days. The film was enclosed in a can wrapped in mineral wool to retain the heat generated by the process of decomposition.

TEMPORARY CARE AND STORAGE OF DETERIORATED NITRATE ARTIFACTS.

If negatives on nitrate base are found to be in an advanced state of decomposition, a photographic duplicate should be made immediately. If the film base is heavily stained and moisture from the breath makes the gelatin slightly sticky, the negatives must be duplicated within one or two years. In any case, each deteriorated negative should be removed from the old enclosure, put in a good-quality paper envelope, and stored temporarily until final disposition can be made. The old enclosure should be discarded. Enclosures that have value in and of themselves should be stored separately from the photographic material and be cross-referenced. Any information that may have been on the old envelope should be transferred to the new one. If there is surface dirt on the negatives, it can be removed, with KODAK Film Cleaner. A nitrate-base negative that has deteriorated should not be wet with water. The gelatin may be soft and will be dissolved by the water. Many old negatives have dichroic or silver sulfide stain on them: this is usually on the surface of the gelatin. The stain may be removed or reduced by rubbing the negative with Du-

Pont White Polishing Compound or similar products which can be obtained from most automotive supply stores. These products are not considered general purpose remedies for silver mirroring. A small amount of the compound should be put on a piece of cotton wool and the negative should be rubbed gently with the wool until the deposit has been removed. It is important not to damage the image or to bend the negative because the base is usually very brittle and easily broken.

After the deteriorated negatives have been treated to remove any dirt or stains and placed in new enclosures, they should be stored until such time as they can be duplicated on a more stable film. Collection size is a consideration in the storage of these negatives. Still camera negatives on nitrate base that are from an amateur, scientific, or industrial collection are apt to be small in size and therefore much less hazardous to store because of their reduced mass. They can usually be stored in envelopes or containers that allow more exposure to air and ventilation. On the other hand, collections containing motion picture, aerial, x-ray, and professional sheet film, because of their size, usually have to be stored in large masses in nearly airtight containers or poorly ventilated storage areas. Storage conditions such as these are of major concern.

Negatives on nitrate-base material should be packed loosely in ventilated metal boxes or cabinets and stored in a room apart from other negatives or photographic materials. The temperature in the storage area should not exceed 21°C (70°F); a lower temperature is desirable if it can be achieved without increasing relative humidity above 45 percent. From the standpoint of retarding decomposition, RH below 40 percent is desirable, but there is a risk of negatives becoming very brittle if conditions are too dry. A correct balance in the relative humidity must be achieved which will avoid the base of the negative becoming too brittle or the gelatin becoming so tacky that it will adhere to the negative enclosure. For information on the control of relative humidity, see the section on archival storage in the chapter on storage. The above storage recommendations are only for small quantities of material; larger quantities should be stored in vaults that meet the specifications of the National Fire Protection Association, 60 Batterymarch St., Boston, Mass. 02110. The standards and requirements for storing nitrocellulose film are discussed in detail in their publication "National Fire Codes" Vol. 1, 1948.

A method of stabilizing deteriorating nitrate still camera negatives temporarily that has been used successfully by the University Museum of the University of Pennsylvania is described below. A layer of twenty-five to thirty 20.3 cm x 25.4 cm (8 x 10-inch) negatives are placed carefully in KODAK Storage Envelopes for Processed Film. Two layers of forty 12.7 cm x 17.8 cm (5 x 7-inch) negatives or smaller placed side by side can also be used. These envelopes are available in 22.9 cm x 25.4 cm (9 x 10-inch) and 12.7 cm x 15.2 cm (5 x 6-inch) sizes. If the envelopes are to be heat-sealed, a paper guard must be placed between the film and the envelope's opening. Each envelope is identified with a sticker label indicating contents, size, temperature, and relative humidity. Twenty to fifty envelopes are then placed in an archival box and the material is put in a commercial freezer with a relative humidity of 45 percent and a temperature of −18°C (0°F). A freezer such as the Imperial model manufactured by Northland Refrigerator Company, Greenville, Michigan, is used. When the materials are removed for further preservation study, they are allowed to adjust to normal room conditions for four days.

KODAK Storage Envelopes for Processed Film are available from photo dealers in the two sizes given above. Often there is a need for larger sizes. In this event, the same material from which these envelopes are made is available from Northern Packaging Corp. in Rochester, N.Y., and Crown Zellerbach Flexable Packaging Div. in Saddlebrook, N.J. (See the appendix for complete addresses.) After obtaining the material, the conservator can fabricate the envelopes himself or have it done through a jobber.

After negatives on nitrate base have been duplicated they should be carefully destroyed. Only small numbers of films in good condition can be discarded into normal trash-disposal channels; nitrate negatives should never be incinerated with office wastepaper. Unstable or deteriorated nitrate films present hazards similar to explosives and must be handled with the same respect. Such films should be kept under water in a suitable steel drum until disposal can be arranged. Any substantial quantity of films should be regarded as unstable, whatever its apparent condition. The safest method of disposing of nitrate films is by carefully controlled burning by qualified personnel in a good incinerator equipped with pollution-control devices. Because of the rapid combustion and intense heat generated by burning nitrate film, only a small quantity of film should be burned at one time. Mixing with other combustible wastes can keep the volume low.

Chapter IX Storage and Display of Photographic Artifacts

One of the most important factors affecting the preservation of photographic records is the storage and display conditions to which they are subjected. This includes the material in which the artifact is enclosed, the area in which it is stored, and the manner in which it is displayed. Each must provide an environment that is beneficial to the preservation of the image. Assuming that the artifact has been properly processed and that the nature and causes of deterioration are understood, the photographic curator's principal work begins: storage and display of the artifact, the duplication of originals by photographic reproduction, and any restorative procedures that may be necessary. In the next several chapters these subjects will be discussed as they apply generally to all photographic artifacts. More specific information on the storage, display, and effect of postprocessing treatments on color images can be found in Chapter VII.

Storage Materials

Processed negatives, slides, and prints should be enclosed in envelopes, sleeves, file folders, or albums to protect them from dirt and mechanical damage and to facilitate identification and handling. The principal physical and chemical requirements for paper and plastic enclosures are outlined in ANSI Standard PH1.53-1984 "Photography (Processing) Processed Films, Plates and Paper-Filing Enclosures and Containers for Storage." Certain paper and plastic enclosures are satisfactory provided the temperature and relative humidity are within safe tolerances (see the chapter on deterioration). However, these materials are permeable and do not protect against environmental effects. The paper used should be chemically stable and have a slightly rough or matte surface to prevent sticking and ferrotyping. It should have an alpha cellulose content in excess of 87 percent, be free of groundwood, contain neutral or alkaline sizing chemicals, have a pH between 7.0 and 9.5 for black-and-white materials with a 2% alkali reserve, and be void of waxes, plasticizers, or other ingredients that may transfer to photographic materials during storage. "Paper that is in direct contact with processed color photographic material should have a similar composition to that used for black-and-white except that the pH should be between 7.0 and 7.5 and the 2% alkaline reserve requirement shall not apply." Alkaline sizing chemicals should not be present in excess as is the case with some "acid-free" materials. Analysis for total alkalinity may be required.[26] Highly plasticized sheetings or coatings of unknown quality are suspect as enclosure materials because solvents and plasticizers may have a harmful effect on the photographic image. Chlorinated and nitrated sheeting should not be used. Cellulose nitrate in particular should be avoided. The standard further states that various adhesives are hygroscopic, thus increasing the possibility of local chemical activity. However, it is generally recommended that only nonhygroscopic (not water-absorbing) adhesives be used. Any adhesives should be free of ingredients such as sulfur, iron, and copper that might attack the silver image, gelatin or paper support. In addition, papers known to be harmful to books and artwork are also harmful to processed photographic materials.

Conservators can determine the suitability of materials for enclosing photographic artifacts by following one of several test procedures:

1. The test procedure outlined in ANSI Standard PH1.53-1984 describes a way to determine if there is any chemical interaction between the paper enclosure and the processed photographic material. This test is advised especially if technical data has not been published by the manufacturer with respect to photographic use.

2. The presence of chemical impurities such as peroxides and sulfides in materials being considered as protective storage for photographic artifacts can be determined by impregnating the material with hydrochloric acid.[27] This test has not been used or evaluated by Eastman Kodak Company. Strips of silver plate that have been carefully cleaned are then placed in contact with the material. Distilled water is added to the test chamber and the entire unit is heated for at least 8 hours at 75°C (167°F). Any discoloration of the silver surface indicates an unsafe material for enclosing photographic artifacts.

3. The Barrows Spot Test Kit[3] identifies materials that are harmful to processed photographic materials. The kit contains three solutions and an instruction book. A simple spot application identifies acid, alum, and groundwood. This test can be an invaluable aid to the conservator or technician who selects his own enclosure material.

Unsafe Materials. A number of materials often used in the storage of negatives and prints are detrimental to the image and its support. Unfortunately, the choice of containers and packaging materials is limited, and there is no easy way to determine whether or not a material is suitable for long-term storage unless it has an extensive history of suitability. The following suggestions are based on the best knowledge available at the time of this publishing, *but no assurances can be given, because manufacturers may change their formulations without informing the public.* Photography is a relatively young science whose lifetime is less than 200 years; experience with long-term keeping is thus limited. Moreover, there is a tendency to apply experience with the paper used in making books and ledgers to that used in making photographs and without supporting evidence such experience may not apply. For example, nonacid papers made for book archives may have an alkalinity that promotes increased life for books, but is suspect with some color prints. Among the materials known to be detrimental to photographs are wood and wood products, such as plywood, hardboard, chipboard, low-grade paper, glassine, and strawboard. There is also concern with chlorinated, nitrated and formaldehyde-based plastics, lacquers, enamels, materials that contain plasticizers, and residual catalysts that volatilize. Recommended materials are plastics that have been thoroughly investigated and shown to have archival properties such as triacetate and polyester films and polyolefins such as polyethylene and polypropylene. Damage to photographs is greatest when they are in direct contact with harmful materials but damage also occurs when the volatile elements contaminate the air in the immediate vicinity of the artifact or are present in enclosed containers. There is insufficient information on many other plastics and positive recommendations cannot be made. Low-grade paper cartons and wrappings, under improper storage conditions often yield hydrogen peroxide which can be very damaging (see the chapter on deterioration).

Cardboard boxes in which unexposed film, plates, and paper are packaged should not be used for enclosure materials. Packaging material which is suitable for unexposed sensitized materials may not be inert to processed materials. Other items that may be detrimental to processed photographic materials while they are in storage include rubber, rubber cement, and hygroscopic adhesives or those containing iron, copper, sulfur, or other impurities. Pressure-sensitive tapes and mounting material, as well as acid inks and porous tip marking pens that use water-base dyes should also be avoided.

The substances just mentioned may, singly or in combination, cause staining and fading or other degradation of photographs. The severity of these effects depends largely on atmospheric conditions in the storage area and on the amounts of residual processing chemicals in the photographs. Consequently, it is difficult to determine the effect of any one agent by itself without reference to all the others. Therefore, to allow for all of the factors that may influence the deterioration of a photographic image, the archivist should adopt an uncompromising attitude in selecting storage materials for valuable records.

Particular mention should be made of glassine in the list of unsafe materials used for enclosing photographic artifacts. This is a thin but fairly tough, glazed, nearly transparent paper that has been used extensively for negative envelopes and interleaves. During manufacture a transparentizing agent such as ethylene glycol is usually added to the product. With age and dry storage this material tends to become brittle and during subsequent handling may even shatter; conversely in the presence of high temperature and high relative humidity (90°F and 90% relative humidity), the transparentizers may exude and on coming in contact with the negative surface, cause ferrotyping. When glassine enclosures are found to be in a collection or when they must be used, they should be examined at regular intervals and replaced when deterioration is evident. Negatives that are stored in glassine enclosures should not be overstacked or overpacked in a container. Such conditions can produce pressure on the enclosure that will cause ferrotyping. If a file of photographic artifacts has been affected by water and the glassine enclosures have become fixed to either the emulsion or the gelatin backing or both, it is sometimes possible to remove the enclosure by soaking it in a KODAK PHOTO-FLO solution. This is only possible if the gelatin layers are not too soft.

Figure 70 Under conditions of high relative humidity, glassine envelopes may stick to the emulsion or the gelatin backing on negatives. Removal of the envelope defaces the negative as shown. Courtesy Thomas T. Hill.

Recommended Enclosures and Materials.

From the foregoing it is evident that the materials that can be used to enclose photographic artifacts safely are limited. However, negatives, prints, slides, and transparencies can be prepared for safe storage by placing them in a variety of appropriate enclosures. Storage materials that are considered harmless are described in the following text and most of them are available from archival suppliers. In the interest of providing conservators with complete information, sources of storage materials considered to be safe are given in an appendix to this publication. *References to products of other manufacturers should not be construed to constitute an endorsement, inducement, or warranty of their quality or performance. Moreover, since Kodak has no control over the quality of these products and the changes in manufacturing procedures that may vary from time to time, it assumes no responsibility for losses resulting from their use. Information regarding the suitability of a product for a contemplated use should be obtained directly from the manufacturer.*

Figure 72 A variety of materials are available for enclosing negatives. Illustrated above are a thumb-cut envelope made from non-buffered Renaissance paper, a seamless envelope made of the same paper, and a transparent uncoated polyethylene sleeve. Materials provided by Light Impressions, Rochester, NY. Jerry Antos.

Figure 71 A framed daguerreotype of Daguerre by Sabattier-Blot. To enclose this artifact safely, archival-quality corrugated board has been cut to size and built up in strips to fit the piece and enclose it. Then the piece was wrapped in an archival envelope.

Enclosures that are used by conservators for containing photographic artifacts for archival keeping include envelopes, sleeves, folders, interleaves, wrapping tissues and papers, albums, bags, boxes, and the files in which these may be stored. The enclosures may be open or sealed: open enclosures include sleeves, envelopes, folders, wrappers, jackets for enclosing individual items and albums; sealed enclosures include any device that is lighttight and impermeable. Not all of these enclosure designs are made from all of the materials discussed in this section. Some of those more commonly used are described in the following text.

Figure 73 Negative showing envelope seam stain on the negative emulsion. Courtesy Thomas T. Hill.

PAPER ENVELOPES. Envelopes made from the highest quality paper have proven to be the most satisfactory for enclosing photographic materials. High quality paper provides a stable material over a long period of time and it does not contain ingredients that will adversely affect an artifact in storage. The choice of the paper stock from which the envelope is made is very important. At one time it was thought that an all-rag paper was the only material that could meet the standards of purity necessary for long-term keeping; today, purified wood pulp papers with essentially the same characteristics as stable rag paper are available. These are acid-free, high-alpha-cellulose papers that are buffered against changes in pH.

Two very critical aspects of paper envelopes are the position of the glued seam and the adhesive used to seal it. Most older envelopes were made with the seam in the center, and it was usually sealed with a hygroscopic

animal or vegetable glue. As a consequence, the glue absorbed moisture from the air, which caused a band of stain to form across the artifact in a position corresponding to the seam of the envelope. This occurred particularly when the artifact contained residual processing chemicals. Buckling also occurred, due to pressure at the seam. The adhesive used to manufacture the envelope should, therefore, be nonhygroscopic and nonreactive. Polyvinyl acetate appears to be a suitable adhesive, but natural glues, pressure-sensitive adhesives, and ether-linked materials generally are not. Stain transference from the seam of the envelope to the artifact can be prevented by inserting the back of the item next to the seam and then using a sheet of acid free paper between the two. PermaLife® paper, manufactured by Howard Paper Mills, is suggested for this purpose. It has a pH of 8.5 and meets the specifications for black-and-white set forth in ANSI Standard PH1.53-1984. For color specifications see page 68.

A simple envelope that permits the negative to be viewed in place has been manufactured by G. Ryder & Co. Ltd. of the United Kingdom[27]. This envelope wraps around the negative in such a way that the emulsion side is placed against the back of the envelope and the sides and front of the envelope fold over it. This design avoids scratching or removal of a flaking emulsion that can occur when the "slide-in" type envelope is used. In addition, the envelope is made from a paper that is of photographic conservation quality and is available in standard photographic sizes.

KODAK Storage Envelopes for Processed Film.
These are heat-sealable envelopes made of aluminum foil that have been extrusion-coated with polyethylene on the inside and laminated to a paper on the outside.

Although recommended for the cold storage of processed Kodak color films, they serve the same purpose for the archival storage of other sheet films, photographic prints, and even as a temporary storage medium for cellulose nitrate films. They are appropriate for keeping in conditions of 70°F (21°C) or lower and a relative humidity of 25-30%. When photographic materials are stored in these envelopes under these conditions, the envelopes must be heat-sealed and certain precautions must be observed: (a) the materials must be separated and conditioned to the above temperature and humidity for at least one hour; (b) dissimilar materials should not be stored together—that is black-and-white materials should not be stored with color; (c) the materials should be inserted separately or in groups enclosed in sleeves with no interleaving; (d) each envelope should be limited to a maximum of 50 sheets of noninterleaved films or prints or to a thickness of 1.27 cm (1/2 inch); (e) the air should be pressed out before the envelope is sealed; (f) they should be stored in a manner that does not subject the contents to extreme pressure; (g) and the contents should be allowed to reach room temperature before the envelope is opened. These precautions apply to the use of all storage envelopes and not just to Kodak storage envelopes.

The most effective long term storage involves placing these envelopes (as indicated above) in storage vaults kept at as low a temperature as possible. It is not necessary to control the RH because this is a function of the envelope. Other alternative procedures have been considered such as storage in vacuum or in an inert atmosphere. These alternatives have not been adequately investigated to warrant positive recommendations.

Figure 74 KODAK Storage Envelopes for processed photo materials consist of a laminate of paper, aluminum foil, and polyethylene. Photo on the left shows an open envelope. On the right, the various layers are shown from bottom to top: paper, foil, and polyethylene respectively.

CELLULOSE ACETATE SLEEVES. Transparent enclosures such as cellulose acetate sleeves provide a way to view and handle photographic materials without removing them from the enclosures. They permit immediate identification and inspection of color transparencies and black-and-white negatives and prints while protecting them from scratches and finger marks. However, even though the acetate material of the sleeves is as durable as the film base itself, the glossy surface may cause ferrotyping or glazing of the gelatin surface as in the case of negatives. There is a transmission differential between the glazed patches and the rest of the negative, which produces density variations in a print from such a negative. Glazing generally occurs in high relative humidity that would not be considered as normal storage. Very extended keeping under conditions of very high relative humidity and temperatures may produce an "acetic acid smell." Acetate sleeves having this characteristic should be discarded. Eastman Kodak Company manufactures these sleeves in a range of roll and sheet film sizes for photographic artifacts. Although they are used extensively in the photographic trade and their use is satisfactory, good quality paper envelopes are preferred for long-term storage. Glazing or ferrotyping that can occur with plastic sleeves is avoided as is the extra cost of these materials.

FOLDERS. Single-fold seamless holders very much like manila file folders but made from acid-free, high alpha cellulose papers that meet the specifications of ANSI Standard PH1.53-1984 are also appropriate for enclosures. They are also available in triacetate, polyester, or polypropylene.

INTERLEAVES. These are either paper or plastic sheets that are used to separate individual artifacts one from the other.

WRAPPING TISSUE AND PAPER. These materials are available in large sheets or rolls and are used for wrapping and interleaving rolled prints and packets of artifacts. Prints and negatives can also be wrapped in, or interleaved with, the wrapping paper used by the manufacturer in packaging unexposed films and papers. This paper has been specially prepared to have no effect on the sensitized materials.

ALBUMS. A popular storage medium for prints with amateurs and conservators alike, albums are not suitable for long-term keeping, unless they are fabricated with materials that make them safe for this purpose. Usually they contain pages made of low-grade papers which can affect the stability of prints adversely. The conservator or the private individual can make albums

Figure 75 Albums are a common way for photographs to be stored. This is a wrapper for an album of calotypes. In the first photo, the calotype is shown in the open album on one page with the opposite page blank. The second photo shows the album closed in its open wrapper. The wrapper is made of archival material and tied with 100% cotton tape so the chemicals don't interact. Wrappers can be made to fit each individual situation. In the third photo the wrapper is tied for archival keeping. In addition to the wrapper a white piece of board is measured and trimmed to fit the object as additional support.

that are safe for long-term keeping by using 100 percent rag paper or mount board or by purchasing albums or ring binders that are made for this purpose. A ring binder made of polyethylene and plated steel that is appropriate for archival materials is available from the Quill Corporation; a photo album containing insert sheets made of special *Poly-C*® polypropylene is available from Daytimer's Inc.

BAGS, AND ESPECIALLY BOXES, of various sizes and design are available from suppliers.

OTHER MATERIALS. There are a number of other polyester and plastic materials that can be used in various forms to enclose photographic artifacts.

Polyester (Polyethylene Terephthalate). This is a film base material that can be used for interleaves, sleeves, and jackets. An uncoated polyester such as MYLAR* D film, offers a number of advantages: it does not contain a plasticizer, it is relatively unaffected by most solvents, it has low moisture transmission, it gives protection against large changes in relative humidity, it has low permeability to gases which provides protection against pollutants and it is physically tough.

Polypropylene. This is a plastic material that can also be used for storage. Enclosures of polypropylene are very resistant to environmental changes, they are very tough, are usually transparent, and are considered safe for long-term keeping.

Polyethylene. As far as is known, no deleterious chemical reactions take place when polyethylene enclosures without surface coatings are used with photographic materials. However, there are other problems that may arise: (1) glazing can occur when a negative and the polyethylene are under pressure; (2) if a fire occurs in the immediate vicinity of the storeroom, the low melting point of polyethylene compared to paper, acetate, and polyester is considered a negative attribute when considering it as an enclosure material.

*MYLAR and TYVEK are trademarks of E. I. duPont de Nemours and Co., Inc.

TYVEK*. This is a material made by spinning continuous interconnecting strands of very fine high density polyethylene and bonding the fibers into sheets under heat and pressure. The material looks like paper and is used for envelopes, interleaves, wrappings, and sleeves. It is said to be particularly useful in protecting the emulsion from ferrotyping due to high relative humidities and temperature in the storage area: photographic film stored in this material withstood temperatures of 60°C (140°F) and 70% relative humidity incubation for 14 to 28 days without adverse effect.[28] However, the seams must be sealed with a nonreactive adhesive or the processed material placed in folders that do not use adhesives. Tyvek has been used in astronomical observatories since 1972.

Laminate. Occasionally it is desirable to laminate processed prints or films to cellulose triacetate, MYLAR (polyester), or other safe plastic sheeting. Laminates provide excellent protection against fungus and bacterial attack, moisture, dirt, and objectionable gases in the air. Enough UV absorbers can be incorporated into the laminate to block essentially all ultraviolet radiation, thereby eliminating most, if not all, dye fading in color materials that is due to UV radiation. Not all laminates contain UV absorbers.

The laminate adhesive is very important with respect to the stability of the photographic image. The adhesive should not contain any ingredients that will be harmful to the print, film, or the laminate. There is insufficient data on the effects of lamination on long-term image stability and therefore no specific recommendations can be made for thermosetting, pressure-sensitive, or contact adhesives. However, where applicable, lamination can be accomplished using a gelatin as an adhesive. Those experienced in laminating techniques will be able to determine when gelatin can be used as an adhesive.

Identification of Photographic Artifacts for Storage

It is good practice to identify both the photographic artifact and the enclosure in which it is stored. In this way, if the enclosure is lost, destroyed, or becomes illegible, the material being stored in it will still be identifiable. Some forms of identification can cause deterioration of the image; for this reason it is important for conservators and individuals to be familiar with those techniques and materials that are considered safe from the standpoint of image stability.

If captions are used as a means of identification, the information should be copied onto high quality permanent paper such as any 100 percent cotton-fiber paper. Then the copy sheet should be separated from the image by a sheet of uncoated polyester or cellulose triacetate. An example of the former is MYLAR Film D; KODAK Sleeves are an example of the latter. When information or identification is made on the negative and/or print, polyester or cellulose triacetate sleeves should be used so the information can be read. The same information, including identifying numbers, should be included on all pieces. For more information on this subject see the section "Identifying Negatives and Prints" in the chapter on Collection Management. The following markers should be avoided in identifying artifacts: volatile dye markers, wax crayons, grease pencils, ball point pens, rubber stamps, or pressure sensitive labels and tapes. They may either transfer the marking substance to the emulsion layer, smear the message, or render it illegible. For satisfactory general use India ink is recommended for marking negatives and a No. 0 or No. 1 lead pencil is suggested for marking prints. Excessive pressure should not be used. The following materials are also suitable for use in marking negatives or prints:

1. KODAK No. 85 Black Ink for EASTMAN Visible Edge Numbering Machine.

2. KODAK Negative Retouching Pencil

Archival Storage Area Recommendations

Storage materials for the protection of photographic artifacts have been discussed. The area in which valuable records are stored is as important to assuring their longevity as are the materials in which they are enclosed prior to storage. Recommendations for establishing and maintaining an optimized storage area are outlined in this section. It may not be possible for all institutions, having or acquiring collections, to satisfy all of these recommendations. However, conservators should be familiar with the requirements for archival storage and try to achieve stepwise progress to these optimum recommendations. It is the conservator's responsibility to maintain good storage conditions for those artifacts that have not deteriorated and to prevent further damage to those that have.

Building Structure Considerations. Many of these factors are already known to those involved in conservation work but they are summarized here because of their importance to photographic collections.

LOCATION OF THE STORAGE AREA. The undesirable atmospheric conditions discussed in the chapter on deterioration can be avoided by obtaining a storage area on a main or upper level floor provided it is not in the attic. If this is not possible, the steps discussed in the following text will help to avoid the dangers inherent in these locations. Space should be available not only to house existing collections but to allow for future expansion. The storage area should also be located so that it is free of any duct work leading to or from areas—such as a restoration laboratory—where foreign chemicals or dirt are likely to be. These elements could be carried by the ducts into the storage area.

DAYLIGHT. A minimum of window area is advisable because of the possible effect of light on materials in a collection, especially color images. Windows should be covered with commercially available plastic sheeting designed to reduce ultraviolet and blue light. Such coverings can be applied on the outside or the inside but, in the latter case, only certain materials are considered safe. Some of these materials are polyester, polypropylene or cellulose acetate having an incorporated ultraviolet absorber. KODAGRAPH Sheeting is an acetate material that is appropriate for inside window covering; PLEXIGLAS UF-3 is a polyester material that is appropriate. Lighting in a storage area is an important factor especially with materials that are light sensitive and not enclosed in light-proof containers. The storage area should be illuminated for storage only and not for display or study of the artifacts. The lowest levels of visible light should be used. Ultraviolet radiation should be excluded. Heating of the photographic material due to the absorption of light including infrared radiation should be kept minimal. Tungsten room light is preferred to fluorescent lighting but it may not be the safest in the collection storage area. Recently developed high pressure sodium lamps have virtually no ultraviolet output, are low in heat generation compared to tungsten, have long life, high efficiency, high wattages for economical operation, and are usually installed as an indirect source. Should the orange color be objectionable, color-corrected 250-watt high pressure sodium lamps (such as Westinghouse "CERAMALUX-4") can be used with equal effectiveness.[29]

WATER CONTROL. There should be no water or steam pipes in the storage area particularly in the ceilings or walls adjacent to shelves or cabinets. There should also be no running water facilities immediately above the storeroom. Sprinkler systems installed for fire protection are another threat: a faulty sprinkler may operate without being exposed to great heat. For all these reasons, the preferred storage container should be airtight. However, if they are not airtight, they are

satisfactory if they protect the contents from water. File cabinets should be covered with plastic sheeting that will not degrade photographic images in order to prevent water from entering. Any boxes or containers of photographic records should be raised at least 6 inches above the floor to avoid possible damage from water on the floor. One of the dangers from an attic location is the water from a heavy rain or melting snow that can enter through a leaky roof, a situation that may go unnoticed until considerable damage has been done. Similarly, basement locations, besides being damp, may have burst water pipes or backed-up sewers during heavy and prolonged rain. Dehumidifiers may be helpful in overcoming some of these conditions. Their use is discussed on page 102.

ELECTRICITY. Old electrical wiring can be hazardous because of potential sparking or electrical short circuits that may lead to a fire. In very old buildings it is advisable to redo the wiring in the storeroom as well as in the areas adjacent to the storeroom. Certain electrically operated copiers should be located away from collection areas because of electrical sparking and ozone that may be emitted.

FLOOR COVERING, PAINT, AND INSULATION. These items should be carefully considered. Many plastic tiles and linoleums have ingredients that are volatile and therefore potentially dangerous to photographic images. Some polyvinylacetate formulations have been said to be satisfactory for floor coverings. Varnishes and paints are also suspect especially if they are oil-based. Water-based latex paints are satisfactory for walls and ceilings. Otherwise photographic artifacts should not be placed in the storeroom until at least five or six weeks after the painting has been completed and the paint is fully cured. For more information on this subject see the section entitled "Air Contamination," in the chapter on deterioration. In the case of insulation, polyurethane foam should not be used: polystyrene foam is recommended instead. If airtight enclosures such as Kodak Storage Envelopes are used, the concerns above do not apply.

FIRE PREVENTION. A great deal has been said about protecting photographs from deterioration by chemical agencies, but this kind of damage is relatively slow and it can be prevented or arrested if observed in time. Damage by fire and the water used to extinguish fire is usually sudden and total. Noncombustible materials should be used wherever possible in the construction of the storeroom as well as for the fittings and fixtures. Fire prevention is particularly important when a considerable quantity of nitrate-base film is stored. For advice on the subject of fire prevention, consult the National Fire Protection Association, 470 Atlantic Avenue, Boston, Massachusetts 02210.

CONTROL OF DUST. The presence of dust is often overlooked in the storage of photographs, but it is probable that some forms of deterioration can be attributed to reactive particles of various substances that become airborne and find their way into any but the most efficiently sealed containers. It would be difficult to determine if any particular spot or blemish on a print or a negative was caused by a particle of some kind, but since the possibility exists, some attention should be given to the control and filtration of air being distributed to the storage area. Aside from particles that might be chemically reactive, dust often contains abrasive materials that might damage films. Fungus spores are also associated with dust particles. For information on the effect of fungus in the deterioration process, see the chapter entitled "Deterioration." Large particles can be trapped by ordinary air filters if the filters are kept clean and changed frequently; smaller particles, such as those in tobacco smoke, are not easily contained. People are responsible for significant amounts of dirt. They track it into a room and move it about as they move. They shed lint from their clothing and particles from their hair and skin. To minimize dirt from these sources, good housekeeping should be practiced and smoking, eating, and drinking should be prohibited in a storage area.

In the event of a major disaster, such as the occurrence of volcanic ash, the following action should be taken: the air intake system should be shut off and the inside air should be recirculated until the danger is over; the roof should be hosed down and the filters replaced; the exterior walls should be hosed off and mats placed inside all building entrances; all vents to negative and print storage areas should be closed; plastic bags should be put over any film equipment and lenses; all items coming into the building should be cleaned.

Atmospheric Conditions in the Archival Area.

When atmospheric conditions in the storage area cannot be maintained within the recommended tolerances of temperature, relative humidity, and cleanliness, appliances to humidify, dehumidify, cool, or clean the air are necessary.

HUMIDIFICATION. Humidification is rarely necessary unless the relative humidity in the storeroom falls below 15 percent for extended periods. This condition frequently occurs in temperate climates during the winter when the incoming air is heated. If the heating system does not include a means of humidifying the air, a separate automatic humidifier should be installed in the storeroom and the humidistat set to maintain a relative humidity of about 40 percent. Since the humidity control on such appliances is usually not calibrated in terms of relative humidity, the value should be checked with a sling psychrometer or a wet-and-dry-bulb thermometer. To avoid the somewhat time-consuming operation of using a sling psychrometer, a good-quality hair hygrometer can be used if it has been checked against the more accurate instrument. The water in a humidifier can be replenished manually, or the water level can be kept constant by piping the water supply to the appliance and using a float valve to control it. However, this latter method entails some risk of flooding, because a sticky float valve may fail to shut off the water. For trouble-free operation of a humidifier, always keep it clean and free from the calcium deposits left by the evaporation of water. If the appliance has a water tank, it should be kept clean to prevent the formation of biological slime that may decompose to produce hydrogen sulfide (see page 51). Trays or other vessels of water or chemical solutions are not recommended for humidification because of the risk of over-humidification.

DEHUMIDIFICATION. In situations where the temperature remains at 10-16°C (50-60°F) for long periods, the relative humidity is likely to be 60 percent or even higher. Such conditions exist in basements, caves, or in the lower part of large stone buildings. As stated previously, the use of a basement is not recommended, although it may be unavoidable in some circumstances. When the relative humidity approaches the acceptable maximum, a dehumidifier is necessary. An electrical, refrigeration-type dehumidifier controlled by a humidistat is the most suitable unit. The condensate should be piped from the unit to a drain carrying it outside the room; otherwise, constant attention is needed to avoid the risk of overflow. The use of silica gel or other desiccants is not recommended for permanent installations unless there is no alternative. Desiccants

create the risk that fine dust, either abrasive or reactive, may come in contact with the stored material. Also, they require constant renewal or treatment. However, silica gel can be used to protect a small quantity of material from dampness if no other means of dehumidification is available. Such an occasion might arise when a quantity of negatives is transported from one location to another in a very damp climate. See page 80, "Using a Desiccant" and ANSI PH1.43-1983.

AIR CONDITIONING. Although appliances for adding moisture to or extracting it from the air are useful in many cases, the most satisfactory system is complete air conditioning with equipment that is capable of maintaining the proper levels of temperature, relative humidity, and freedom from contaminants. This equipment is necessarily expensive, but in any situation where the photographic material is sufficiently valuable, the cost is justified. The following discussion about air conditioning is of a general nature; more specific information from an air-conditioning engineer is essential in order to match the equipment to the conditions and the requirements of the particular situation. There are engineering firms with considerable experience in the design and installation of air conditioning equipment for the storage of valuable photographic records. (See the appendix for the names of these firms.)

Window, or household, units are not suitable for an archival storage area. One reason is that they must be vented to the outside of the building and then preferably on a north-facing or well-shaded wall. Although these units extract some moisture from the room air, they do so mainly when the compressor is operating. When the compressor shuts off automatically at a preset temperature, the fan continues to run and moist air is blown back in to the room over the wet cooling coils. This may cause the relative humidity in the room to rise above the desired value. If a portable air conditioner must be used, one should be chosen that does not have a much greater cooling capacity than the size of the room demands. The compressor will then operate for longer periods than it would if the capacity of the unit exceeded that needed to cool the area. In any case, the relative humidity should also be checked and if it is consistently too high, a dehumidifier should be in-

stalled as well. An air conditioner should not be turned off over the weekend; the humidity will increase in the storage area and in a period of 12-48 hours this could result in an increase in the moisture content of the artifacts.

Whatever type of air-conditioning unit is decided upon, it should be capable of maintaining both relative humidity and temperature within specified limits throughout the year. An upper limit of about 20°C (70°F) with RH between 20-50 percent is satisfactory for black-and-white materials. The most appropriate temperature and relative humidity for long-term storage of color materials is a temperature as low as is convenient to maintain with a relative humidity between 25-30 percent. Color materials should also be kept in the dark when not being viewed. Where considerable quantities of nitrate film base are stored, a lower temperature, 10°C (50°F), is desirable, and the upper limit of relative humidity must not be exceeded. A lower limit of 20 percent is desirable; otherwise, the film may become too brittle. This risk is not as important with single negatives as it is with motion picture films. Excessively low relative humidity is generally not a problem in conditioning air at relatively low temperatures—10°C (50°F) to 21°C (70°F). On the other hand, maintaining an acceptably low RH with air that has been cooled to 10°C (50°F) or lower is a more difficult matter, and the initial cost of suitable machinery is high. This is not only because extra cooling capacity is needed but because a second stage of cooling and reheating is required to remove moisture from the air. *For archival storage of negatives and prints, the limits of temperature and relative humidity given here are necessary.* However, when economy in air-conditioning equipment is of greater importance, the limits can be relaxed to some extent, provided that an RH exceeding 60 percent does not prevail often or for more than a few days.

A slight positive pressure should be maintained within the storage area to prevent untreated air from entering it. The air conditioner should preferably be located outside the storage area for ease of maintenance, inspection, or repair in case of breakdown. A high-quality unit should be purchased to eliminate frequent repairs or replacements. All ductwork as well as the conditioner housing should be insulated. Ducts carrying air from the unit or from the storeroom should have automatic fire-control dampers.

When air conditioning is not available, certain types of household refrigerators or freezers can be used to provide safe storage of valuable films or prints. This approach provides custodians and collectors with an inexpensive and practical means of humidity-controlled cold storage for either black-and-white or color materials. Modern frost-free units can maintain a temperature of about 1.5°C (35°F) and a relative humidity

of 25-35 percent regardless of the ambient humidity and temperature levels. Only the refrigerator compartment of these units should be used because the freezer compartment maintains high humidity levels. Units described as "cycle defrost" or that have manual defrost freezer sections maintain 90-100 percent humidity levels and are not recommended. Neither are home freezers. Prints or films should be placed inside appropriate enclosures to protect them from changes in relative humidity when the door is opened. When removed from the compartment the boxes of films or prints should immediately be placed in a plastic bag to prevent moisture condensation. The details of unit design and of storage of photographic materials are quite extensive and important. Further information can be obtained from literature on the subject. The custodian should be familiar with these procedures before purchasing or using a frost-free refrigerator or freezer.

In the event of a power failure, the unit should be kept closed until the power is restored; if this time exceeds 48 hours the door should be opened until the power is restored. Loss and deterioration can be prevented by the use of a Sound/Off Monitor which emits an attention-getting, 45-decibel, alternating beep tone when the power goes off. It contains a 9-volt battery that is good for 3 days and is available from laboratory supply houses such as Fisher Scientific or VWR Scientific.

Archival Storage of Films, Plates, and Prints. The recommendations for the storage temperature and humidity of films, plates, and prints are a temperature of 21°C (70°F) and a relative humidity of 30-50%. Cycling of temperature should not exceed 4°C (7°F). The special considerations applying to nitrate-base negatives are discussed in the chapter on deterioration. The archival storage of color materials is discussed in Chapter VII.

The above temperatures and measurements of relative humidity will provide very good storage conditions for long-term keeping of black-and-white materials but storage of color materials in a freezer is preferred for maximum long-term keeping.

To provide uniform humidity in storage drawers and cabinets, ventilators should be provided in the storage area and incoming air should be filtered to remove as much dust and foreign material as possible. In large cities, particularly those in which iron and steel are manufactured, the air may contain relatively large amounts of sulfur dioxide and other gases—consequently some means of cleaning the air in the storage area is recommended.

Generally, processed materials should never be stored in contact with or in the same files with any of the following: nitrate-base films; blue prints; diazo ma-

Figure 76 An archival storage vault installed at the Art Institute of Chicago by Harris Environmental Systems, Andover, MA:

(1) interior of the vault with the evaporator in the room.

(2) entrance to the vault in the precondition area. Storage shelves are in the foreground.

(3) the mechanical room serving the vault.

(4) the control panel and automatic recorder for humidity and temperature. Photographs courtesy Doug Sieverson, Art Institute of Chicago.

terials; vesicular films; stabilized or other rapidly and poorly processed records not intended for long-term keeping; any material showing signs of deterioration, staining or discoloration; and magazine or newspaper clippings. Black-and-white negatives and prints should not be stored in close proximity or interfiled with color negatives, color instant prints, transparencies, slides, or prints.

FILMS. When black-and-white negatives on acetate or polyester film base are properly processed, and are protected in storage from the effects of heat, moisture, oxidizing gases, and reactive storage materials they are extremely stable articles. In those cases when the original is expected to be a *permanent or archival record*, that is to be *stored safely* for a long, long time, it should be stored in a KODAK Storage Envelope for Processed Film. Acetate and polyester film negatives should be stored in a fire-resistant vault for protection against outside fire and be constructed and equipped according to the recommendations of the National Fire Protection Association. Such vaults should also be designed to provide very low temperature storage conditions particularly when color materials are being stored (see the section on air conditioning earlier in this chapter).

PLATES. Glass is the most stable of the materials used as a support for photographic images. However, glass plates present problems because of their weight, bulk, and fragility. For these reasons, they should be stored vertically with rigid dividers between them at frequent intervals. Each plate should be stored in its own enclosure. Glass plates, or for that matter processed films and prints, also should not be stored in the original boxes in which they were sold. These boxes are not designed or formulated for archival storage. Since most plates are comparatively old, they may show some signs of deterioration in the form of yellow stain, silver sulfide deposit, or dichroic silver stain, particularly around the edges of the negatives, where air has been able to penetrate the packaging. Very often, individual envelopes were not used, and the plates were stored without any protection other than the boxes. This permitted the formation of silver-sulfide stain around the edges of the plates. This type of stain is largely a surface deposit, which can be partially removed by polishing or by chemical treatment, whichever seems more suitable. See ''Procedures for the Removal of Stains,'' in the chapter on restoration.

PRINTS. The same conditions are required for the storage of prints as are required for films on acetate or polyester base. Prints should not be stored in wooden boxes or wooden filing cabinets, nor should they be kept in boxes made from cardboard, except those made especially for archival storage. Cabinets and other containers made from wood or wood pulp contain noncellulose materials, such as lignins, waxes, and resins. These materials oxidize or break down in time to produce acids and other substances that migrate to any material that is in their immediate vicinity. Moreover, the peroxides released by the bleached wood often used for storage cabinets, as well as the residual solvents from varnishes, can cause substantial damage to photographic prints. Fireproof containers such as enameled steel, stainless steel, or anodized aluminum are preferable, and they may be necessary to meet fire regulations for the storage of valuable records. Prints should not be stored in contact with one another nor with the backs of the boards on which other prints are mounted. Each piece should be interleaved with high-quality paper or transparent plastic sheets made from uncoated cellulose acetate, polyethylene terphthalate, polypropylene, or TYVEK (see the section on storage materials in this chapter).

Display of Photographic Prints

Unlike negatives which are usually stored for most of the time, prints are often displayed or put in open view. A print may be considered a work of art or it may be the only representation of a particular subject in exis-tence. In any case, if it is considered worthy of exhibit it must be protected during display and the handling that display entails. The display of photographic prints is discussed in this section; additional information may be obtained by referring to ANSI Standard PH1.48-1982 "Photography (Film and Slides)—Black-and-White Photographic Paper Prints—Practice for Storage."

Making Prints for Exhibition. The following suggestions are intended for those who make their own prints or can set specifications in ordering prints from a supplier. Exhibition prints may be made specifically for the purpose, or prints from a file may be prepared for exhibit. The extent of the effort to be put into processing for stability is dictated to an important degree by the estimated future usefulness and value of the prints. When possible it is advisable to process for long-term or archival keeping to avoid a possible need for reprocessing. When existing prints are involved, especially old ones, consideration must be given to their present value and the risk of damage if any additional processing is undertaken to prepare them for exhibition. In this case it is preferable to make a copy negative of the original. New prints can then be made from the negative thereby preserving the original from any damage. Prints should not be large. There are two reasons for this: large prints are more easily damaged than small ones and small- or medium-size prints are easier to store, particularly if they are mounted on boards of uniform size. Many custodians favor prints not larger than 28 x 36 cm (11 x 14 inches).

Figure 77 The print display area at the International Museum of Photography at George Eastman House showing the correct display of prints. Photo by Don Buck, Eastman Kodak Company Photographic Illustrations Department.

MOUNTING. There are differences of opinion concerning the need for mounting prints. Some custodians reason that unmounted prints occupy less space, involve fewer materials that might prove deleterious to the images, and can be readily reprocessed if it should become necessary. On the other hand, mounting provides rigidity, prevents wrinkling, gives a degree of physical protection, and is preferred when prints are prepared for sale or display. Vintage prints that are in a collection should never be mounted. The original should be kept in safe storage as described in this chapter and a copy duplicate made for display purposes. When prints are mounted, it is recommended that the materials used for mounting be marked on the back of the mount. One mounting technique that has been used successfully by some conservators to provide flat mounts for rigidity, physical protection, and filing involves using unexposed and processed photographic paper of the same weight or thickness as the finished print. The prints are mounted back-to-back on it. When long-term keeping is an objective, it is essential that the mount be of archival quality. (See the following section for a description of archival mounting support.) In any case, the mounting of contemporary or newly made prints and the method of mounting is the responsibility of the custodian.

Mounting Materials and Techniques. There are two broad classes of mounting based upon the intended use of the mounted print—archival or conservation mounting for long-term preservation and decorative or utility mounting for short-term display. The primary concern in this book is archival or conservation mounting of prints.

Mounting Support. There are a variety of supports and methods that can be used for mounting prints. Ideally, the technique employed should be reversible. One professionally preferred method of mounting is the use of paper hinges or acid-free corner pockets. This technique allows for subsequent safe demounting and print inspection. However, through the years and even to the present time mounting board has been the most widely used. During the nineteenth century and well into the twentieth century, mounting boards did not meet the quality standards of present day products. Because much of the photographic processing done during this time was inferior and left damaging chemicals in the photographs, the degrading effect of these chemicals overshadowed most changes in the mountboard. Nevertheless, there have been many artifacts that showed the staining effects of mount board decomposition. A paper product that is being considered for use as a mounting board should be free of groundwood, alum, or alum-rosin sizing and have a pH value very close to 7.0 or very slightly higher. Most of the mountboards considered satisfactory for photographic use have been designed primarily for museum use. Generally, they are acid-free and buffered within the pH range 7.0 to 9.0. Even though the pH may be within this range an excessive amount of buffer can be harmful. One such mountboard contained 10-100 times the average concentration. Color prints stored for only a few months on this material showed considerable damage.[30] A test for total alkalinity could have prevented the loss. Several excellent boards are made of 100 percent cotton fiber and purported to be free of chemical compounds which would damage photographs during periods of intended use. One such product is Archivart Photographic Board. This is a 4-ply, 100 percent cotton-fiber material that is unbuffered, has a neutral pH, and is manufactured specifically for photographic use.

There are several other inert supports for mounting prints. They are clean glass, polyethylene, polystyrene, cellulose esters (KODACEL Sheeting), polyesters (MYLAR and ESTAR Base) and archival mounting board such as Acid Free Mounting Board from Light Impressions Corp. Other support materials that might be considered are listed in the appendix; however, they require testing.

Adhesives. There are many reasons for sticking or attaching one object to another permanently or temporarily. The chemical means for accomplishing this is an adhesive which may be available in a number of forms such as a thermoplastic tissue, brush-on liquid, spray-on liquid, or a pressure sensitive two-sided tape. Whatever the form, the adhesive layer should be soluble in an innocuous solvent so it can be easily removed.

Dry Mounting Tissue. This is the recommended adhesive for conservation mounting. These tissues are used for mounting prints because the tissue provides a barrier between the mount and the print; the print is kept flat edge-to-edge; and the method is quick and easy. A smooth-surface board provides the best mount especially for glossy prints and avoids the possibility of the "orange peel" effect. Prints, whether mounted or not, should be interleaved in files to prevent contact between the back of the mountboard and the face of an adjacent print.

Two types of dry mounting tissue are recognized by American National Standard (ANSI) PH4.21-1979®, "Specification for Thermally-Activated Dry-Mounting Tissue for Mounting Photographs." Type 1 tissue is a permanent type and deliberate detachment of the print from the mounting surface at normally used temperatures (80 to 135°C [175 to 275°F]) is not possible without causing injury to the print or the mounting surface. Type 2 is a thermally detachable type of tissue that

allows demounting of the print from the mounting board upon reheating. Information on methods of demounting can be found in the chapter on restoration.

KODAK Dry Mount Tissue, Type 2, provides an adhesive for mounting color and black-and-white prints made on Kodak papers. The surface temperature of the mounting press platen should be between 82-99°C (180-210°F). This Type 2 tissue was formulated for use with RC papers but it can be used to dry mount fiber-base prints with the same platen temperature. In any case, the prints and the mountboards should be kept dry or free of any excess moisture and the manufacturer's instructions carefully followed. When low humidity exists or changes in humidity occur, there is the danger of mosaic cracking of the emulsion on prints that have been drymounted. See Figure 25 for an example of mosaic cracking.

Other Adhesives. There are other adhesive materials which are used frequently and recommended for conservation mounting. Some of these may be satisfactory. However, the solvents and techniques used with these materials should be investigated since images can be attacked through the base side of the print. In addition, the manufacturing design and formulation can change without notice. Some of these products are listed in the following sections but they should be tested for archival keeping with photographic materials before being used for this purpose. The Photographic Activity Test described in ANSI Standard PH1.53 is recommended for this test. While there are some concerns about the test, it is the best method for testing the use of these products, at this time.

Double-sided Pressure Sensitive Adhesives. 3M Positionable Mounting Adhesive #567 and Ilford Mounting Panels are used in the "cold-mount" method. This method is similar to the dry mounting tissue method but does not require the application of heat. These products are pressure-sensitive, double-sided adhesives that are positioned first on the photograph and then rolled or squeezed to bond the adhesive to the print. After removal of the liner, the other side is then bonded to the mounting board by rolling or squeegeeing.

Adhesive Tapes. These generally are narrow width tapes used to attach labels or other data to mounts and enclosures. 3M SCOTCH No. 810 Magic Transparent Tape is a pressure-sensitive tape that consists of a cellulose acetate backing and a homogeneous, synthetic acrylic polymer coating of pH = 7.0 that does not discolor or dry out with age. Rohm & Haas markets an adhesive ACRYLOID B-72 Tape and a polyvinyl acetate tape both of which are colorless and soluble in their original solvents for more than 200 years based on accelerated testing. Experience so far indicates that well-buffered

polyvinyl acetate adhesives can be used with paper. ELVACE 1874, distributed by Talas, is a polyvinyl acetate emulsion adhesive that is satisfactory. A gummed linen fabric tape (often called HOLLAND Tape) is also considered appropriate.

Since little data are available to indicate archival qualities of adhesive tapes, it is suggested that such tapes not be used in direct contact with a photograph in order to avoid possible discoloration, staining, or other damage.

Undesirable Adhesive Products. Starch paste, animal glue, rubber cement, shellac and contact cement should not be used. Water-base pastes and shellac were common in the nineteenth century. Rubber cement generally contains a large amount of sulfur which will cause staining. Synthetic adhesives generally are not recommended whether in the form of tapes or spray-ons. The solvents may cause print staining. Nevertheless, efforts

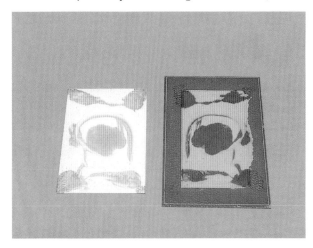

Figure 78 A print that has deteriorated as a result of adhesive used in the mounting: Note: (1) yellowing in the middle of the image in the bottom photo; (2) the adhesive and stain on the back of the print in the top photo left; and (3) the effect of the adhesive on the mount in the top photo right. Note the relationship of the yellow area in all three pieces. Courtesy Thomas T. Hill.

continue to produce adhesives that the manufacturer considers safe for use with photographs.

Despite warnings to the contrary, some photographers insist on attaching prints with an adhesive onto materials such as tempered compressed hardboard and using this as a substrate on which to mount prints. Since materials of this type can release solvents and hydrogen peroxide, prints mounted on these supports are in danger.

There are several adhesives that have been used for mounting photomurals and large black-and-white prints onto substrates such as walls. These adhesives can be used on both fiber-base and RC papers. Prints mounted in this manner are not considered prints for long-term keeping; that is they are considered expendable after a short period of display time. Further information on these applications can be found in KODAK Publications G-12, "Making and Mounting Big Black-and-White Enlargements and Photomurals," and E-67, "Finishing Prints on KODAK Water-Resistant Papers."

BORDERS. Examination of many old photographs indicates that those mounted with wide borders on the mount often suffer less from atmospheric deterioration than those with narrow borders. For this reason, it is desirable to mount prints with borders about 8 cm (3 inches) wide at the top and sides, and about 9 cm (3 1/2 inches) wide at the bottom. Since mounts are often damaged in shipping and handling, the wide borders allow for some trimming of damaged edges.

MATTS. Of significant importance in the conservation of photographic prints, matts serve as dual-purpose storage and display housings. They are hinged overlays consisting of a window with beveled edges cut in the center of a piece of conservation matt board which is larger than the print. The matt protects the print in storage and while on display from contamination by atmospheric gases, other materials or prints that might come in contact with the print. It also provides a border in a frame. Suitable plastic protective sheets that can be used for this purpose include cellulose triacetate and polyester, both without any surface coating.

LACQUERS. Print lacquers provide physical protection from fingerprints and fungus attack, and they act as a temporary moisture barrier. The use of a lacquer will also help prevent the emulsion of a print from sticking to the glass or whatever material that is used as an overlay, matt or an interleaving. Since lacquer formulations vary, only a lacquer designed for photographic applications should be used. Vintage prints in a photographic collection should never be lacquered. For more information on lacquers, see Chapter VII.

FRAMES. Photographs that are going to be displayed for more than a few months should be framed for protection against physical damage, the accumulation of airborne dirt and grease, and especially against oxidizing gases and other pollutants. Glass or an acrylic material, such as PLEXIGLAS, LUCITE or PERMACRYL is often used for the face of the frame. The latter materials are less prone to develop an electrostatic charge than glass, and ferrotyping of the print surface is less likely to occur should the conditions become humid or should the picture be hung on a cold wall. Aluminum or stainless steel framing materials are preferred for long-term keeping. Frames made of wood, especially bleached wood may cause problems. Varnished, stained, or oiled frames should be avoided: there are no known "safe" wood sealers.

The material that is used as a backing in a frame is important. Natural or anodized aluminum and high-quality mountboard are preferred. When aluminum is used, a sheet of acetate, polyester, or polypropylene should be placed between the print back and the aluminum sheet to prevent soiling from dirt and/or oil from the aluminum. The use of pressed woods, such as plywood and masonite, is not recommended. Raw woods contain oxidizing agents and other substances that will stain the mount and, in time may affect the print. For this reason, when there is no alternative to wood, a sheet of cellulose acetate or polyester should be placed against the back of the print and the wood backing should then be wrapped in aluminum foil. The foil is placed over the inside area and fastened around the edges. (The back side should not be sealed to permit some ventilation.) Instead of aluminum foil, an acetate or polyester sheet or a high-quality mountboard can be used as a barrier layer but these are not as effective.

Effects of Lighting. Black-and-white prints that have been processed properly suffer little from exposure to light for several years provided the following conditions do not occur and certain precautions are observed. Long-term exposure of prints, family portraits, etc to light sources rich in ultraviolet radiation, such as fluorescent tubes or direct daylight, may cause stains to develop in the photographs. Photochemical deterioration of the paper base and/or gelatin can produce decomposition products that will affect the silver image as well as the nonimage areas. Tungsten filament spot lamps require heat filters. An increase in temperature greater than 1°C (33.8°F) in 10 hours is unacceptable in a display area. Daguerreotypes, ambrotypes, and tintypes were sometimes colored with fugitive pigments. Albumen prints were often colored with dyes and the paper base tinted with dyes that had very poor light fastness. Objectionable dye fading has been observed in the artifacts after only 4 months exposure to

between 54 and 108 lux (5 to 10 footcandles) of tungsten illumination with ultraviolet radiation being filtered out.

For display purposes, tungsten illumination is preferred but whatever light source is used, it should be no more intense than is necessary to provide adequate viewing. An intensity between 54 and 160 lux (5 to 15 footcandles) of incandescent lighting is considered adequate.

Actual keeping data has been available for fiber-base paper for at least 100 years but only for 20 years for resin-coated (RC) paper. This is one reason why fiber-base paper is recommended for prints that are designated for long-term keeping. Light is the main cause of deterioration of color prints on display even when strong blue light and ultraviolet are eliminated. Valuable color originals should not be displayed but copies should be made of the originals; the copies should then be used for display purposes, and the originals and copy negatives kept protected in files. In the case of black-and-white prints that are designated for long-term display, a negative should be made and carefully filed before the prints are put on display, if negatives do not already exist. When originals, either black-and-white or color, are displayed in display cases, the cases should be illuminated from the outside to avoid heat buildup within the case. If this is not possible, the light source should be sealed off from the display area and be well ventilated. This applies to nineteenth century artifacts as well as contemporary ones. See Chapter VII for more detail on lighting effects on color materials.

Chapter X Preservation Through Photographic Reproduction

The reproduction of photographic images by copying and duplicating is one of the principal ways of conserving photographic artifacts. Two-dimensional, reflective objects such as photographs, paintings, maps, printed matter, and drawings can often be improved by making photographic copies of them. For the photographic conservator, *copying* can be particularly helpful in pre-serving discolored, stained, and faded prints; daguerre-otypes, ambrotypes, tintypes, calotypes and albumen prints; as well as numerous kinds of black-and-white and color prints. *Duplicating* makes it possible to make corrections and changes to original transparent materials such as negatives, positives, and transparencies by producing photographic duplicates. It also provides a way of producing copies in quantity.

Figure 79 Restoration of a faded EKTACHROME Film transparency. The image on the left is a copy of the faded transparency; the image on the right shows how the same subject appears after precise photo reproduction.

Figure 80 Preservation of an old family photograph through copying. The original photo on the top is as it appeared with cracks, breaks in the emulsion layer, abrasion, and possibly mold or fungus. On the bottom, the final print after photographic reproduction. To achieve this, an internegative was made on KODAK Professional Copy Film 4125 ESTAR Thick Base. A print was then made from the internegative and necessary air brushing and retouching was performed on the print. Then a second copy negative was made from which the final print was produced. Courtesy of the family of the late William Puckering.

There are other reasons why copying and duplicating techniques are important to the conservation of photographic artifacts: (1) to convert a potentially unstable record into one having improved stability; (2) to make an exact duplicate or facsimile for use so the original can be safely filed; (3) to preserve valuable information without particular concern for producing a facsimile copy; (4) to produce an improved rendition of the original by removal of stains, cracks, tears, etc; (5) to improve poor tone reproduction (for example, duplicating high contrast, wet-plate negatives by reducing contrast in the duplicate to print better on present day materials); (6) to provide a photographic record of an artifact prior to physical or chemical treatment of the original; (7) and to make a record of the steps taken during the restoration procedure.

This section explains the application of copying and duplicating techniques in the preservation of black-and-white and color images of old and contemporary photographic prints, negatives, and transparencies. These procedures are not the same as the copying and restoration work offered by many professional photographers who either do the work themselves or send it out to a specialist. Their work involves making copies, miniatures, or even tinted copies from old and damaged pictures often of a familial or of a sentimental nature. Besides copying to the desired size, they spot, etch, do pencil work, airbrush to repair cracks and soiled areas, reconstruct missing portions, and remove figures or details. These artistic techniques are often incorrectly referred to as restoration. They are not recommended for use on archival collections. The cost of the photographic work and hand finishing is high and the artwork, however skillfully it may be done, tends to detract from the authenticity of an original image. Duplicating and copying as described in the following text is not intrinsically difficult and it is not expensive. However, experience with and knowledge of various techniques and materials is helpful in working with the many different types of originals that the conservator may encounter. These techniques and materials as well as explanations of the procedures mentioned in this chapter are described in detail in the KODAK Publication M-1, *Copying and Duplicating in Black-and-White and Color.*

Black-and-White Reproduction Techniques

Copying Black-and-White Prints. Before copying, duplicating, or restorative techniques can be applied to a photographic artifact, any surface dirt on the emulsion or support side of the artifact must be removed. The cleaning of artifacts is described in detail in the chapter on restoration.

CLEAN PRINTS. Clean black-and-white prints can be copied on a negative film to produce an internegative from which the final print is made. Regular camera films do not have optimum tone reproduction characteristics for copying. Special copy films are recommended in order to provide the best reproduction of the original. These films are KODAK Professional Copy Film 4125 (ESTAR Thick Base) and KODAK Ortho Copy Film 5125. Originals larger than 11 x 14 inches cannot be copied in the 35 mm format without loss in image quality because of limitations of the optical system. Sensitized films are not affected by these limitations.

DISCOLORED AND STAINED PRINTS. Stain removal from a negative or print by chemical means entails some risk of further damage to the original. Therefore stain removal by photographic means should be tried first. This involves making a photographic copy of the original by using a panchromatic film and a filter that is the same color as the stain. In the process, the effect of the stain can often be reduced or even eliminated. Almost any color stain can be removed in this way except a stain that has a muddy or black composition. The best filter usually makes the stain disappear when viewed through the filter but this may not be possible if the stain contains some gray or black. It may be necessary to resort to a chemical or physical treatment of the copy negative or a print made from it. This is described in the chapter on restoration. Even then, a protection copy of the original is required and the use of a filter to do this, will at the least, reduce the effect of the stain.

Some of the films, developers, and filters recommended for copying some selected discolored or stained originals are summarized opposite. The strength of the developer, the filter required, and the filter factor all depend upon the color and the degree of color change.

Figure 81 Eliminating or reducing stains on originals by the use of filters and copying on an appropriate panchromatic film such as KODAK Technical Pan Film.

This old drawing was mounted in an overlay. The exposed area had turned yellowish in color, while the protected area remained white. This copy was made without filtration.

This copy was made with a red filter, KODAK WRATTEN Filter No.25. The filter has lightened the yellowed area in the copy.

Many reddish-colored stains mar this old photograph. This copy was made without a filter on KODAK Technical Pan Film.

This copy, also on KODAK Technical Pan Film, was made through KODAK WRATTEN Filter No.25 (red). The filter has lightened the stains considerably, making them easier to retouch.

Discoloration or Stain	KODAK Film	KODAK Developer	KODAK WRATTEN Filter
B/W Prints with Yellow/Brown Discoloration in Dark Tones	EKTAPAN Film 4162 (ESTAR Thick Base)	DK-50 or HC-110, Dilution B	(47B) Blue
	PLUS-X Pan/5062 (35 mm)	DK-50 or HC-110, Dilution B	
	Technical Pan Film 2415*	HC-110 (various dilutions), D-76 or TECHNIDOL‡	
B/W Prints with Image Faded to Yellow	Commercial Film 4127/ ESTAR Thick Base	D-11, D-192, or DEKTOL	(47B) Blue
	Contrast Process Ortho Film 4154 (ESTAR Thick Base)	D-11, D-192 or DEKTOL	
	Technical Pan Film 2415*	D-11, D-19, or DEKTOL	
B/W Prints with Yellow or Reddish Brown Stains	PLUS-X Pan/5062 (35 mm)	HC-110, Dilution E	(25) Red and/or (12) Yellow
	EKTAPAN Film 4162 (ESTAR Thick Base)	HC-110, Dilution E	
	Technical Pan Film 2415*	HC-110 (various dilutions) or D-76	
B/W Prints with Colored Stain from Ink or Dye	PLUS-X Pan/5062 (35 mm)	HC-110, Dilution E	Use Filter of Same Color as from Ink or Dye Stain
	EKTAPAN Film 4162 (ESTAR Thick Base)	HC-110, Dilution E	
	Technical Pan Film 2415*	HC-110 (various dilutions), D-76, or TECHNIDOL‡	
Brown Toned B/W Prints with Stains	EKTAPAN Film 4162 (ESTAR Thick Base)	HC-110, Dilution E	Use Filter of Same Color as Stain
	Technical Pan Film 2415*	HC-110 (various dilutions), D-76 or TECHNIDOL‡	
Ambrotypes/Tintypes with Stains	SUPER XX Pan Film 4142 (ESTAR Thick Base)	HC-110† or D-76†	Use Filter of Same Color as Stain
	Technical Pan Film 2415*	HC-110, D-76 or TECHNIDOL‡	
Daguerreotypes	PLUS-X Pan /5062 (35 mm)	HC-110† or D-76†	Use Filter of Same Color as Stain
	Technical Pan Film 2415*	HC-110, D-76 or TECHNIDOL‡	

*Technical Pan Film produces increased contrast compared to other films.
†Strength of developer dilution depends upon the intensity of the stain.
‡TECHNIDOL LC or TECHNIDOL Liquid Developer can be used with Technical Pan Film 2415.

A TYPICAL APPLICATION OF *KODAK* TECHNICAL PAN FILM FOR USE IN COPYING YELLOWED AND FADED ORIGINALS. One of the most perplexing problems in copying yellowed and faded photographs, especially for the inexperienced, is the choice of the correct film, filter, and developer. KODAK Technical Pan Film 2415 has many characteristics which make it exceptionally well suited for this purpose.* It has extremely fine grain, extremely high resolution, and unusual flexibility in processing. The fine grain characteristics of this film makes it ideal for copying medium- to low-contrast originals with 35 mm cameras. With a concentrated developer such as KODAK HC-110 Developer, it is possible to use a range of developer dilutions to accommodate originals with varying density ranges. (For an explanation of density range, see the chapter on processing for black-and-white stability and the glossary in the appendices.)

The following example can serve as a point of reference for such an application and illustrates the possibility of using a single film, developer, and printing paper for reproduction of a series of stained originals. The originals of the illustrations on this page and the next were selected because they had various density ranges. They represent photographs in progressive degrees of fading, from prints that are almost normal to severely faded and yellowed specimens. A negative was made from each of the originals that had good printing characteristics. Each of the reproductions made from the negatives showed an improvement in tone rendition over the original.

The chart below shows how the different originals were handled with two developer dilutions using KODAK HC-110 Developer. KODAK POLYCONTRAST Rapid II RC Paper with KODAK POLYCONTRAST Filters was used to make the prints. The originals that were extremely faded and yellowed required the use of a KODAK WRATTEN Filter No. 47B (blue) over the camera lens. The developing time was 8 minutes for all of the films in both of the dilutions. These developing times are a starting point and should be used as a guide only. Preliminary tests should be made to determine the optimum time of development.

Figure 82 Copying Yellowed and Faded Originals with KODAK Technical Pan Film.

Set 1. In this series, KODAK Technical Pan Film developed in KODAK HC-110 Developer, Dilution F, is used to compensate for variations in original print contrast. This print is only slightly faded, and is copied in a manner similar to copying regular prints.

The copy print has close to the same tonal characteristics as the original print.

*KODAK Technical Pan Film 6415 and its accompanying developer was introduced as we were going to press. This film has some of the same applications as Technical Pan Film 2415 but in a larger format. For details on this new film request a single copy of P-255 from Dept. 412-L, Eastman Kodak Company, Rochester, N.Y. 14650.

Original	Filter	HC-110 Developer	KODAK POLYCONTRAST Filter	Density Range of Original
#1	47B	Dilution B	3 1/2	0.50
#2	47B	Dilution B	3 1/2	0.61
#3	47B	Dilution B	3	0.94
#4	47B	Dilution B	2 1/2	0.99
#5	—	Dilution F	2	1.05
#6	—	Dilution F	1	1.12

Figure 82 (continued)

Set 2. This print has slightly less contrast than the first original. Exposure and processing were the same, however, and the contrast gain was achieved in printing.

The copy print has been brought back to a normal contrast.

Set 3. The contrast of this print has been reduced considerably by the effects of time and fumes in the air. Perhaps it was not washed adequately when it was made.

Because of the strong brown color of the original, a KODAK WRATTEN Blue Filter 47B was used to copy this print, and a stronger developing solution, KODAK HC-110, Dilution B, was used to develop the copy negative.

Figure 82 (continued)

Set 4. The contrast of this print is lower yet, probably due to the effects of poor processing, time, and atmospheric contaminants. In this print, the highlights have stained, lowering the reflection density range.

This print was copied the same as set 3, but printed with more contrast. Because the highlights have been raised in tone, and the dark tones deepened, a normal tonal range has been achieved.

Set 5. The same things have happened to this original as happened to the set 4 original, only more so. While the image is discernable, the print has a very low contrast.

The copy print has brought back the contrast, but the shadow detail has been nearly lost. (It may not have been in the print originally.)

Figure 82 (continued)

Set 6. This print has browned and faded so badly that the image is very difficult to make out. However, the flexibility of this method of copying is useful, even with this type of original.

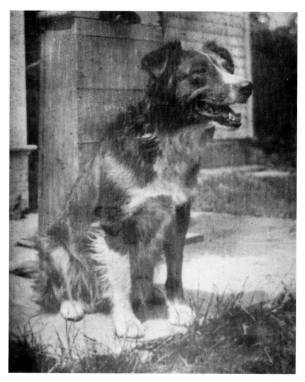

By using the blue filter, a full development, and by printing with a high-contrast KODAK POLYCONTRAST Filter, the image in the copy print has been made quite visible.

Some old deteriorated photographs may have reddish patches or spots. They are stains or are the result of oxidative deterioration. In this case it is usually desirable to eliminate or minimize the tone of the stain or spot. KODAK Technical Pan Film 2415 offers an advantage in this case. Used in conjunction with a red filter, such as a KODAK WRATTEN Filter No. 25, it is a very effective tool for minimizing reddish stains. When using the No. 25 filter with KODAK Technical Pan Film and tungsten illumination, a filter factor of 2 is required. This means that an exposure twice that used without the filter is necessary.

Because of its special characteristics, this film is valuable for copying with small format cameras. When copying with roll film, originals should be grouped together according to contrast so that low-contrast originals are exposed on one roll of film, normal-contrast originals on another, etc. Then the roll that contains the low-contrast originals can be developed longer (or in a stronger developer dilution or in a more active developer). The roll that contains normal originals can be developed for the normal time, etc. Using the example provided above, it is possible to group the originals into two categories for copying so that only two rolls of film will be necessary: the extremely low-contrast originals requiring a strong developer dilution, and originals that are near normal in contrast requiring a weaker dilution. Contrast refinements can be made for negatives within these groups during printing by using an appropriately graded paper or KODAK POLYCONTRAST Filters with variable-contrast papers such as KODAK POLYCONTRAST Paper.

Small Tank Processing of KODAK Technical Pan Film 2415. This film can be processed in small 16-oz stainless steel or 20-oz plastic tanks with spiral reels. The processing technique should be practiced until carefully controlled to avoid nonuniform-processing effects. These can result from pouring the developer on the dry film through the light trap in the tank top, the use of a water presoak prior to development, or improper agitation. Overagitation caused by vigorous shaking within the first 30 seconds of development usually causes nonuniform development especially adjacent to sprocket holes. On the other hand, insufficient agitation during this critical film-wetting period will also cause development nonuniformity because of uneven initial development. Because everyone's agitation style is slightly different even when using the same instructions, it is difficult to give definitive instructions. Experimentation by the user is recommended.

The following instructions for reel-type developer tanks will provide a reference or starting point. The technique has produced acceptable results with Technical Pan 2415 Film as well as with other films.

1. Fill the tank with developer.

2. In the dark, drop the loaded reel into the solution smoothly and without agitation.

3. Attach the top to the tank. Then, to dislodge any air bells from the film promptly tap the bottom of the tank against the work surface from a height of approximately 1 inch.

4. Use initial agitation of up to 4 inversions (down, up). Steps 2-4 will take from 7 to 10 seconds depending upon the type of tank. See diagram below.

Figure 83 Extend your arm and agitate the tank 180° at the wrist with no lateral arm movement.

5. Let tank sit for remainder of the first 30 seconds.

6. After 30 seconds, start 5-second inversion cycle at 30-second intervals. These agitation cycles should consist of 2 to 5 inversion cycles depending upon contrast desired and individual technique.

Duplicating Black-and-White Negatives and Positives

CLEAN NEGATIVES AND POSITIVES. Negatives and positives that are free of local stains can be duplicated either in one direct step or in a two-step procedure that involves making a film interpositive from which the duplicate negative is printed.

One-Step Procedure. Duplicates or "second originals" comparable in quality and sharpness to the originals can be made on a film designed for the purpose— KODAK Professional B/W Duplicating Film/4168 (formerly SO-015). The duplicates are formed with one exposure and simple development. The image on a direct duplicate negative that has been exposed emulsion-to-emulsion will be reversed from left to right. This film is available in 10.2 cm x 12.7 cm (4 x 5-inch), 12.7 cm x 17.8 cm (5 x 7-inch), and 20.3 cm x 25.4 cm (8 x 10-inch) sheets. A second film, KODAK Rapid

Figure 84 One-step negative duplication

A black-and-white negative is being placed in a contact-printing frame along with a sheet of KODAK Professional B/W Duplicating Film 4168. The enlarger serves as a light source. This takes place in the dark or under red safelight conditions. Photo by Tom Beelmann.

Process Copy Film/2064 is available in 135/size. Both films are blue-sensitive and can be handled under red, yellow-green, or deep amber safelight filters.

Since the emulsion of KODAK Professional B/W Duplicating Film/4168 is necessarily slow, the film is best exposed by contact. The film can be developed in a tray with KODAK DEKTOL Developer (diluted 1:1) for 2 1/4 minutes at 21°C (70°F) or in a tank with KODAK Developer DK-50 (full strength) for 5 minutes at 21°C (70°F). The duplicating film can also be processed in one of the KODAK VERSAMAT Film Processors. The processed film should be well washed and meet the ANSI residual hypo standards for archival keeping to protect against degradation. It should then be treated with KODAK Rapid Selenium Toner to enhance image stability. Although exposure by contact printing is the easiest method of producing the duplicate negatives, they can also be exposed by projection in an enlarger. This method is sometimes necessary if good contact cannot be obtained with buckled negatives. Buckling is sometimes caused by subjecting negatives to excessive heat, but with old negatives it may be caused by shrinkage or deterioration of the film base. Nitrate base in an advanced stage of decomposition is always affected in this way. Exposure by projection is also necessary, of course, if the duplicates must be smaller or larger than the originals. However, high degrees of enlargement require longer exposures than contact printing.

Two-Step Procedure. Duplicate negatives can also be made in two steps using an intermediate called an interpositive or a diapositive. The two-step procedure is used when more control over the quality of the duplicate negative is needed. This can be achieved better in two steps than in one. In fact, the amount of control is so great that sometimes a corrected diapositive is made and a duplicate negative used for printing in preference to printing the original negative. The extra step makes more retouching possible (the diapositive can be enlarged) and eliminates the risk associated with retouching an original negative. There are also more opportunities to manipulate local tone control through dodging, burning-in, intensification, dyeing, and chemical reduction.

Interpositives can be made on KODAK SUPER-XX Pan Film 4142 or on KODAK Commercial Film 4127 (ESTAR Thick Base) or 6127 (acetate base). SUPER-XX Pan Film has a long straight-line characteristic curve which makes it well suited for this application. It is especially useful when duplicating negatives that have high contrast such as old glass plates that were made to be printed on albumen paper. Contrast can be reduced by moderately overexposing and shortening the developing time. KODAK Commercial Film is easier to handle in the darkroom. Because it is a blue-sensitive film, it can be handled under safelight conditions normally used only for printing. It is also a finer

Figure 85 Two-step negative duplication
Film is being placed on the easel to make an enlarged interpositive from a black-and-white negative. This is done in the dark when panchromatic film is being used or under a red safelight when the film is orthochromatic. Photo by Tom Beelman.

This illustration is from a print that was made from the original negative. Stanley Klimek.

This illustration is from a print made from a duplicate negative produced by the two-step procedure.

grain film than KODAK SUPER-XX Pan Film. This may be important if the final negative is to be enlarged. The interpositive can be exposed with an enlarger or by contact. When exposing with an enlarger, the original negative should be oriented in the negative carrier the same as it would be for making a print (emulsion down). The film for the diapositive should be held down by an easel covered with black paper. It should be inserted emulsion side up. Because film is more sensitive to light than paper, when exposing film under an enlarger, care must be taken to avoid fogging. Light leaks from the enlarger bouncing against a light-colored wall can create a substantial amount of image degrading fog. Dirty lenses can be a source of flare, which can also degrade the image quality.

The duplicate negative is usually contact printed from the interpositives. This reduces the possibility of flare and sharpness loss due to enlarger optics. The

119

same film that is used to make the interpositive can be used to make the duplicate negative. Suggested developing times for two different films and developers are listed below. These are starting points from which more precise times for a particular set of circumstances can be established. The developing times are for tray development at 68°F (20°C).

Suggested KODAK Films and Developers For Duplicating Negatives by the Two-Step Procedure

Interpositive	Duplicate Negative
SUPER-XX Pan Film— develop for 7 min in DK-50 Developer	SUPER-XX Pan Film— develop for 8 min in DK-50 Developer
Commercial Film— develop for 4 min in HC-110 Developer, Dilution B	Commercial Film— develop for 7 min in HC-110 Developer, Dilution B

To make duplicate negatives that have good printing characteristics it is important that the density range of the duplicate negative matches the density range required for the photographic paper and printing system that will be used to print the negative. Because original negatives do not always have a density range that matches the printing system, it is very practical to alter the density range or contrast when making the duplicate so that it is close to the density range required for that particular printing system. Density range is discussed further in the chapter on processing for black-and-white stability and in the KODAK Publication F-5, *KODAK Professional Black-and-White Films.*

STAINED NEGATIVES. As in the case of copying black-and-white prints, any surface dirt should first be cleaned from the negative before duplicating procedures can be started. Stained negatives can be duplicated by making an interpositive on KODAK Separation Negative Film 4131, Type 1. Recommended filters for removing some stain colors are listed in the following table:

Stain Color	Filter Color	KODAK WRATTEN Filter No.	Filter Factor* (Tungsten)
Yellow	Yellow	15	1.5
Red, amber, orange	Red	25	4
Green	Green	58	8
Blue-green, blue	Blue	47	20

*A filter used over the lens reduces the intensity of light reaching the film during exposure. This varies from filter to filter and the exposure must be increased to compensate for the light loss. The filter factor is the number of times the exposure with a filter must be increased compared to exposure without a filter.

To make an interpositive, use a speed of ASA 64 and multiply the exposure required without a filter by the factor shown in the table. Aiming for a highlight density of about 0.40, develop the interpositive in KODAK Developer DK-50, which is a published formula also available in prepared powder form. Using the developer without dilution, develop the film for 4 minutes in a tray with constant agitation at 20°C (68°F). If the exposure was made through the No. 47 filter, increase the time to 4 1/2 minutes.

If the interpositive is printed by projection in an enlarger or copying camera, the filter can be used over the lens. In this case, a piece of filter only slightly larger than the lens mount is required.

The same film, with the same procedure but without a filter, can be used to make the duplicate negative. It should be processed in the same way, but exposed for a shadow density of about 0.30. When making either an interpositive or a duplicate negative, care should be taken to give sufficient exposure for full detail in even the clearest parts of the image. A good duplicate negative has no clear shadows. Since panchromatic sensitivity is not needed, KODAK Commercial Films 6127 and 4127 (ESTAR Thick Base) are more economical for making duplicate negatives. KODAK Developer DK-50 should be used without dilution and the negative developed for 8 minutes in a tray with constant agitation at 20°C (68°F).

NITRATE-BASE NEGATIVES. Most negatives on nitrate film base, particularly those on thin roll-film base, present little problem in duplication, except that many of them have a heavy yellow discoloration, which increases the exposure required. Very old negatives, especially those on thick sheet film base, are often buckled, and therefore cannot be exposed by contact. Moreover, these negatives may be so brittle that they may break up under the pressure needed for good contact. Consequently, they must be exposed by

projection in an enlarger or photographed with a camera by the light transmitted when the negative is placed on an illuminator of some kind. The use of an enlarger is preferable, because the exposure will usually be shorter. To obtain the best definition from the buckled negatives, the enlarger lens should be stopped down to the smallest aperture consistent with reasonable exposure times. Modern enlargers designed for color printing have more powerful illumination than the older ones intended for black-and-white printing. Consequently, if a contemporary enlarger is available, it should be used for making the duplicates. In any case, the enlarger should have an efficient heat-absorbing glass in the system and the cooling blowers, if any, should be working properly. A detailed procedure for using KODAK Professional B/W Duplicating Film/4168 (formerly SO-015) that maintains the density relationships for a specific collection of deteriorating nitrate film base and glass plate negatives (without distortion) has been described in the Journal of Imaging Technology.[31] A combination exposure consisting of a uniform exposure followed by an image-forming exposure was used to produce an extended exposure scale. At a gamma of 1.0 the exposure scale of 0.8 was extended to 1.60Δ log E.

Sometimes, the gelatin of nitrate-base negatives has become sticky if decomposition is in an advanced stage. This happens most often when the negatives have been stored in batches in a closed, airtight container. Before duplicating negatives that are in a tacky condition, spread them out on a table in a dry atmosphere for about an hour, or until they can be handled. This amount of drying will generally prevent the gelatin from sticking to the emulsion surface of the duplicating film or to the glasses in the negative carrier of the enlarger. Handle negatives that are in advanced stages of decomposition very carefully, because they may be brittle enough to break very easily. Finally, when duplicating nitrate-base films that are edge-marked "nitrate" be sure to mask the "nitrate" out so that it does not reproduce on the safety base film used for the duplicate.

GLASS PLATES. Glass plates can be duplicated by contact printing the image onto KODAK EKTAPAN Film 4162. A film interpositive will give improved results compared to a paper interpositive. A vacuum frame should be used for good contact. A diffusion light source is superior to a specular source. KODAGRAPH Sheeting (Orange) is an effective filter over the vacuum frame. The interpositive should then be processed in KODAK HC-110 Developer. To make the duplicate negative, contact-print the interpositive film onto KODAK EKTAPAN Film 4162 and process it in HC-110 Developer.

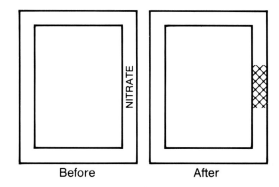

Figure 86 Some nitrate sheet films are identified along one edge with the word NITRATE. Before duplication on a safety-base film, this identification word should be masked out to prevent duplication of it on a safety film.

Often glass plates are cracked or broken and if this is the case, some preliminary steps must be taken before the plates can be duplicated. In the case of a cracked plate, it simply needs to be taped to a piece of clean glass. If the plate is broken in several pieces, it should be bound between two sheets of glass. If the original plate is a negative, it should be put in a diffusion enlarger and a print made on a smooth, lustre paper. White or light spots or streaks should be retouched to match the surrounding image tones; then a copy negative should be made. If the original is a glass positive— such as an old 8.3 x 10.2 cm (3 1/4 x 4-inch) lantern slide—an enlarged negative should be made from it in an enlarger. KODAK Commercial Film 4127 is a suitable material for this purpose. The negative should be retouched to match light spots or streaks in the surrounding image tones; prints can then be made as required.

IDENTIFICATION OF DUPLICATE NEGATIVES. When a considerable number of duplicate negatives are being made, it is important to have some positive and simple method of identifying the duplicates with the corresponding originals. If a negative number appears on the clear margin of the original, that number can be printed automatically on duplicates made by contact (see page 20). Very often, however, the number, or perhaps a legend, appears only on the negative envelope. If the envelope bears a number, it should be printed with India ink on the margin of the original. If the envelope bears only some descriptive wording, a number should be assigned to each negative and record and that number should be recorded (with attention to legibility) on both the envelope and the negative.

Color Reproduction Techniques

Color originals may show signs of fading after some time even if they have been kept in the dark. How much depends on the temperature and relative humidity of the keeping area and the degree of exposure to light either by projection, printing, or display. Many of these originals can be restored by copying and duplicating methods that yield an improved reproduction of the faded material. More recent films for making corrected duplicates have considerably improved keeping characteristics. However, it cannot be assumed that even these films will last forever and therefore, the implication is that new duplicates should be made from a master file duplicate whenever there is any evidence of dye fading. (See the section Filing and Cataloging in the chapter on Collection Management.) Valuable color records can be preserved by use of these duplication techniques.

Duplication may be accomplished in most cases by contact printing in an enlarger or in a camera. The method used is dependent on factors such as volume, equipment available, the characteristics of the particular Kodak products employed, and the degree of correction required. In all cases the proper light source, filters, and exposure time must be used with each color film product. It is possible to improve off-color originals with filters and also increase or decrease contrast. The techniques employed are similar to those used with black-and-white artifacts with three exceptions: the processing is different; the contrast cannot be controlled by adjustment of developing times; and the color balance must be maintained by the correct choice of lights and film or by the use of filters.

Copying Color Prints. Color negative films are recommended if the end product is a color print. KODAK VERICOLOR Internegative Films are designed specifically to copy color prints or color transparencies and provide more accurate tone reproduction when used properly. Specifically, these films are KODAK VERICOLOR Internegative Film 4112 (in sheets), KODAK VERICOLOR Internegative Film 6011 (in rolls), and KODAK VERICOLOR Internegative Film 4114, Type 2. The latter film is for use only in copying KODACHROME and EKTACHROME Film transparencies. Visual judgment of results is unsatisfactory. It is necessary to use color densitometry to obtain the critical exposure balance required.

KODACOLOR and VERICOLOR Films have been used for this purpose but lower reproduction quality can be expected. Generally, copying color prints on KODAK Transparency and Slide Films yields lower quality compared to the use of color negative films.

Color prints can also be copied in one step using the KODAK EKTAFLEX PCT Reversal Film. The procedure produces a reasonably good quality color copy. For archivists, family historians, and all custodians it provides the added advantage of improving the image stability of a color print that may be fading or damaged. The dyes used in color prints from KODAK EKTAFLEX PCT Reversal Film have excellent dark storage characteristics.

Figure 87 Copying Color Prints

This reproduction was made directly from a color print made on KODAK EKTACOLOR 74 RC Paper from an original color negative. This subject was chosen because of the variety of colors to show how well color prints of all colors can be copied. Norm Kerr.

This reproduction was made from a copy color print. The print above was copied on KODAK VERICOLOR Internegative Film 4112 (ESTAR Thick Base) and the copy print on KODAK EKTACOLOR 74 RC Paper. The color match between the copy print and the original is generally good, but some colors do not match exactly.

Figure 88 Duplicating Color Transparencies

When carefully made, duplicate transparencies made on KODAK EKTACHROME Duplicating Film 6l2l can closely match the originals.

This illustration was made directly from the original transparency.

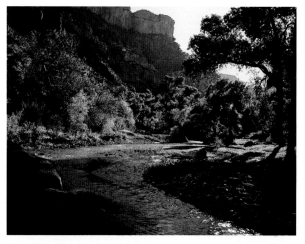

This illustration was made from a duplicate on a camera transparency film and shows increased contrast.

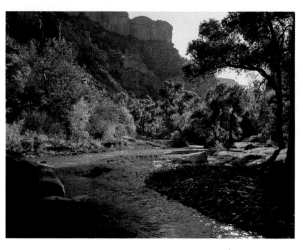

This illustration was made directly from a duplicate on KODAK EKTACHROME Duplicating Film 6121. A subject with a long scale was selected for this series of illustrations because this type of subject is most difficult to duplicate satisfactorily.

Duplicating Color Negatives and Color Transparencies.

Custodians of photographic collections often have a need to duplicate color negatives and transparencies. In some cases the sensitized products used permit some correction of color and contrast changes but most importantly they present the possibility of improved image stability because of the improved dye properties.

COLOR NEGATIVES. The simplest and most direct method of duplicating color negatives is to print the color negative on a color reversal film such as the duplicating films mentioned in the above section. Another method is to neutralize the orange-colored minimum density of the negative with filtration. Further information on duplicating color negatives is contained in the KODAK Publication CIS-59 "Color Duplicates of KODAK Color Negative Film." A copy of this publication is available by writing to: Customer Technical Services, Eastman Kodak Company, 343 State St., Rochester, NY 14650.

COLOR TRANSPARENCIES. The duplication of color transparencies is usually accomplished in one step using a duplicating film specially designed for the purpose. These films are KODAK EKTACHROME Duplicating Film 6121 (in sheets), KODAK EKTACHROME Slide Duplicating Film 5071 (in rolls), and KODAK EKTACHROME SE Duplicating Film SO-366. The latter film is intended for use with short duration electronic flash. It is important to use the correct light source and filtration with each duplicating film keeping in mind that these conditions vary for each kind of original transparency. Two-step duplication requires making a color internegative from which the duplicate transparency is printed. KODAK VERICOLOR Internegative Films 4112, 4114, and 6011 are used for this purpose. The internegative is then printed on KODAK VERICOLOR Print Film 4111 or KODAK VERICOLOR Slide Film 5072. More information on restoring faded color transparencies is included in the chapter on restoration.

Chapter XI Restoration of Deteriorated Images

When photographs deteriorate or are damaged, there is frequently a strong desire on the part of their owners or caretakers to restore them to their original appearance and condition. There are many physical and chemical treatments which can be utilized to improve the aesthetic, informational, and physical strength of an aged photograph. However, there are many factors which may limit their effectiveness. In fact, it must be said that almost any treatment of an original photograph carries with it a potential to do as much harm as good.

It is only in relatively recent times that a group of professional photographic conservators have come into existence as the historic, aesthetic and collecting value of photographs has grown. Together with professionals in the field of photographic science and allied technologies, photographic conservators are developing many ways of reviving and reclaiming deteriorated photographic images. Many of these methods rely upon advanced technologies, such as x-ray fluorescence and computer enhancement. Such methods do not treat the original and are usually out of the reach of the average person or institution. Many other methods which do treat the original require considerable experience and training in order to implement them successfully. These include such techniques as emulsion transferring, image intensification, and mount removal.

Photographs of great cultural, historic, aesthetic, and collecting value should not be treated by amateurs. Often, it is difficult to assess such values if the individual is unfamiliar with the field. Guidance and advice in such matters should be sought before undertaking any restorative techniques. The Conservation Department of the International Museum of Photography at the George Eastman House and the Photographic Conservation Committee of the Society of Photographic Scientists and Engineers can be consulted for such advice and will make references to appropriate skilled professionals or organizations.

However, all photographs do not have great cultural, historic, aesthetic, and collecting value nor is every individual in a position to seek out and pay for the services of trained professionals. It is for these individuals and for others who wish to understand some of the methods employed by conservators that the following information is given. Some of these techniques are very basic and simple. Others are quite complex in practice.

By no means is the information given meant to be comprehensive. Such an endeavor would fill many books. What is given reflects the most common solutions to the most common problems encountered with modern materials. It is offered with the best intentions of meeting a real need at least part way.

Preliminary Steps

Before restorative processes are started on a photographic artifact, there are several preliminary steps which should be taken.

1. Documentation of Condition

Documentation of condition at the time of receipt and the restorative treatment prescribed for the artifact should be a requirement. The documentation should at least fulfill the requirements of the Ethics and Standards Committee of the American Institute for Conservation, "Procedures for Engaging in and Reporting of Examination and Treatment of Works of Art by Professional Employees of Institutions."[32]

It is equally important to have a written agreement with the owner of the artifact—if it is someone other than the institution commissioned to do the restoration—that he or she understands and assumes full risk in the event that the restoration is not entirely successful.

2. Examination of the Artifact

The materials, especially in old photographs, vary and it is not always easy for the conservator to tell at a glance what the artifact is. The physical condition should be carefully examined for identification and any physical weaknesses such as severe brittleness that might preclude further treatment. Wetting with solution treatment may affect fragile paper fibers and cause prints to tear or fall apart. Discolorations and stains should be carefully studied to determine their character. This examination will dictate the treatment to use.

3. Making a Photographic Copy

A photographic copy should be made of each deteriorated artifact before the original is subjected to any treatment including cleaning. (Cleaning is described in detail in a following section.) This provides a record of the artifact as it was received. Loose dirt should be dusted from the artifact. Then a copy should be made on panchromatic film with a filter of the same color as the stain. In the process, the stain may be removed. Even if the stain is not completely eliminated, a second record or insurance copy has been made. Another useful technique for making a record copy is to copy the artifact on KODAK VERICOLOR III Film and then print the color negative on KODAK EKTACOLOR Professional Paper.

4. Cleaning of the Artifact

Each negative or print should be cleaned to remove surface dirt. Before any cleaning is done that involves the use of liquids, especially solvents, certain spot tests should be made to determine whether the emulsion vehicle is albumen, gelatin, or collodion. An additional spot test should be made on glass plates to determine whether they have been varnished. KODAK Film Cleaner can be used for this purpose.

Some of the chemicals used in restoration work are poisonous and flammable and should not be used carelessly. Restoration work done by individuals who are not knowledgeable and experienced with the chemicals and the techniques they are using is dangerous to both the worker and the artifact. The information on the use of photographic chemicals contained in the beginning of this publication should be read carefully and followed by individuals doing restorative work. Material Safety Data Sheets describing health hazards and safe handling procedures should be obtained before using any of these chemicals.

5. Identification of the Emulsion Vehicle

The spot test procedures for the possible determination of the emulsion vehicle of an artifact include the following steps:

a. Identify the emulsion side, then apply one drop of water or alcohol to a nonsignificant, non-image edge area. This application is best undertaken with an absorbent point of a micro swab dipped into the water and lightly touched to the

Figure 89 Before cleaning or restoring an artifact, a spot test should be made to determine whether the emulsion vehicle of the artifact is albumen, gelatin, or collodion. If swelling occurs after a drop of water has been applied to a nonsignificant part of the image as shown by the spot on the lower right of the photo, a gelatin emulsion is indicated. Photo Don Buck, Eastman Kodak Company Photographic Illustrations Department.

edge of the bottle. Just one drop should be left on the tip before placing it onto the chosen point of the artifact.

b. The drop should be observed for a few minutes or until a physical change is noted. Then carefully blot the surplus water or alcohol with an absorbent blotting paper. Press it down over the spot, but do not rub the surface with it.

c. Finally, observe the spot test area at an oblique angle to determine evidence of swelling. Examine the blotting paper to determine if any of the emulsion layer transferred.

After application of a drop of water, swelling indicates gelatin. After application of a drop of alcohol, solution and transfer to the blotter indicate collodion. When neither water nor alcohol affects the surface layer, albumen is indicated. Some practice on known artifacts is suggested since observation is not always successful or positive.

Some Restorative Techniques

WARNING: *Some of the chemicals used in restoration work are poisonous and flammable and should not be used carelessly. Restoration work done by individuals who are not knowledgeable and experienced with the chemicals and the techniques they are using is dangerous to both the worker and the artifact. The information on the use of photographic chemicals contained in the beginning of this publication should be read carefully and followed by individuals doing restorative work. Additionally, the chemicals should be used in strict compliance with the safety procedures recommended by the manufacturers. Kodak neither recommends nor assumes any responsibility for injury or losses resulting from the use of any of the following restoration procedures or other manufacturer's chemicals.*

Cleaning Artifacts.*

After the emulsion has been identified, each artifact should be cleaned to remove dirt and greasy residues from both the surface and the support side. The use of cotton gloves is recommended when handling photographic artifacts primarily to avoid fingerprinting. Negatives and prints are usually in enclosures and if this is the case, the artifact should be placed on an auxiliary support before the enclosure is removed. The enclosure should be carefully removed from the artifact; not the reverse. The auxiliary support provides a rigid surface to work upon thereby minimizing damage to items during examination.

Whether negatives, plates, or prints are being cleaned, the first cleaning operation involves careful dusting of both the emulsion and nonemulsion surfaces with clean camel's hair brushes. This should be repeated until the dust has been removed.

CLEANING PRINTS.

Clean the emulsion side by applying a cotton ball or swab to the emulsion surface after dipping the swab lightly in KODAK Film Cleaner. Move the swab in a circular motion while rotating it between the finger tips. Continue to replace and use swabs until the cleaner no longer streaks and the swab no longer picks up dirt or grease.

To clean the support side of a print, place the emulsion side down and apply eraser powder to the back of the print. Move it around with a gentle circular motion working from the center outward. Reapply and treat the print until the powder no longer discolors. Do not apply film cleaner to the support and never apply eraser powder to the emulsion.

This method can be used to clean mounts. It should not be used to treat black-and-white photographs that have been oil-tinted.

Resin-coated papers can be cleaned on both sides with KODAK Film Cleaner.

*The general cleaning procedures described for photographic artifacts and those recommended for cleaning prints are based on techniques originally developed by the Canadian Conservation Institute in the late 1970s.

CLEANING FILMS AND PLATES.

Most of the negatives and plates submitted for cleaning are likely to carry a considerable amount of surface dirt which may consist of processing scum plus fingerprints and dirt picked up in later handling. Very often, too, the emulsion surface has been scratched and abraded by careless handling. There are several ways of treating these conditions.

After dusting both the emulsion and nonemulsion sides of these artifacts, they can be cleaned by applying film cleaner as described in the previous section. However, many wet plate collodion negatives and some glass plate negatives were varnished as part of their processing. When the spot test described previously is used with KODAK Film Cleaner and upon critical viewing shows a devarnished area, this indicates that the plates being tested cannot be cleaned with the film cleaner without removing the varnish overcoat or damaging the collodion.

Another cleansing treatment that is appropriate only for gelatin-silver bromide or gelatin-silver chloride emulsions coated on acetate or polyester film base is described below. This procedure, although involving some risk of damage, has been found to be quite effective with the majority of such negatives. It will not work, however, on old photographs, such as collodion wetplate negatives, daguerreotypes, tintypes, ambrotypes, or prints on albumen papers. It should never be used on photographs of unknown character. These artifacts should not receive any chemical treatment, nor should they be soaked in water unless a practical test on a similar but expendable subject has been made. It will also not work on negatives where fungus has invaded the emulsion causing the gelatin to become soluble in water. A negative that has been damaged in this way either from fungus or another cause cannot be treated successfully in any aqueous solution, even a hardener. In such cases, a small expendable area of the negative should be pretested with water. If the gelatin is found to be soft, it may be best to omit step 1 and go directly to step 2. The following procedure should also be used only for negatives on acetate or polyester base.

1. First soak the negative thoroughly in clean water, and while it is under water, swab the surface with a wad of soft cotton. In some cases, this will be the only treatment that is needed.

2. If swabbing with water does not remove the deposits, harden the negative in KODAK Special Hardener SH-1 and rinse it thoroughly.

3. Support the negative on a sheet of glass and swab the surfaces carefully with a wad of cotton soaked in a 5-percent solution of sulfuric acid.† To reduce the danger of damaging the emulsion, make sure that

the temperatures of the wash water and the acid solution are not above 21°C (70°F). Protective gloves and safety glasses with side shields or goggles should be worn in this operation.

†**WARNING:** *Always add the sulfuric acid slowly to a considerable quantity of water with stirring; otherwise, the solution may boil and splatter acid on the hands or face, causing serious burns. Never add the water to the acid.*

4. Rinse the negative thoroughly to remove the acid, refix it in a fresh acid hardening fixing bath, wash it thoroughly, and dry it.

This treatment will usually clean off the surface deposits. In addition, the slight softening and swelling of the gelatin will tend to fill in or smooth out shallow scratches and surface abrasions.

CLEANING TRANSPARENCIES.

Black-and-white and color positive transparencies (such as slides on KODACHROME and EKTACHROME Films) can be cleaned by removing the films from their holders and wiping them with soft plush or absorbent cotton moistened sparingly with KODAK Film Cleaner. The holders should be discarded. Prior to 1970, transparencies from KODACHROME Film were lacquered to protect them from fingerprints, scratches, and fungus growth. This does not present a problem for cleaning and restoration; a lacquered surface is more readily cleaned, and in cases of minor damage it is possible to restore the surface by removing the old lacquer and applying a new inert lacquer to the surface. Most lacquers can be removed by either of the following methods. If there is fungus growth on the artifact, the second method should be used. When neither of these methods are successful, it may be appropriate to use solvents. Further information on the use of solvents to remove lacquer is contained in Chapter VII.

Method No. 1—Sodium Bicarbonate Solution. Dissolve a level tablespoon of sodium bicarbonate (baking soda) in 240 mL (8 fluidounces) of room-temperature water. If the artifact is a transparency from KODACHROME Film, add 15 mL (1/2 fluidounce) of formaldehyde, 37 percent solution. Agitate a transparency for 1 minute, or a color negative for 4 minutes. Rinse for 1 minute in room-temperature water. Bathe the film for about 30 seconds in KODAK PHOTO-FLO Solution (diluted as stated on the bottle) and hang it up to dry in a dust-free place. When the film is completely dry it can be relacquered.

Method No. 2—Ammonia-Alcohol Solution. Add 15 mL (1/2 fluidounce) of nondetergent household ammonia to 240 mL (8 fluidounces) of denatured alcohol. Use shellac-thinning alcohol. Agitate the film in the solution for no longer than 2 minutes at room temperature. Longer times may change the color in areas of minimum density. Hang the film up to dry.

An effective way to clean slides when there is a large number is to use an ultrasonic cleaner of the type sold for cleaning small metal parts and surgical and dental instruments. A cleaner of 1-pint capacity should be adequate for cleaning slides.

Removing Dry-Mounted Prints From Mounts.

When the mounting board on which a print is mounted needs to be replaced or the print itself needs restoration, the print must be demounted. A print should not be treated with any solutions intended for chemical restoration while it is still attached to the mounting support. In addition, if the original negative is no longer available, a copy negative of the print should be made before any physical, mechanical, or chemical treatment is performed on the print and mount.

The type and manufacturer of the materials that were originally used to mount an artifact as well as the procedures used are usually unknown. If there is a question as to the type of mounting tissue used, a small area should be tested with a hand iron or a tacking tool to determine if heat alone can be used for the demounting. Extreme care should be exercised so the print is not damaged. Use of heat may not be advisable where prints are already in a dry, brittle condition.

If it can be determined that the print was mounted with Type II mounting tissue, it can be unmounted by careful application of heat to the print-mount combination. Normally the mounted print can be placed in a hot dry mount press and heated under pressure to soften or melt the adhesive. Immediately after removal from the dry mount press, the print should be gently peeled from the mounting board. For very old mount-

Figure 90 Teflon sheeting is inserted between the print and the mountboard to prevent the readherence of the two. This is continued with great care as the mounted print is heated for delamination in the dry-mount press.

ed prints, it may be possible to peel back only a small portion of the print before the mounting adhesive cools and rehardens. Insert TEFLON Sheeting between the delaminated print surface and the mounting board, and reheat and repeat the peeling process. Working carefully, repeat the process until demounting is completed. Patience and careful technique are required to produce an undamaged print.

It is unlikely that demounting of prints by heating will be possible without damaging or destroying the print if Type I dry mounting tissue was used in the original mounting.

Where demounting by heating is unsuccessful, use of alternative methods may be necessary. One alternative is to soak the print and mounting board in water. Place the print and mount facedown in a tray partially filled with water. When the board is thoroughly soaked, carefully peel the mount away from the print. Do this very carefully to avoid tearing the print. Often it is best to remove only small sections of the board at a time. With this procedure the original dry mounting tissue will be left adhering to the print.

It may be possible to soften or dissolve the adhesive in the mounting tissue with the application of a solvent. Use of different solvents may be necessary for mounted black-and-white or color prints. Care should be exercised with the use of any solvents. Prints from the era 1885-1930 may have collodion emulsions and will therefore dissolve in alcohols and other types of solvents.

First, trim the mount and print so that the mounting tissue is freshly exposed at the print edge. This will allow the solvent easy access to the mounting tissue. Place the mounted print, print side up, in a tray partially filled with solvent. Use sufficient solvent to cover the print completely. For black-and-white prints, try solvents such as acetone, 50-percent aqueous acetone, toluene, hexane, cyclohexane, methyl alcohol, or denatured ethyl alcohol. Make certain that prints are thoroughly dry before attempting to demount them. For color prints, solvents must be nonaqueous; such aromatic and aliphatic hydrocarbons as toluene, hexane, or cyclohexane may be used to soften dry mounting adhesives. Such low-molecular-weight alcohols (dry) as ethanol or methanol may be satisfactory for dissolving the adhesive.

These solvents should be used with care. They are all flammable and will ignite when exposed to open flames, sparks, static electrical discharges, or unprotected electrical equipment including motors and switches that are not certified as explosion proof. The solvents are volatile and must be used in a well-ventilated place, such as a chemical fume hood or with equipment that provides adequate exhaust from the workplace. Avoid unnecessary skin and eye contact and inhalation of the solvent vapor.

Leave the print and mount in the tray long enough for the adhesive in the mounting tissue to soften and/or dissolve. Separation of the print and mount can be facilitated by slowly pulling the edges of the print away from the mounting board. The tissue may adhere to the print or the mount. Keep the solvent level high enough to cover the mount and print completely. When the print has been demounted, gently swab the surfaces with fresh solvent to remove any remaining adhesive. Dry the print and examine it for any adhesive or drying spots. After it has been thoroughly dried, the print can be remounted with fresh materials.

In a very few instances, there may be no way to remove the print from the mounting board except by paring away the mount with a sharp knife or scalpel. This procedure requires extreme care and is tedious and time consuming. It is also very risky. Some conservators have designed special tools and techniques to split the print away from the backing without tearing it. Before the mount is separated from the print, any information about the print such as signatures or inscriptions that were on the front or back of the mount should be noted elsewhere. After demounting and any restorative treatment that may be required, the print can then be remounted on a chemically neutral support and the information recorded on the new mount.[33]

Removal of Stains, Discoloration, Fading.

Most stains, discolorations, or fading found on negatives and prints can be eliminated or reduced by making a copy negative using a panchromatic film and a filter having the same color as the stain. This technique has been explained in the previous chapter "Preservation Through Photographic Reproduction." There are other methods for removing stains which are described in this section.

RESTORING STAINED OR DISCOLORED PRINTS ON DEVELOPING-OUT PAPER BY BLEACH AND REDEVELOPMENT. This method involves the treatment of a print on a developing-out paper with a bleach solution that converts the discoloration or stain if it is either silver or silver sulfide to silver halide. The silver halide is then redeveloped to form the original silver image. When there is a yellowish-brown stain in the non-image area, a preliminary test must be made to determine whether or not silver or silver sulfide is present as a result of the decomposition of silver hypo complexes resulting from improper fixation. If these substances are present in the non-image area, the bleach and redevelopment procedure will

Figure 91 This print was discolored and yellowed from initial poor processing and subsequent poor storage. The upper right half was treated in a potassium permanganate bleach solution and redeveloped in KODAK DEKTOL Developer. An excellent restoration was achieved in this case. Courtesy Thomas T. Hill.

produce an unwanted darkened background. Therefore do not use the bleach and redevelopment method. The presence of silver or silver sulfide in the non-image area can be determined by treating a small expendable area of the artifact with a ferricyanide bleach solution. If silver is present, it will be converted to silver halide; if a stain remains, this indicates the presence of silver sulfide. This can be identified positively by adding a drop of potassium cyanide solution* to the stain. This will dissolve the silver sulfide. Then add a small drop of a 1 percent solution of sodium nitroprusside to the drop of cyanide solution. A pink color indicates the presence of silver sulfide.

***DANGER:** Potassium cyanide and solutions of potassium cyanide should be handled with extreme care. Potassium cyanide can be fatal if swallowed, inhaled or absorbed through the skin. Protective gloves should be used in the preparation of the solution. Wash thoroughly after handling. Cyanide salts and solutions should be used in well ventilated areas. Potassium cyanide reacts with acids to form the poisonous gas, hydrogen cyanide. Place clearly recognizable poison labels on all containers of the chemical. Keep out of the reach of children.

A second test to detect the presence of residual fixer chemicals or the effect of oxidizing gases from the atmosphere on the photographic record should also be made prior to bleaching and redeveloping. This test involves placing a drop of developer on an expendable part of the non-image and/or the image area of the artifact. If the discoloration or stain was caused by fixer residues, there will be no effect. On the other hand, oxidizing fumes in the environment can form silver oxide which is redeveloped to silver. The drop of developer will not affect any silver sulfide present. This test distinguishes sulfiding from oxidizing of the silver.[34]

Spot stains on artifacts usually cannot be removed by bleach and redevelopment without leaving a ghost outline of the stain spot. These spot stains may be removed photographically with the appropriate combination of panchromatic film and filter (see page 113). Some additional artwork or treatment with chemicals on an intermediate copy may be necessary.

Many stains can be removed by the bleach and redevelopment method with KODAK Stain Remover S-6 or with the newer KODAK Cupric Chloride Special Bleach Bath. The latter is a faster-acting bleach that shows less gel swelling and no brown manganese dioxide stain as normally occurs with the S-6 bleach.

KODAK Cupric Chloride Special Bleach. Bleach the image in Cupric Chloride Special Bleach for 30-60 seconds at 20°C (68°F) or until the silver image becomes milky white in appearance. Rinse it in running water for 30 seconds. Expose the image to a strong light source (sunlight, arc light, or a high-intensity fluorescent or tungsten light) for about 30 seconds or until the image "prints out" and becomes more visible. Redevelop it in DEKTOL Developer or KODAK Developer D-72 diluted 1:2 with water or KODAK EKTAFLO Developer diluted 1:9 with water. Finally, rinse the image in an acetic acid stop bath (KODAK Stop Bath SB-1); then wash it thoroughly in running water. Then treat with a solution of KODAK Rapid Selenium Toner.

CAUTION: Slow-working developers, such as KODAK Developer D-76, KODAK MICRO-DOL-X Developer, and KODAK Developer DK-20, should not be used, since they tend to dissolve the bleached image before the developing agents are able to act on it.

KODAK Stain Remover S-6. Mix equal parts of Solution A and Solution B as provided, adjust the temperature to 20°C (68°F) and bleach the image for 3-4 minutes. Treat with a 1 percent solution of sodium bisulfite to re-

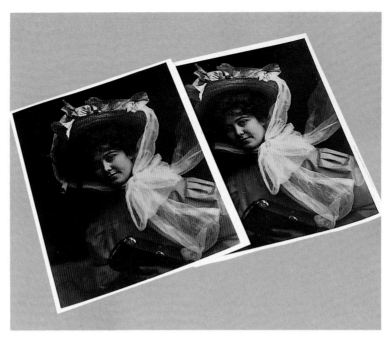

Figure 92 The left-hand print was severely discolored. It was restored, right, by treatment in a copper chloride bleach solution and redeveloped in KODAK DEKTOL Developer. Note: The bright yellow stain and brown discoloration indicates very poor processing.

move the brown stain of manganese dioxide. Wash for 3 or 4 minutes and then expose to a strong light until the white silver chloride turns purple. Finally, redevelop in DEKTOL Developer, KODAK Developer D-72 (1:2) or KODAK EKTAFLO Developer 1:9 and wash thoroughly.

There is never any certainty that a bleach and redevelopment procedure will remove unwanted image discoloration or non-image stain. It is therefore very important to make preliminary small scale tests on an expendable original from the same batch of originals or on a small area or strip cut from the edge of the original.

The following example is typical of the unexpected result. A photographic plate had unusual intense brown-stain lines across the image area. Ammonium hypo reducer removed the brown stain but left clear lines. A second test piece was treated by bleach and redevelopment which produced extremely dense image lines where the brown lines had been. This result indicated the deterioration to be oxidation of the image silver in the line format because of a chemically reactive ink or rubber band.

RESTORING FADED IMAGES ON PRINTING-OUT PAPERS. Printing-out papers were used in the nineteenth and early twentieth centuries and were the papers on which many of the early photographic artifacts were made. It is difficult to distinguish between prints made on these papers and those made on the later developing-out papers but this difference must be recognized before any restoration work can be started. The best way to accomplish this is simply through experience in identifying nineteenth and twentieth century prints and comparing them to the later developing-out prints. After identification has been made, the restoration can begin.

There is no definitive recommendation for the bleach and redevelopment of print-out papers because of the wide variety of gold toners used. Chemically speaking a rehalogenating bleach should be practical but no specific treatment is available.

Stained or fogged prints on printing-out paper that were merely printed and not fixed or toned should not be treated chemically. If the degree of stain is minimal, the prints can often be copied successfully on a panchromatic material. A yellow filter, such as a KODAK WRATTEN Filter No. 15, should be used over the print to avoid further darkening of the image by the action of light and to increase the contrast of the image.

TABLE OF STAINS AND DISCOLORATION AND SUGGESTED REMOVAL PROCEDURE.
Several techniques for removing stains, discoloration, and fading have been discussed in the previous text. Many of these image defects have been mentioned throughout this publication. The table below draws this information together in concise form giving the preferred solution treatment for restoration. Where possible, a second treatment is suggested. Although not stated in the table, the artifact should be rinsed with water between and at the end of each treatment.

Table XI-1

Typical Discolorations and Suggested Techniques for Removal

Discoloration/ Stain	Removal Procedure
Aluminum Sludge	Preharden in SH-1, then bathe in 2 percent hydrochloric acid.
Blue and Brown Iron	Immerse in 10 percent potassium oxalate, wash thoroughly.
Bluish Green	Cannot be removed from prints; for films treat with 5 percent potassium citrate after hardening in SH-1.*
Brown Rust	Bathe in 10 percent oxalic acid or bleach and redevelop.
Calcium Sulfite	Preharden in SH-1; then bathe in 2 percent hydrochloric acid. May be soluble in acetic acid.
Developer Oxidation	Preharden in SH-1, wash 5 min, bleach in S-6, rinse, immerse in sodium bisulfite to remove brown stain, wash, expose to strong light, develop.
Dichroic Silver	Bathe in Ammonium Hypo Reducer†
Dye and Ink	Bleach and redevelop.
Dye Fading	See the chapter on color images.
Envelope Seam	Bathe in Ammonium Hypo Reducer—if necessary, bleach and redevelop.
Faded Prints Made on Printing Out Papers	Copy photographically.
Fungus	If not too advanced, wipe with KODAK Film Cleaner.
Intensification	Bleach and redevelop.
Lemon-Yellow Iodide	Bathe in fresh fixing bath (any retained in the fixer disappears on washing).
Microblemishes	Not possible, no known technique.
Mountant Stains	Remove print from mount, bleach and redevelop.
Nitrate Film	Duplicate on safety-base film.
Opalescence (yellowish-white)	Preharden in SH-1, wash thoroughly, immerse in 10 percent sodium sulfite at 100-120°F (38-49°C) until dissolved, wash thoroughly.
Purplish image tone (plumming)	Cannot be removed.
Selenium-toned prints	Immerse in 10 percent sodium sulfite 4-5 minutes at 100°F (38°C).
Silver sulfide	Bathe in Ammonium Hypo Reducer and/or bleach and redevelop.
Silver-white	Immerse in water and dry at normal temperature.
Surface Scum (Organic Matter)	Bathe in water and wipe with a wet sponge; if the stain is resistant it may be removed with KODAK Abrasive Reducer.
Vegetable Extracts	Bleach and redevelop.
Yellowing	Bleach and redevelop.

*SH-1 is a KODAK Special Hardener recommended for treatment of negatives that normally would be softened by the chemical treatment given for the removal of stains.

†Ammonium Hypo Reducer is prepared by adding 15.0 grams citric acid per litre to KODAK Rapid Fixer with hardener diluted 1:3.

Figure 93 Dichroic silver stain (tarnish) can be removed with ammonium hypo reducer. Photo on the left shows a technique for removal—a ball of absorbent cotton is dipped into the reducer solution and then applied with a circular motion. Photo on the right shows the same negative with the cleaned areas. Jerry Antos.

Restoration of Daguerreotypes

Cleaning. Liquid or abrasive cleaning treatments should not be attempted with these artifacts and the surface should never be touched in any manner because it is extremely sensitive. Potassium cyanide and various thiourea solutions have been recommended in the past for cleaning and removal of tarnish. These chemical treatments are considered irreversible and not thoroughly understood. Recent studies[35][36][37][38] made of the effects of liquid cleaner indicate they should *never be used* because of the severe chemical and microstuctural damage to the image. The result of this "etching" action is often seen as a change in the optical properties or appearance of the image. It is believed that these treatments make the image more vulnerable than ever to attack. Evidence of this fact is the reappearance of tarnish spots known as "daguerrian measles." Other occasional defects evident after cleaning, such as green salts, indicate reaction with the copper plate base. Colored daguerreotypes are untreatable by all wet methods because the color pigment particles are removed from the surface.

Preservation. Since it is inadvisable to attempt any of the presently known restoration procedures there are certain steps that can be taken to help preserve these images until harmless cleaning methods become known. The first step is to seal the artifact in the 19th century manner with a new stable cover glass and mat. Then it should be taped, sealed, and stored in an environment

Figure 94 Preservation Wrapping of a Daguerreotype

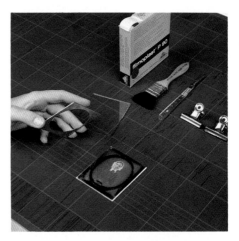

Step 1. The metal mat and cover glass have been removed from this sixth plate daguerreotype.

132

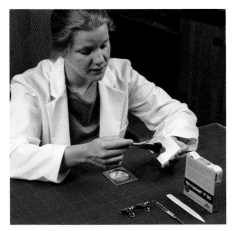

Step 2. Elizabeth Frey, Conservation Technician at the International Museum of Photography at George Eastman House removes dust and other debris with a handheld bellows blower, being careful not to touch the surface of the plate. The cover glass is dusted with a soft brush to remove lint.

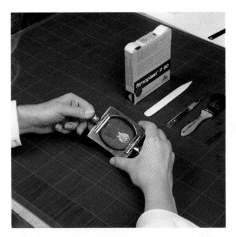

Step 3. The package (glass, mat, plate and backing) is carefully lifted and clipped together, after careful alignment, in preparation for taping.

Step 4. The longest sides of the package are taped first. Then the clamps are removed. The taping both holds the package together and helps to seal out air and dirt.

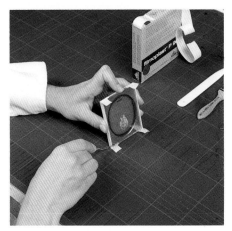

Step 5. The excess flaps are trimmed.

Step 6. Then the shorter edge is taped, thus sealing the entire package.

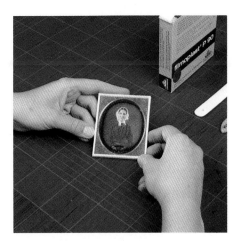

Step 7. The finished package, taped, and sealed for preservation. Series by Don Buck, Eastman Kodak Company Photographic Illustrations Department.

133

of 40 percent relative humidity and 18.3°-21.1°C (65-70°F). Daguerreotypes that are in good condition with little or no evident tarnish but that appear dull may require either the replacement of the old cover glass with a new cover glass made of modern conventional glass or a careful cleaning of the cover glass with a soap solution to remove surface dirt. They should then be rinsed with fresh water. Daguerreotypes that have no original case or have badly damaged, non-reusable cases should be sealed inside protective housings that have been constructed of the safest, cleanest materials. Recommended materials include a 100 percent rag board that is sulfur-free with a neutral pH, high quality archival paper, inert polyvinyl acetate adhesive, and properly cleaned glass.

The use of a thiourea cleaner might be warranted in very severe cases of tarnishing where the image is not discernible. It has been suggested that it is possible to control the rate and selectivity of thiourea cleaners by keeping the pH and thiourea content very low and including a surfactant in the formula. Extreme caution is necessary.[38]

Restoration of Glass Plate Negatives

Glass plate negatives in photographic collections have often deteriorated as a result of silver and silver sulfide stains caused by oxidizing gases. This is one of the most common stains found in photographic artifacts. These negatives can be cleaned by a process similar to that

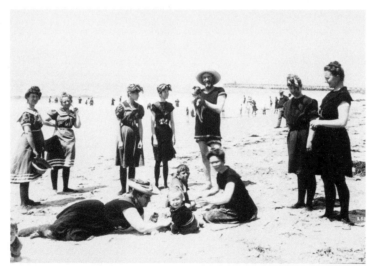

Figure 95 Restoration of an old glass plate negative that is severely stained and tarnished: at the top an illustration of the original and at the bottom, the restored print. The details of this restoration are unknown but possibilities include the thiourea treatment and/or treatment with ammonium hypo reducer. This photo illustrates the possibilities of chemical restoration. Courtesy Larry Booth.

used for cleaning daguerreotypes.[39] Since the method requires the immersion of the plate in solutions, care should be taken so that the emulsion does not lift from the glass plate. If this occurs, the treatment should be discontinued immediately.

The following solutions are used with this treatment.

Table XI-2
Solutions for Removing Stains from Glass Plate Negatives

	Solution No. 1 Ammonia Solution			Solution No. 2 Thiourea Solution		
	Avoir	Metric		Avoir	Metric	
Distilled water	9.0 fl oz	265 mL	Distilled water	16.0 fl oz	475.0 mL	
Non-detergent ammonia	3.0 fl oz	90 mL	Thiourea crystals	0.65 fl oz	19.0 grams	
			Phosphoric acid	0.35 fl oz	10.0 mL	

The glass sides of the plate should be washed with water and swabbed with alcohol, if necessary, using sterilized cotton; the emulsion side should be wet with tap water. Then both sides of the plate should be cleaned initially with Solution 1, swabbing them gently with cotton. Rinse the plate in tap water. Next, Solution 2 should be applied to the plate with cotton, wiping the emulsion very lightly and repeatedly, especially if the emulsion is very thin or in bad condition. Plates in good physical condition may be immersed and swabbed. Rinse the plate immediately with tap water for at least one minute. Place it in a fixing bath with agitation for another minute. Then, rinse it in tap water, bathe it in hypo clearing agent for 30 seconds and rinse it in running tap water for 2 - 2 1/2 minutes while holding the plate in the air. Finally, rinse the plate in KODAK PHOTO-FLO Solution and set it in a drying rack. If silver or streaks remain, repeat the procedure.

Restoration of Wrinkled Negatives[40]

Early film bases were subject to chemical degradation which caused very high base shrinkage and consequent emulsion distortion. Consequently, wrinkled or buckled negatives may be found in a collection of old photographic images. These negatives may be on cellulose nitrate or cellulose diacetate film base. The chemical degradation of these materials was probably accelerated by poor storage conditions.

There are some significant differences in the restoration procedures for cellulose diacetate and cellulose nitrate base negatives. The same solvent is used in both procedures but, in the case of the diacetate film, the solvent dissolves the subbing layer that provides adhesion of the emulsion to the support. In the case of the cellulose nitrate negatives, the solvent dissolves the cellulose nitrate making it necessary to protect the emulsion while removing the gelatin backing first and then the film base (see the following discussion). The solvent used is 2-butanone, EASTMAN Organic Chemical #383, also known as methylethyl ketone.

Before beginning the restoration procedures certain precautionary steps should be taken. Extreme care should be used in handling the chemicals and under no circumstances should fumes from the chemicals involved be inhaled. A fumehood with an explosion-proof exhaust fan is recommended. The operator should wear protective (polyvinylalcohol) gloves and lab apron and safety glasses.

Plastic (polyvinylchloride) should not be used because the solvent will dissolve the plastic. The solvent should be kept away from heat, sparks, and flames because it is explosive. A duplicate negative of the artifact as it exists should be made before any work begins. Finally, it is advisable to practice with some unimportant negatives of the same type as are being restored before working with a valuable negative.

RESTORING CELLULOSE DIACETATE NEGATIVES. Trim a 0.8 mm (1/32-inch) wide strip from all four sides of the negative and place the negative in a stainless steel, glass, or enamelled tray. Cover the film with the solvent, 2-butanone, EASTMAN Organic Chemical #383, for 3 to 4 minutes and then gently separate the emulsion from the base at the corners. If it does not separate, transfer the negative to an extra strong mixture of KODAK PHOTO-FLO 200 Solution diluted one part solution to ten parts water and heat at about 24°C (75°F). It is possible that the base may fall apart if chemical degradation is severe enough but the emulsion will stay intact if it has been handled gently and carefully. A new base is needed for the emulsion

membrane. KODAK Roller Transport Cleanup Film 4955 which has a polyester base that is coated with gelatin can be used for this purpose or a piece of undeveloped film on ESTAR Base that has been completely fixed and washed can also be used. The emulsion membrane should be lifted carefully and placed in the center of the new base material. Slowly apply concentrated PHOTO-FLO 200 Solution 1:10 with an eye dropper to the membrane on the new base material and flatten it as the PHOTO-FLO 200 Solution penetrates. Once the emulsion membrane is flat, protect it by covering it with another piece of film to make an emulsion sandwich. For this purpose use 3M translucent stripping film which has been fixed, washed, and dried in advance. Peel off the dry emulsion layer of the stripping

film and then place the stripping film emulsion against the flattened-out emulsion membrane. Smooth it gently with a rubber squeegee, working from the center to the outside. If the old emulsion membrane has any rips or separations, carefully lift a corner of the stripping film emulsion and move the edges together with the tip of a stylus or the end of a retouching brush.

RESTORING CELLULOSE NITRATE NEGATIVES. The negative should be placed face down on a glass plate and taped down on all sides with a solvent-resistant tape such as 3/4-inch SCOTCH Brand Polyester Film Tape No. 850 or 853. This combination is then placed in a tray and covered with a chlorine bleach such as CLOROX or SUNNY SOL. A white foam will

Figure 96 Restoration of a wrinkled diacetate sheet film negative: at the top, a copy print of the original wrinkled negative and at the bottom, a print made from the restored negative image. Courtesy Presidential Libraries of the National Archives.

form as the gel backing dissolves. This should be wiped off with lintless material such as WEBRIL Wiper or KIM-WIPES. When the backing has been completely removed in this manner, the negative on the glass sheet should be immersed in the solvent 2-butanone. This will convert the cellulose nitrate film base to a syrupy liquid that can be gently scraped off with a stiff cardboard squeegee. When the film base has been completely removed, the surface should be carefully wiped down with a solvent. The tape should then be gently peeled away from the glass and emulsion layer. The thick edge of nitrate base that was protected by the tape should be very carefully trimmed. The emulsion is now ready for transfer to a new support. This is accomplished exactly in the same manner as described for cellulose diacetate negatives. Sometimes a cellulose nitrate negative is first sprayed with lacquer on the emulsion side to avoid stretching of the emulsion. In this case, after separation has been effected the opposite side should be lacquered to equalize stress. A suitable lacquer is SIGMA PROTECT-O-COTE. However, instead of using PHOTO-FLO Solution for the lamination, a gelatin solution is required to provide adhesion. The gelatin solution is made by dissolving a seven-gram packet of KNOX Gelatin in 16-ounces of hot water and then allowing it to cool before use.

The emulsion sandwiches described above have shown very good stability and for this reason prints can be made from the restored negative image. However, there is no experience with long-term stability and it is therefore advisable to make duplicate negatives promptly from the restored image.

No hand retouching should be done on restored negative images without specific written permission from the owner of the artifact. Any necessary retouching should be done on prints made from the negatives or on the duplicate negatives.

Removal of Fungus.
Fungus is frequently found on artifacts in photographic collections. How it forms and how it can be prevented was discussed in the chapter on deterioration. In many cases, the growth or mold can be removed with careful procedures and the item restored to nearly its original condition. Fungus growth on an emulsion usually makes the gelatin soluble in water. For this reason, water should not be used to remove fungus from color or black-and-white negatives, transparencies, slides, and prints. It will damage the image.

REMOVAL OF FUNGUS FROM PRINTS.
Surface fungus on glossy prints can cause dull spots. If these spots are apparent, the fungus can be removed by wiping it with a soft, plush pad, absorbent cotton, or a chamois moistened sparingly with KODAK Film Cleaner. If there is evidence of degraded gelatin such as localized stripping, this means that the fungus has permanently damaged the emulsion and restoration is not possible. If the fungus attack is only slight and localized, the deterioration may be corrected by photographic reproduction but retouching of the copy negative or print made from it will probably be necessary. Any enclosures or storage containers that have been in contact with the prints should be destroyed.

REMOVAL OF FUNGUS FROM FILMS AND SLIDES.
If surface fungus is detected on negatives and slides, it can be removed in the same way as from prints by wiping them with a soft plush pad, absorbent cotton, or a chamois moistened sparingly with KODAK Film Cleaner. Slides should be removed from their cardboard mounts before cleaning and new mounts should be made after the cleaning.

Some films in photographic collections may be coated with a film lacquer if they were processed prior to 1970. (Kodak stopped lacquering films after 1970 and never lacquered EKTACHROME Films.)

If the fungus growth has not penetrated to the emulsion of films that are protected by a film lacquer, the lacquer can usually be removed by soaking the film in a dilute solution of sodium bicarbonate (baking soda). Dissolve a level tablespoon of soda in a pint of water at room temperature. If the artifact is a slide on KODACHROME Film, add about 1/2 fluidounce of formaldehyde (15 mL), 37-percent solution. Agitate the transparency for 1 minute, or a color negative for 4 minutes. Rinse for 1 minute in room-temperature water. The film should then be bathed for about 30 seconds in KODAK PHOTO-FLO 200 Solution (diluted as stated on the bottle) or an equivalent, and hung up to dry in a dust-free place. The film can be relacquered after it is completely dry.

This treatment should not be used if the fungus growth is extensive. If fungus has penetrated the emulsion, some of the emulsion may be removed by treatment with water. A test should be made using the least important slide or section of film before treating valuable films.

To remove film lacquer from films which have been damaged by fungus, treat the films with a solution of denatured alcohol and nondetergent household ammonia (1/2 oz of ammonia to 8 oz of alcohol). The type of alcohol used should be that used for thinning shellac and it can be purchased from paint and hardware stores. Rubbing alcohol should not be used. Any nondetergent household ammonia, either cloudy or clear, can be used if it is fresh and strong. The negatives and slides can be cleaned by dipping them and agitating

them in the alcohol-ammonia mixture or by wiping them with absorbent cotton saturated with the mixture. The film should be supported emulsion-side up, on a smooth nonporous surface such as a sheet of glass, to avoid scratching or marking the film base. The slides should be dried before being remounted. Negatives from KODACOLOR Film can be cleaned by dipping and agitating them in the solution for no longer than 2 minutes.

Slides that are 135 size or smaller should not be remounted in their original holders after the fungus growth has been removed. The slides should be thoroughly dried and then mounted in new cardboard mounts or in glass mounts. Experience with large numbers of glass-mounted, tape-bound slides in the tropics has disclosed very little evidence of trouble although there is a tendency for fungus to grow on the inside surface of the glass. When slides are bound in glass, both the film and the glass must be dry. Warming the slide glass and film to about 5.5°C (10°F) above room temperature for 5 to 10 minutes before assembly is usually sufficient. This can be accomplished by placing the materials on a piece of window glass mounted a few inches above a lighted electric lamp. It is advisable to wear cotton gloves or hold a clean, lintless tissue between the fingers and the film to avoid touching the film surfaces.

There is no known satisfactory method for complete restoration when the gelatin has become etched or distorted by fungus. If the fungus is in the gelatin backing only, the backing can be removed but the film may curl excessively as a result.

Restoration of Faded Color Transparencies. Transparencies found in photographic collections often show signs of fading, particularly those made on films 10 to 30 years ago. Not all transparencies are affected by fading. Generally speaking, KODACHROME Film transparencies do not show dye fading; KODAK EKTACHROME Films processed in the chemical Processes E-1, E-2, and E-3 may show some dye loss. A change in the color balance indicates some loss of dye in one or more layers of the transparency. There is usually a loss in contrast as well. The degree of dye loss varies with film type, film age, storage conditions, exposure to light, the quality of the process, and other variables beyond the control of both consumer and film manufacturer. Of special note is the dye fading that occurs in dark storage which is normally proportional to the amount of dye that formed in the image when it was processed. These faded transparencies can be restored by duplication procedures. The procedures used may vary from application to application depending on the different types of dyes in the transparency originals; the contrast relationship of the particular duplicating film emulsion; the degree and type of dye fading; the sensitivity of each emulsion layer to red, green, and blue light; the type of scenes; and the efficiency of filters. For information on restoring faded transparencies and negatives refer to CIS Publications 22 and 23 "Restoring Faded Color Transparencies by Duplication." These publications are available from Customer Technical Services, Eastman Kodak Company, Rochester, NY 14650.

Appendix A KODAK Processing Chemicals and Formulas Referred to in This Publication

Eastman Kodak Company manufactures a wide range of prepared chemicals for use in photographic processing. In addition, it has developed formulas for preparations similar to some of the prepared chemicals for those who wish to make their own chemicals. Information on the prepared chemicals and formulas mentioned in the foregoing text is given in this appendix for the benefit of conservators who are involved or interested in photographic processing themselves.

Photographic processing involves many complex reactions of chemicals in solution. These reactions determine to a great degree, the properties, and qualities of the image. Therefore, the purity, strength, and uniformity of the chemicals and the manner in which they are combined are of utmost importance in achieving results of uniformly high quality. Kodak-prepared chemicals provide accurately compounded solutions as well as savings in time. They require only dilution or dissolution according to the directions on the package. Some of these packaged preparations are essentially the same as the published formulas and are designated by the formula numbers. Other preparations, identified by trademarked names, are not identical with any published formulas, though in many cases their photographic properties are similar to those of certain popular formulas. Kodak-prepared chemicals offer many other advantages: a single product may contain many component parts, including chemicals that are not ordinarily stocked by dealers. They are thoroughly tested for reaction to humidity, heat, and cold; resistance to aeration; capacity; ease of mixing; clarity of solution; and useful life. For those who prefer to mix their own solutions from the published formulas, Kodak tested chemicals are available. They have been tested for purity and uniformity and when used according to the instructions given in the formulas produce solutions of consistent and reliable quality. Additional information on Kodak- prepared chemicals and formulas for photographic processing can be obtained in the Kodak publication J-1, *Processing Chemicals and Formulas* and in the publication *Chemicals in Conservation: A Guide to Possible Hazards and Safe Use* (see the bibliography).

KODAK-Prepared Developers

CAUTION: *Kodak chemicals should be used in strict compliance with recommended safety procedures and precautionary statements accompanying these chemicals should be read and understood before using them. It is recommended that all users read the two above publications prior to using these chemicals. Further information about the safe use of these chemicals can be obtained by referring to the section entitled "Using Photographic Chemicals" in the front of this publication.*

KODAK MICRODOL-X Developer. KODAK MICRODOL-X Developer is an excellent fine-grain developer which produces low graininess coupled with high sharpness of image detail. The stock solution can be diluted 1:3, in which case greater sharpness can be attained, with a slight sacrifice of quality in grain characteristics and a loss in film speed. MICRODOL-X Developer has very little tendency to sludge with use, is free from sludge when dissolved in hard water, and has no tendency to form scum on exhaustion, aeration, or replenishment.

Development Recommendations: The average development time, using the developer full strength, is about 10 minutes in a tank at 20°C (68°F).

Capacity: Without replenishment, 4 rolls of 620-size film or 36-exposure 35 mm film or equivalent (2,060 square centimetres—320 square inches) per 946 millimetres (1 quart) of full-strength developer. After the first roll has been developed, the development time must be increased by about 15 percent for each succeeding roll developed per litre (quart). With replenishment, capacity is increased to 15 rolls per quart, and development time remains constant.

For MICRODOL-X Developer, diluted 1:3, capacity is two rolls (1030 square centimetres or 160 square inches) per 946 millilitres (1 quart). When developing a roll of 36-exposure 35 mm film in an 8-fluidounce (236-millilitre) tank of MICRODOL-X Developer diluted 1:3, increase the recommended developing time by about 10 percent. MICRODOL-X Developer (1:3) cannot be replenished. Discard after use.

Replenishment: Small tank—Add 30 millilitres (1 fluidounce) of MICRODOL-X Replenisher per 516 square centimetres (80 square inches) processed.

Package Sizes: KODAK MICRODOL-X Developer is supplied in packets, to make 4 fluidounces (118 millilitres); also packages to make 1 quart (946 millilitres) and 1 and 5 gallons (3.8 litres and 19 litres). KODAK MICRODOL-X Liquid Developer is supplied in 1-quart (946-millilitre) bottles of ready-to-use solution. MICRODOL-X Replenisher is supplied in packages to make 1 quart (946 millilitres) and 1 gallon (3.8 litres).

KODAK DEKTOL Developer. KODAK DEKTOL Developer is a single-powder, easily prepared developer for producing neutral cold-tone images on cold-tone papers. It remains unusually free from muddiness, sludge, precipitation, and discoloration throughout the normal solution life. It has a high capacity and uniform development rate.

Development Recommendations: Dilute 1 part of stock solution with 2 parts of water. Average development times for recommended papers range from 1 to 1 1/2 minutes at 20°C (68°F).

Package Sizes: Cartons of 6 packets each, to make 8 fluidounces (236 millilitres) of working solution; also packages to make 1 quart (946 millilitres) and 1/2, 1, 5, 25, and 50 gallons (1.9, 3.8, 19, 95, and 189 litres) of stock solution.

KODAK EKTAFLO Developer, Type 1.

KODAK EKTAFLO Developer, Type 1, is a concentrated liquid developer that is diluted 1:9 for print processing. Its characteristics are similar to those of KODAK DEKTOL Developer, in that it yields neutral or cold tones on cold-tone papers.

Development Recommendations: Average development times for recommended papers range from 1 to 1 1/2 minutes at 20° C (68° F).

Package Size: 1 gallon (3.8 litres) of the concentrate in a plastic container.

KODAK EKTAFLO Developer, Type 2.

KODAK EKTAFLO Developer, Type 2, is a concentrated liquid developer for warm-tone papers. It is similar to KODAK EKTONOL Developer and yields warm, rich tones on papers for which its use is recommended. The concentrate is diluted 1:9 for use.

Development Recommendations: Develop warm-tone papers for 2 minutes at 20° C (68° F). Increased developing time results in colder tones.

Package Size: 1 gallon (3.8 litres) of the concentrate in a plastic container.

KODAK Developer D-11.

KODAK Developer D-11 is a vigorous film-and-plate developer with good keeping properties, for general use where high contrast is desired. When very high contrast is desirable, use KODAK Developer D-8. D-11 Developer is recommended for use with high-contrast films for reproducing written or printed matter, line drawings, and similar material.

Development Recommendations: For line subjects, use without dilution. For development of copies of continuous-tone subjects, dilute with an equal volume of water. Develop about 5 minutes in a tank or 4 minutes in a tray at 20°C (68°F).

Package Sizes: To make 1 and 5 gallons (3.8 and 19 litres).

KODAK Developer D-19. A high-contrast, clean-working developer, KODAK Developer D-19 produces brilliant negatives with short development times. It has good keeping properties and high capacity. D-19 Developer is recommended especially for continuous-tone work that requires higher-than-normal contrast.

Development Recommendations: Develop about 6 minutes in a tank or 5 minutes in a tray at 20°C (68°F).

Package Sizes: To make 1 and 5 gallons (3.8 and 19 litres).

KODAK Developer DK-50.

Clean-working and moderately fast, KODAK Developer DK-50 is extremely popular with commercial and portrait photographers. It can be used with or without dilution, in a tank or tray, to produce crisp-looking negatives from all types of subjects. DK-50 Developer is highly recommended for portraiture.

Development Recommendations: For tank development of portrait negatives, dilute with an equal volume of water; develop about 10 minutes at 20° C (68° F). For tray development, use without dilution; develop about 6 minutes at 20° C (68° F).

For commercial work, use without dilution. Develop about 6 minutes in a tank or 4 1/2 minutes in a tray at 20° C (68° F).

Replenishment: Add 30 millilitres (1 fluidounce) of KODAK Replenisher DK-50R per 8 x 10-inch (20.3 x 25.4-centimetre) sheet or equivalent (516 square centimetres or 80 square inches) processed.

If the developer is diluted 1:1 for use, the replenisher should be diluted in the same proportion.

Package Sizes: To make 1, 3 1/2, and 10 gallons (3.8, 13.2, and 38 litres). KODAK Replenisher DK-50R is available in a 1-gallon (3.8-litre) size.

KODAK Developer D-76. KODAK Developer D-76 is unsurpassed by any other Kodak developer in ordinary use for its ability to give full emulsion speed and maximum shadow detail with normal contrast. Films developed in D-76 Developer have excellent grain characteristics. For greater sharpness, but with a slight sacrifice in grain characteristics, dilute the developer 1:1. D-76 Developer has excellent development latitude, and produces relatively low fog on forced development. This developer has long been a favorite of pictorial photographers.

Development Recommendations: For sheet films, the average development time is about 9 minutes in a tray or 11 minutes in a tank at 20°C (68°F).

Replenishment: Add 30 millilitres (1 fluidounce) of KODAK Replenisher D-76R per 8 x 10-inch (20.3 x 25.4-centimetre) sheet or equivalent (516 square centimetres or 80 square inches) processed.

Package Sizes: To make 1 quart (946 millilitres) and 1/2, 1, and 10 gallons (1.9, 3.8, and 38 litres). KODAK Replenisher D-76R is available in a size to make 1 gallon (3.8 litres).

KODAK HC-110 Developer.

KODAK HC-110 Developer is a highly active solution designed for rapid development of most black-and-white films. Available in concentrated liquid form, it yields six different working solutions when diluted according to instructions. It is an extremely versatile developer and, because of its concentrated liquid form, is easy to mix and use.

HC-110 Developer produces sharp images with good grain characteristics, maximum shadow detail, and long density scale, but causes no loss in film speed. It is particularly suitable for commercial, industrial, and press photography. For more detailed information, consult KODAK Pamphlet No. G-13, *KODAK HC-110 Developer*. A single copy can be obtained on request from Eastman Kodak Company, Department 412-L, 343 State Street, Rochester, New York 14650.

Development Recommendations: Prepare stock and working solutions as indicated on the bottle. The average development time in a tank, at 20°C (68°F), with Dilution A (1:15 dilution of the concentrate), is 3 1/2 minutes for film packs and rolls, 3 3/4 minutes for sheet films; with Dilution B (1:31 dilution of the concentrate), 5 3/4 minutes for film packs and rolls, 6 1/4 minutes for sheet films.

Replenishment: Add KODAK HC-110 Developer Replenisher solution to Dilution A at the rate of 22 millilitres (3/4 fluidounce) per 516 square centimetres (80 square inches) of film. To replenish Dilution B, dilute the stock replenisher solution with 1 part of water per 2 parts of replenisher, and replenish as directed for Dilution A.

Package Sizes: KODAK HC-110 Developer is supplied in highly concentrated liquid form in bottles to make 2 and 3 1/2 gallons (7.6 and 13.2 litres) of Dilution A; KODAK HC-110 Developer Replenisher is supplied in a bottle to make 1 gallon (3.8 litres).

KODAK TECHNIDOL LC Developer.

KODAK TECHNIDOL LC Developer is manufactured for use with KODAK Technical Pan Film 2415. It is available in a 3-packet pouch. Each packet holds enough powder to make 1 U.S. pint (473 mL) of solution sufficient to process two 135-36-size rolls of KODAK Technical Pan Film 2415 in conventional stainless steel spiral reel tanks. It should be used to process one or two rolls at the same time. Processing two rolls in succession is not recommended. The developer should be used immediately after mixing because it is a one-time developer. It must be used within 24 hours after mixing. Refer to the packet.

The suggested processing conditions for KODAK TECHNIDOL LC Developer with KODAK Technical Pan Film 2415 are as follows:

Exposure Index: 25 for trial exposures (based upon the formula EI = 0.81. E is the 1/25 second exposure in lux seconds required for a density of 0.1 above minimum density.)

Development: Refer to small tank processing section

Temperature: 20°C (68°F) 25°C (77°F) 30°C (86°F)

Time: 15 min 11 min 8 min

Develop to the desired contrast index, based on the suggested starting points. The contrast index is dependent primarily upon the developer, temperature, dilution, and development time chosen. It is affected to a lesser extent by exposure time, specific processing techniques, and normal product variability. Therefore, the times given above should be considered as starting points only.

NOTE: If one of the optional developer temperature recommendations are used, the rinse and fix temperatures should be maintained within 1.7°C (3°F) of the developer temperature, and the wash temperature maintained within 3°C (5°F) of the developer temperature.

KODAK Developer Formulas
KODAK Fine Grain Developer DK-20

This developer is recommended for use with films and plates.

Water, about 50°C (125°F)	750.0 millilitres
KODAK ELON Developing Agent	5.0 grams
KODAK Sodium Sulfite (Anhydrous)	100.0 grams
KODALK Balanced Alkali	2.0 grams
KODAK Sodium Thiocyanate (Liquid)	1.5 millilitres
KODAK Potassium Bromide (Anhydrous)	0.5 gram
Cold water to make	1.0 litre

The average development time with this developer is 15 minutes in a tank at 20°C (68°F).

The useful life of DK-20 Developer can be increased 5 to 10 times by the use of KODAK Replenisher DK-20R.

KODAK Developer DK-50

Stock Solution

Water, about 50°C (125°F)	500.0 millilitres
KODAK ELON Developing Agent	2.5 grams
KODAK Sodium Sulfite (Anhydrous)	30.0 grams
KODAK Hydroquinone	2.5 grams
KODALK Balanced Alkali	10.0 grams
KODAK Potassium Bromide (Anhydrous)	0.5 gram
Water to make	1.0 litre

See the section on prepared developers in this section for information on use.

KODAK Developer D-72

Water, about 50°C (125°F)	500.0 millilitres
KODAK ELON Developing Agent	3.0 grams
KODAK Sodium Sulfite (Anhydrous)	45.0 grams
KODAK Hydroquinone	12.0 grams
KODAK Sodium Carbonate (Monohydrated)	80.0 grams
KODAK Potassium Bromide (Anhydrous)	2.0 gram
Water to make	1.0 litre

FOR USE: Dilute 1 part of stock solution with 2 parts of water.

KODAK DEKTOL Developer is a packaged preparation with similar photographic properties.

KODAK Developer D-76

Water, about 50°C (125°F)	750.0 millilitres
KODAK ELON Developing Agent	3.0 grams
KODAK Sodium Sulfite (Anhydrous)	100.0 grams
KODAK Hydroquinone	7.5 grams
KODAK Borax (Granular)	20.0 grams
Water to make	1.0 litre

See the section on prepared developers for information on use.

Kodak-Prepared Stop Baths, Fixing Baths, and Hardeners

KODAK Indicator Stop Bath. Supplied in convenient concentrated liquid form, KODAK Indicator Stop Bath makes up quickly into a nonhardening stop bath for use with films, plates, or papers. Light yellow when freshly mixed, the bath turns purplish blue when exhausted; it then appears dark under a safelight, and must be discarded.

Package Sizes: Available in 16-fluidounce (473-millilitre) and 1-gallon (3.8-litre) bottles of concentrated solution.

KODAK Rapid Fixer. KODAK Rapid Fixer is a concentrated easy-to-prepare hardening fixing bath with long life and high capacity. It is intended primarily for very rapid fixing of films and plates, but with proper dilution can be used for papers. The proportion of hardener constituent may be varied in special cases according to summer and winter requirements. When it is mixed in the recommended proportions, the hardening action is sufficiently rapid to allow taking full advantage of the very rapid fixing rate.

For Films or Plates: Dilute in the ratio of 946 mL (1 quart) of Solution A to 1.89 litres (1/2 gallon) of water; then add slowly, while stirring, 90 mL (3 ounces) of Hardener Solution B; finally, add water to make 3.78 litres (one gallon).

For Papers: Dilute in the ratio of 473 mL (1 pint) of Solution A to 1.89 litres (1/2 gallon) of water.

KODAK Formulas for Stop Baths, Fixing Baths, and Hardeners
KODAK Stop Bath SB-1

Water	1.0 litre
*KODAK 28% Acetic Acid	48.0 millilitres

*To make approximately 28% acetic acid from glacial acetic acid, dilute 3 parts of glacial acetic acid with 8 parts of water. Rinse prints 5 to 10 seconds with agitation.

KODAK Fixing Bath F-6. In warm weather and in inadequately ventilated darkrooms, the odor of sulfur dioxide given off by the KODAK Fixing Bath F-5 may be objectionable. This can be eliminated almost entirely by omitting the boric acid and substituting twice its weight in KODALK Balanced Alkali. This modification, which is known as KODAK Fixing Bath F-6, can also be used to advantage for fixing prints, since it washes out of photographic papers more rapidly than the baths which have a greater hardening action. It should be used in conjunction with a stop bath such as KODAK Indicator Stop Bath or KODAK Stop Bath SB-1 to obtain the full useful life.

KODAK Special Hardener SH-1

Water	500 millilitres
Formaldehyde, about 37% solution by weight	10.0 millilitres
KODAK Sodium Carbonate (Monohydrated)	6.0 grams
Water to make	1.0 litre

This formula is recommended for the treatment of negatives that normally would be softened by the chemical treatment given for the removal of stains or for intensification or reduction.

After hardening for 3 minutes, negatives should be rinsed and immersed for 5 minutes in a fresh acid fixing bath and then washed thoroughly before they are given any further chemical treatment.

See Also Formula Page 88.

Formulas for KODAK Testing Solutions for Print Stop Baths and Fixing Baths

The KODAK Testing Solutions for Print Stop Baths and Fixing Baths provide a quick and accurate method for determining when such baths should be revived or discarded. Since the appearance of a fixing bath, or of an acid stop bath without indicator, changes very little during its useful life, some means of determining when it is unfit for further use should be employed. These solutions permit a quick check on the acidity of the stop bath and the silver content of the fixing bath.

KODAK Stop Bath Test Solution, SBT-1

Water (distilled or demineralized) at 26.5°C (80°F)	750.0 millilitres
Sodium Hydroxide	6.0 grams
With stirring add:	
Bromocresol Purple (EASTMAN Organic Chemical No. 745*)	4.0 grams
Mix for 15 to 20 minutes, then add phosphoric acid (86%)	3.0 millilitres
Water to make	1.0 litre

*EASTMAN Organic Chemicals can be obtained from many laboratory supply dealers.

Caution: The Stop Bath Test Solution contains chemicals that can be hazardous if not used in accordance with recommended safety procedures.

Sodium hydroxide is caustic and is capable of causing severe burns in all tissues. Special care should be taken to prevent contact with skin or eyes. A face shield or goggles should be used when handling the solid compound.

Phosphoric acid is a strong, nonvolatile inorganic acid. It is corrosive to tissue and can cause severe skin or eye burns. Impervious gloves and goggles should be worn when handling the concentrated solution.

In case of contact with either of these chemicals, immediately flush the involved areas with plenty of water; for eyes, get prompt medical attention.

For information on the use of this solution in determining the condition of a stop bath see Chapter VI, "Processing For Black-and-White Stability."

KODAK Fixer Test Solution, FT-1

Water at 26.5°C (80°F)	750.0 millilitres
Potassium Iodide	190.0 grams
Water to make	1.0 litre

See the section on testing a print fixing solution in Chapter VI for use instructions.

KODAK-Prepared Chemical Processing Aids

KODAK Anti-Fog, No. 1 (Benzotriazole).
KODAK Anti-Fog, No. 1, tends to suppress fog when added to a film or paper developer, and thus effectively increases contrast by producing relatively fog-free negatives and clean highlights in the prints. Anti-Fog, No. 1, is useful when films or papers tend to show fog from excessive age or unfavorable storage conditions, when long storage of films or papers has occurred between exposure and processing, and when forced development seems necessary. It is also useful in retarding fog during warm-weather processing, when it may not be possible to maintain the developer at 20°C (68°F).

Package Sizes: Available in 50-tablet bottles, and 4-ounce (113-gram) and 1-pound (454-gram) bottles of dry powder.

KODAK PHOTO-FLO Solution.
KODAK PHOTO-FLO Solution is a powerful wetting agent that has been carefully selected as safe and dependable for photographic use. PHOTO-FLO Solution decreases the surface tension of water so that it flows evenly from film surfaces without collecting in drops. Thus the solution prevents the water marks and streaks that might otherwise be produced during drying. It also helps water solutions to flow evenly onto the emulsion surface, and so facilitates the application of watercolors, opaques, and retouching dyes.

No sludge or precipitate forms when KODAK PHOTO-FLO Solution is mixed with hard water, or when it is contaminated by traces of fixing bath introduced by incompletely washed films.

KODAK PHOTO-FLO Solution is available in three different concentrations; when diluted according to instructions, each concentrate yields the same working solution. Working solutions are made by mixing the concentrate with water in the following proportions: for KODAK PHOTO-FLO 200 Solution, 1:200; for KODAK PHOTO-FLO 600 Solution, 1:600; and KODAK PHOTO-FLO 2100 Solution, 1:2100.

Directions for Use: Drying—Wash the films thoroughly, bathe them for about 30 seconds in a working solution of PHOTO-FLO Solution, drain them briefly, and hang them to dry. Wiping is unnecessary. Intensification and reduction—Before intensifying or reduc-

ing negatives, bathe them for about 1 minute in the working solution. This promotes uniform action of the intensifier or reducer. Coloring and retouching films and prints—Add double-strength dilute PHOTO-FLO 200 Solution (i.e., 1:100 instead of 1:200) to the water-color solution or the opaque, or treat the surface of the material with the normal working solution.

Package Sizes: KODAK PHOTO-FLO 200 Solution is available in 4-fluidounce (118-millilitre) and 16-fluidounce (473-millilitre) bottles. KODAK PHOTO-FLO 600 Solution (concentrated) and KODAK PHOTO-FLO 2100 Solution (superconcentrated) are both available in a 1-gallon (3.8-litre) jug.

KODAK Farmer's Reducer.

KODAK Farmer's Reducer is a high-capacity, subtractive reducer which removes equal quantities of silver from high, intermediate, and low densities. It is recommended for all general reduction of overexposed or overdeveloped negatives or slides. The extent of the reduction can be easily controlled by visual examination during the treatment. All operations can be carried out under normal room lighting.

Package Size: Packets to make 1 quart (946 millilitres).

KODAK Hypo Clearing Agent.

KODAK Hypo Clearing Agent can be used to save time and water when removing hypo from films and from nonresin-coated photographic papers. A rinse between fixing and treatment in hypo clearing agent is optional, but significantly increases the capacity of the hypo clearing agent solution.

Directions for Use: After fixing and washing (if desired), treat films for 1–2 minutes, single-weight prints for 2 minutes, or double-weight prints for 3 minutes in the clearing agent solution. Wash according to the times and instructions given with the Hypo Clearing Agent. If longer washing times are used than are suggested, increased stability will result. Nevertheless, the recommended wash times provide a higher degree of stability than would be obtained with normal processing conditions. Even with wash water at temperatures as low as 2°C (35°F), the stability obtained equals that produced by normal washing conditions. See Chapter VI "Processing For Black-and-White Stability" for further information on the use of this product.

Package Sizes: KODAK Hypo Clearing Agent is available in cartons of 5 packets each, each packet to make 5 quarts (4.7 litres), and in packages to make 5 gallons (19 litres) of working solution.

Formulas for KODAK Chemical Processing Aids
KODAK Hypo Eliminator HE-1

Water	500.0 millilitres
Hydrogen Peroxide (3% solution)	125.0 millilitres
*Ammonia Solution	100.0 millilitres
Water to make	1.0 litre

Caution: Prepare the solution immediately before use and keep in an open container during use. Do not store the mixed solution in a stoppered bottle, or the gas evolved may break the bottle.

*Prepared by adding 1 part of concentrated ammonia (28%) to 9 parts of water.

Directions for Use: Treat the prints with KODAK Hypo Clearing Agent, as described in the previous section or wash them for about 30 minutes at 18.5 to 21°C (65 to 70°F) in running water flowing rapidly enough to replace the water in the tray or tank once every 5 minutes. Then immerse each print for approximately 6 minutes at 20° C (68° F) in Hypo Eliminator HE-1 solution, and finally wash about 10 minutes before drying. At lower temperatures, increase the washing time.

Useful Capacity: Approximately thirteen 8 x 10-inch (20.3 x 25.4-centimetre) prints, or their equivalent per 946 millilitres (1 quart).

KODAK Intensifiers and Reducers

With modern negative materials and printing papers, and modern control techniques for exposure and development, reduction or intensification operations are seldom needed, but they may occasionally be used to salvage a mistake when it is not possible to remake the negative.

In general, some increase in graininess may occur with intensifiers, especially in the treatment of coarse-grained emulsions. On the other hand, a decrease in graininess does not usually occur with reducers, although it has been observed in some instances.

Precautions: Intensification or reduction always involves some danger of ruining the image. Therefore, the best possible print should be made before attempting such treatments. In addition, to reduce the likelihood of staining or other damage, the following precautions should be observed: (1) The negative should be fixed and washed thoroughly before treatment and be free of scum or stain; (2) It should be hardened in the formalin hardener, KODAK Prehardener SH-1, before the intensification or reduction treatment; (3) Only one negative should be handled at a time, and it should be agitated thoroughly during the treatment. Following the treatment, the negative should be washed thoroughly and wiped off carefully before drying.

KODAK Abrasive Reducer (Prepared). A prepared paste available in a 15 mL (1/2-ounce) jar that permits quick reduction of dense areas in a negative without scratching. Applied with cotton.

KODAK Mercury Intensifier IN-1 (Formula). Bleach the negative in the following solution until it is white; then wash it thoroughly.

KODAK Potassium Bromide (Anhydrous)	22.5 grams
*Mercuric Chloride	22.5 grams
Water to make	1.0 litre

Following the bleach and wash, the negatives can be intensified in any of the following solutions. Each solution, as listed, gives greater density than the one preceding it.

1. a 10% sulfite solution

2. a developing solution, such as KODAK Developer D-72 diluted 1:2

3. dilute ammonia [1 part of concentrated ammonia (28%) to 9 parts of water]

4. for greatly increased contrast, the following solutions, used as directed:

Solution A

Water	500.0 millilitres
*Sodium Cyanide	15.0 grams

Solution B

Water	500.0 millilitres
KODAK Silver Nitrate, Crystals	22.5 grams

*DANGER! Mercuric chloride and sodium cyanide can be fatal if swallowed, inhaled, or absorbed through the skin. Protective gloves should be worn when handling these chemicals or their solutions. Wash thoroughly after handling. Cyanide salts and solutions should be used in well ventilated areas. Sodium cyanide reacts with acids to form the poisonous gas hydrogen cyanide. Place clearly recognizable poison labels on all containers of these chemicals. Keep out of the reach of children.

To prepare the intensifier, add the silver nitrate Solution B, to the cyanide, Solution A, until a permanent precipitate is just produced; allow the mixture to stand a short time; then filter. The resultant solution is called MONCKHOVEN'S Intensifier.

Redevelopment cannot be controlled as with the chromium intensifier, KODAK Chromium Intensifier In-4, but must go to completion.

Ammonium Thiosulfate Reducer. This very useful reducer is easily prepared by adding citric acid to an ammonium thiosulfate rapid fixing bath, such as KODAFIX Solution.

The reducer gives off a strong odor of sulfur dioxide, and should be used in a well-ventilated room. Do not use it near sensitized photographic products. Before reducing the negative or print, clean it thoroughly; use KODAK Film Cleaner, if necessary, to remove any surface grease left from handling. Thoroughly prewet the material in diluted KODAK PHOTO-FLO Solution, in order to promote uniform reducing action.

Since the reducer is colorless, the course of the reducing action can be observed easily. When the desired degree of reduction is obtained, wash the material thoroughly, and dry.

Normal Ammonium Thiosulfate Reducer: for use in the removal of silver stains and dichroic fog, and for the reduction of prints and fine-grain negative materials.

To Make: Dilute 1 part of KODAFIX Solution with 2 parts of water, or dilute KODAK Rapid Fixer and add hardener, as recommended for the rapid fixing of negatives. To each litre of the diluted fixer add 15 grams of KODAK Citric Acid (anhydrous)†.

Removal of silver stains and dichroic fog. Immerse the negative or print in the solution and swab the surface with absorbent cotton to hasten removal of surface scum. The action is usually complete in 2 to 5 minutes. Remove the negative or print from the solution immediately if any reduction of low-density image detail is noted.

Reduction of prints and fine-grain negative materials. This solution is particularly useful for correcting slight overexposure or overdevelopment; strong reduction may cause loss of image quality.

Strong Ammonium Thiosulfate Reducer: for the reduction of negative materials.

To Make: Dilute the KODAFIX Solution or the Rapid Fixer as directed above, but add 30 grams of KODAK Citric Acid (Anhydrous)† per litre, instead of the 15 grams as recommended.

The time of treatment will depend on the type of material and the degree of reduction desired. The reaction is very slow with high-speed materials.

More complete details on the characteristics of this type of reducer are given in the paper entitled "An Ammonium Hypo Reducer" by Henn, Crabtree, and Russell, *PSA Journal (Photographic Science and Techniques Section)* 17B, November, 1951.

†Possible sulfurization of the thiosulfate in the fixer can be avoided by dissolving the citric acid in a portion of the water used for dilution.

Kodak-Prepared Toners for Post Processing Image Protection

KODAK Rapid Selenium Toner. KODAK Rapid Selenium Toner is a concentrated single-solution toner that can be used at various dilutions with Kodak warm-tone papers to produce several hues of reddish-brown tones. The working solutions have no marked odor and are used at room temperature. The toned image is quite permanent.

Package Sizes: Available in 8-fluidounce (236-millilitre), 1-quart (946-millilitre), and 1-gallon (3.8-litre) bottles.

Tone Control: When the full effect of toning is desired in minimum time, use a dilution of 1 part of toner to 3 parts of water. Complete toning occurs in 2 to 8 minutes at 20°C (68°F), depending on the type of paper used. When intermediate tones are desired, use a more dilute solution, such as 1 part of toner to 9 parts of water. The toning action is then much slower, and the print can be removed when the desired intermediate tone is obtained. Toning continues for a short time in the wash water, and allowances should be made for this action.

KODAK POLY-TONER. By varying the dilution and toning times of this single-solution direct toner, a series of hues can be produced. They range from a reddish brown, similar to that produced by KODAK Rapid Selenium Toner, to a very warm brown approaching that produced by KODAK Brown Toner. KODAK POLY-TONER is recommended for use with KODAK PORTRALURE and EKTALURE Papers.

Tone Control: KODAK POLY-TONER can be thought of as two toners in one solution—the "selenium type" being most active at high concentrations (such as 1:4) and the "brown type" being most active at low, or dilute (1:50), concentrations.

Dilutions of KODAK POLY-TONER

Dilution (Toner:Water)	Temperature	Time (Approximate)
1:4	21°C (70°F)	1 minute
1:24	21°C (70°F)	3 minutes
1:50	21°C (70°F)	7 minutes

In most cases, the 1:24 dilution with a toning time of only 3 minutes will produce the most pleasing tone. Tones intermediate to those produced by the recommended dilutions can be obtained by varying the dilution.

Package Sizes: Available in 1-quart (946-millilitre) and 1-gallon (3.8-litre) containers of stock solution.

KODAK Sepia Toner. KODAK Sepia Toner is a two-solution toner of the bleach and redevelop type. It is one of the few toners that will produce pleasing warm-brown tone on cold-tone papers. With the inherently warm-tone papers, it tends to produce rather pronounced yellowish-brown tones. Appreciable tone control with Sepia Toner is not practical; to avoid irregular tones, prints should be fully bleached before sulfiding.

Package Size: Available in a 2-part packet to make 1 quart (946 millilitres) each of bleach and toner.

Formulas for Aids for Long-Term Keeping
KODAK Gold Protective Solution GP-1

Water	750.0 millilitres
*Gold Chloride (1% stock solution)	10.0 millilitres
KODAK Sodium Thiocyanate (Liquid)	15.2 millilitres
Water to make	1.0 litre

*A 1% stock solution of gold chloride can be prepared by dissolving 1 gram in 100 millilitres of water.

Add the gold chloride stock solution to the volume of water indicated. Dissolve the sodium thiocyanate separately in 125 millilitres of water. Then add the thiocyanate solution slowly to the gold chloride solution, stirring rapidly.

To Use: Immerse the well-washed print (preferably treated with hypo eliminator) in the Gold Protective Solution for 10 minutes at 20°C (68°F), or until a just-perceptible change in image tone (very slightly bluish black) takes place. Then wash for 10 minutes in running water and dry as usual.

The Gold Protective Solution GP-1 provides good image protection but it is not as effective as the prepared toners mentioned previously.

Materials for Use in Testing for Silver and Hypo

Tests for Silver. An overworked fixing bath contains complex silver thiosulfate compounds that are retained by the films or prints and cannot be removed completely by washing. These salts lead to stains which may not become evident for a period of time. The following testing solutions will provide a quick and accurate method for determining when a print fixing bath should be discarded.

KODAK Residual Silver Test Solution ST-1

Water	125.0 millilitres
Sodium Sulfide (Anhydrous)	2.0 grams

Store in a small stoppered bottle for not more than 3 months.

To Use: Dilute 1 part of stock solution with 9 parts of water. The diluted solution keeps for a limited time, and should be replaced weekly. For information on the use of this solution see Chapter VI, "Processing For Black-and-White Stability."

KODAK Rapid Selenium Toner

If a more stable reagent than Silver Test Solution ST-1 is needed, a dilute solution of KODAK Rapid Selenium Toner can be used to test whether prints are thoroughly fixed.

To use, dilute 1 part of KODAK Rapid Selenium Toner with 9 parts of water. These proportions are not critical. Using this solution, follow the directions given above for the use of KODAK Residual Silver Test Solution ST-1.

NOTE: The test fails where a very large excess of hypo is present, as in stabilized prints.

TEST FOR HYPO. The residual hypo content of films and prints can be accurately determined only by actually testing the processed photographic material. A test solution for such a purpose is described below.

KODAK Hypo Test Solution HT-2

Water	750.0 millilitres
*KODAK 28% Acetic Acid	125.0 millilitres
KODAK Silver Nitrate, Crystals	7.5 grams
Water to make	1.0 litre

*To make approximately 28% acetic acid from glacial acetic acid, dilute 3 parts of glacial acid with 8 parts of water.

Store in a screw-cap or glass-stoppered brown bottle, away from strong light. Do not allow the test solution to come in contact with hands, clothing, negatives, prints, or undeveloped photographic material; it will stain them black. For information on the use of this solution to test for residual fixing chemicals, see Chapter VI, "Processing For Black-and-White Stability."

Formulas for Use in the Restoration of Deteriorated Images

A procedure for the removal of certain stains from photographic prints, particularly in the image silver, involves bleaching the image and the stain (usually silver sulfide) to a silver salt that can be redeveloped to produce a normal black-and-white image tone. The formulas for the chemicals that may be used in this procedure are listed in the following section. The bleach and redevelopment technique is fully described in Chapter XI.

KODAK Cupric Chloride Special Bleach Bath

Water	750.0 millilitres
Cupric Chloride	125.0 grams
Citric Acid	4.0 grams
Water to make	1.0 litre

KODAK Stain Remover S-6

Stock Solution A

Potassium Permanganate	5.0 grams
Water to make	1.0 litre

Stock Solution B

Cold water	500.0 millilitres
Sodium Chloride	75.0 grams
*Sulfuric Acid (concentrated)	16.0 millilitres
Water to make	1.0 litre

***CAUTION:** Always add the sulfuric acid to the solution slowly, stirring constantly, and never the solution to the acid; otherwise, the solution may boil and spatter the acid on the hands or face, causing serious burns.

Mix the chemicals in the order given. When mixing Solution A, be sure that all the particles of permanganate are completely dissolved; undissolved particles may produce spots on the negatives.

When you are ready to begin the stain removal procedure, mix equal parts of Solution A and Solution B. This must be done immediately prior to use; the solutions do not keep long in combination.

KODAK Special Preparations

KODAK Film Cleaner. This is a prepared liquid cleaner that can be used to remove surface dirt from negatives. KODAK Film Cleaner can be harmful or fatal if swallowed. Use with adequate ventilation. Avoid prolonged or repeated breathing of vapor and skin contact. Keep out of the reach of children.

Appendix B Sources and Suppliers for Products

For the convenience of our readers, a listing of some of the suppliers of some of the products described in this publication is included in this appendix. This listing does not represent an endorsement by Eastman Kodak Company or any of its representatives of the performance of any product supplied or procedures recommended by the manufacturers or distributors listed or of the safety procedures they recommend. Changes in manufacturing procedures or the raw materials used to fabricate, mold, or assemble these products may result in a less acceptable product than the one in current use. It is suggested that the conservator procure and study the detailed product descriptions given in the catalogs of these suppliers. The products are listed by the chapter numerical order in which they are mentioned. Addresses and phone numbers were correct at the time of compilation.

Chapter VII Color Photographic Images

Low Temperature
Storage Vault
 Advanced Media Archives
 838 Seward Street
 Hollywood, CA 90038
 Attention: Jack B. Goldman

Chapter VIII Deterioration

Davison Silica Gel Air Dryers
 Davison Chemical Divison
 W. R. Grace & Co.
 10 East Baltimore Street
 Baltimore, MD 21202

Hyamine 1622
 Rohm and Haas Co.
 Independence Mall West
 Philadelphia, PA 19106

Imperial Commercial Freezer for stabilizing nitrate negatives

 Northland Refrigerator Co.
 P. O. Box 114A
 Greenville, MI 48838

Laminated polyethylene-aluminum foil paper from which KODAK Storage Envelopes for Processed Film are made.

 Crown Zellerbach
 Flexable Packaging Division
 Park 80 Plaza—West I
 Saddlebrook, NJ 07662

 Northern Packaging Corp.
 777 Driving Park Avenue
 Rochester, NY 14613

Chapter IX Storage and Display of Photographic Artifacts

The materials described in this chapter are available from the following companies. Included are matting, mounting and display boards; paper envelopes; interleaves; acid-free paper; seamless negative enclosures; identification tags; mounting corners; wrapping paper; acid-free tissue; storage boxes; and marking inks. The storage and display materials have conformed in the past to specifications spelled out in ANSI Standard PH 1.53-1984, "Photography (Processing)—Processed Films, Plates, and Paper—Filing Enclosures and Containers for Storage."

Many of the items available are described as acid-free lignin-free, sulfur-free and buffered or unbuffered. Generally, the unbuffered materials have a pH 6.5–7.5, while the buffered ones have pH 8.0 ± 0.5.

Seamless Envelopes for Viewing Negatives in Place
 G. Ryder & Co. Ltd.
 United Kingdom. These materials are now available also from Process Materials Corp. and Light Impressions.

Polypropylene Enclosures
Franklin Distribution Corp.
P. O. Box 320
Denville, NJ 07834
(201) 267-2710

Kleer Vu Industries, Inc.
Kleer-Vu Drive
Brownsville, TN 38012

20th Century Plastics, Inc.
3628 Crenshaw Boulevard
Los Angeles, CA 90016

Ring Binder for Archival Materials
The Quill Corporation
3200 Arnold Lane
Northland, IL 60062

Photo Album for Long-Term Preservation
Daytimer's Inc.
P. O. Box 2368
Allentown, PA 18001

KODAK No. 85 Black Ink for Identifying Artifacts
Customer Technical Services
Eastman Kodak Company
Rochester, NY 14650

Archivart Photographic Board
Process Materials Corp.
301 Veterans Boulevard
Rutherford, NJ 07070
(201) 935-2900

Acid-free mounting board
Light Impressions
P. O. Box 3012
Rochester, NY 14614

Ultraviolet filter sleeves and absorbing diffusers
Rosco Laboratories, Inc.
36 Bush Avenue
Port Chester, NY 10573

Photographic Storage Vaults, Design and Fabrication
Cargocaire Engineering Corp.
79 Monroe Street
Amesbury, MA 01913
Attention: Garry Le Casse

Harris Environmental Systems, Inc.
11-T Connector Road
Andover, MA 01810
Attention: Bruce B. Bonner, Jr.

Slide pages of thermoformed semi-transparent polypropylene
Saf-T-Stor Systems
Franklin Distributors
P. O. Box 320
Denville, NJ 07834
(201) 267-2710

General Materials for Archival Storage and Display
Bankers Box
Records Storage Systems
1789 Norwood Avenue
Itasca, IL 60143
(312) 893-1600

Conservation Materials, Ltd.
340 Freeport Boulevard
Sparks, NV 89431
(702) 331-0582

Conservation Resources International, Inc.
1111 North Royal Street
Alexandria, VA 22314
(702) 331-0532

Hollinger Corporation
P. O. Box 6185
Arlington, VA 22206
(703) 671-6600

Inland Container Corp.
8501 Moller Road
P. O. Box 68523
Indianapolis, IN 46268

James River-Fitchburg, Inc.
Old Princeton Road
Fitchburg, MA 01420

Light Impressions Corp.
439 Monroe Ave.
Rochester, NY 14607
(716) 461-4447

PermaLife® Division
Howard Paper Mills
115 Columbia Street
P. O. Box 982
Dayton, OH 45401

Photofile
Division of Data Systems Supply
P. O. Box 123
Zion, IL 60099
(312) 872-7557

Photo Plastic Products, Inc.
P. O. Box 17638
Dayton, Ohio 45401
(305) 886-3100

Pohlig Bros., Inc.
25th and Franklin Streets
Richmond, VA 23223

Talas Division
Technical Library Services Corporation
130 Fifth Avenue
New York, NY 10011
(212) 675-0718

The Archive
Box 128
Frenchtown, NJ 08825

The Highsmith Co., Inc.
P. O. Box 25/3500
Fort Atkinson, WI 53538

The Paige Company
432 Park Avenue South
New York, NY 10016

University Products, Inc.
P. O. Box 101
South Canal Street
Holyoke, MA 01040
(413) 532-4277

References

1. The American Institute for Conservation of Historic and Artistic Works.
 A.I.C. National Office
 3545 Williamsburg Lane N.W.
 Washington, DC 20008

2. Eskind, A. H. and Barsel. D., "Conventions for Cataloguing Photographs," Image, Vol. 21, No. 4, International Museum of Photography, George Eastman House, Rochester, New York.

3. Tri-Test Paper Spot Test (Kit), W. J. Barrow Laboratory, Richmond, Virginia.

4. Types of Photographs, International Museum of Photography, George Eastman House, Rochester, N.Y.

5. Rasch, R. H., Shaw, M. B., and Bicking, G. W., "Highly Purified Wood Fibers as Paper Making Material," Journal of Research of National Bureau of Standards, 7 (November 1931): 765-782.

6. Woodward, A. I., "The Evolution of Photographic Base Papers," Journal of Imaging Technology (formerly the Journal of Applied Photographic Engineering) 7: No. 4, 117-120 (1981) August.

7. Parsons, T. F., Gray, G. G., and Crawford, I. H., "To RC or Not to RC," Journal of Imaging Technology, 5, No. 2, Spring, 1979.

8. Fordyce, C. R., "Stability of Cellulose Triacetate," Journal of the Society of Motion Picture and Television Engineers, 51: 331 (1948).

9. Adelstein, P. L., and McCrea, J. L., "Stability of Processed Polyester Base Photographic Films," Journal of Imaging Technology, 7, No. 6, December 1981.

10. Drago, F. J., and Lee, W. E., Stability and Restoration of Images on KODAK Professional Direct Duplicating Film SO-015 (ESTAR Thick Base), Journal of Imaging Technology, Vol. 10, No. 3, June 1984.

11. Lee, W. E., Drago, E. J., and Ram, A. T., "New Procedures for the Processing, Handling and Storage of KODAK Spectroscopic Plates, Type IIIa-J," Journal of Imaging Technology, Vol. 10, No. 1., February 1984.

12. Minagawa, Y., and Torigoe, M., "Some Factors Influencing the Discoloration of Black-and-White Photographic Prints in Hydrogen Peroxide Atmosphere," Fuji Photo Film Co. Ltd. presented at International Symposium on the Stability and Preservation of Photographic Images, The Public Archives of Canada, Ottawa, Canada, August 1982. To be published in the Conference Proceedings of the Society of Photographic Scientists and Engineers.

13. Beveridge, D., and Cole, D. H., "Stability of Black-and-White Photographic Images," Ilford Limited, ibid, August 1982. To be published in the Conference Proceedings of the Society of Photographic Scientists and Engineers.

14. James, T. H., "The Stability of Silver Filaments," Photographic Science and Engineering, 9: 121 (1965).

15. Mason, L. F. A., "Photographic Processing Chemistry," The Focal Press, London (1966), page 202.

16. Mason, L. F. A., Gent, M. A., and Parsons, R. R., "Processing Black-and-White Prints on Paper for Permanence," Journal of Imaging Technology, 7, No. 2, (April) 1981.

17. Walls, E. J., and Jordan, F. I., "Photographic Facts and Formulas," revised and rewritten by J. S. Carroll, Prentice-Hall, Inc., Englewood Cliffs, NJ and Amphoto, Garden City, NY, 1975, pp. 157-158.

18. Lee, W. E., Wood, Beverly, and Drago, F. J., "Toner Treatments for Photographic Images to Enhance Image Stability," Journal of Imaging Technology, Vol. 10, No. 3., June 1984.

19. Bard, C. C., Larson, G. W., Hammond, H. and Packard, C., "Predicting Long-Term Dark Storage Dye Stability Characteristics of Color Photographic Products from Short-Term Tests," Journal of Imaging Technology, 6, 42-48 (1980).

20. Adelstein, P.Z., Graham, C.L., and West, L.E., "Preservation of Motion Picture Color Films Having Permanent Values," Journal of the Society of Motion Picture and Television Engineers, Vol. 79, pp 1011-1018 (1970).

21. Weyde, E., "A Simple Test to Identify Gases which Destroy Silver Images," Photographic Science and Engineering, 16, No. 4, pp 283-286, July-August 1972.

22. Feldman, Larry H., "Discoloration of Black-and-White Photographic Prints," Journal of Imaging Technology, 7, No. 1, February 1981.

23. Hendriks, K. B., and Lesser, B., Disaster Preparedness and Recovery: Photographic Materials, American Archivist Vol. 46, No. 1, pp 52-68, Winter 1983.

24. Carroll, J. F. and Calhoun, J. M., "Effect of Nitrogen Oxide Gases in Processing Acetate Film," Journal Society of Motion Picture and Television Engineers, 64, pp 501-507, September 1955.

25. Hutchinson, G. L., Ellis, L., and Ashmore, S. A., "The Surveillance of Cinematograph Record Film During Storage," British Film Institute, 164, Shaftesbury Ave., London, WC2, England. Also published in the Journal of the Society of Motion Picture and Television Engineers, 54, pp 268-274, March 1950.

26. Kelly, G. B. Jr., "Determination of Alkali Reserves of Papers," Bulletin American Institute for Conservation, 13 (1), 16-28 (1972).

27. Collings, T. J. and Young, F. J., "Improvements in Some Tests and Techniques in Photographic Conservation," Studies in Conservation 21: (1976), 79-84.

28. Van Altena, W. F., "Envelopes for the Archival Storage of Processed Astronomical Photographs," Photo-Bulletin No. 1 (1975) American Astronomical Society.

29. Lull, W. P., and Merk, Linda, E., "Lighting for Storage of Museum Collections—Developing a System for Safekeeping of Light-Sensitive Materials," Technology and Conservation, 7, No. 2 (1982) 20-25.

30. Photographic Conservation, Volume 4, No. 2 (June) 1982 T&E Center, School of Graphic Arts and Photography, Rochester Institute of Technology.

31. Heger, V., and Booth, L., "Extending the Linear Exposure Scale of KODAK Professional Direct Duplicating Film," Journal of Imaging Technology, Vol 9, No. 1 (February) 1983, 18-23.

32. Newsletter, American Institute for Conservation, Vol 3, No. 2, (February) 1978. See also Reference (1).

33. Becker, William, B., "New Life for Old Photographs," Camera Arts, March/April 1982, 96-98.

34. Henn, R. W., King, N. H., and Crabtree, J. I., "The Effect of Salt Baths on Hypo and Silver Elimination" Photographic Engineering 7: 153 (1956).

35. Swan, A., "Conservation Treatments for Photographs," Image, Vol. 21, No. 2 (June 1978), 24-31.

36. Swan, A., Fiore, C. E., and Heinrich, K. F. J., "Daguerreotypes: A Study of the Plates and Process," Scanning Electron Microscopy (1979) 1: 411-423.

37. Barger, M. Susan, Krishnaswamy, S. V., Messier, R., "The Cleaning of Daguerreotypes: Comparison of Cleaning Methods," Journal of American Institute for Conservation, 22 (Fall 1982).

38. Rempel, S., "Recent Investigations on the Cleaning of Daguerreotypes," AIC Preprints (1980), Washington, DC, pp 99-105.

39. Enyeart, J. L., "Cleaning Glass Plate Negatives," Exposure, Vol. 12.

40. Reed, Vilia, "How to Work Restoration Magic on Wrinkled Negatives," The Professional Photographer, (July 1980).

Glossary of Terms Used in This Publication

Antihalation Dyes dyes used in or on the film support to prevent exposing light from bouncing back or reflecting back from the support to the emulsion, thereby improving image sharpness.

Arrhenius Prediction an extrapolated value from the Arrhenius activation energy curve at some designated temperature, humidity and property change.

Buffer* a chemical which, when present in a solution, ensures that the pH value does not change appreciably when acid or alkali are added to the solution or liberated during reactions. Buffer solutions typically contain salts of weak acids and strong alkalis (alkaline buffers) or strong acids and weak alkalis (acid buffers) often with corresponding weak acid or weak alkali added. Alkaline buffers are used to maintain the alkalinity of developers despite the liberation of acids during development. Sodium sulphite and carbonate will buffer at pH 10, sodium borate at pH 9.4. Mixtures of sodium borate and borax or dibasic and tribasic sodium phosphate are typical buffers for maintaining different pH values.

Color Shift a change in color brought about by 1) a differential fade rate (for example, in a red, the magenta dye fades faster than the yellow dye making the red shift orange, 2) generation of an unwanted colored species in an image area (for example, putting yellow in cyan sky making it turn green).

Conservation (Photographic) a term used to encompass both preservation and restoration.

Density Change the amount of change in an image as measured with a densitometer, spectrophotometer or similar device.

Density Range a very useful derivation from the sensitometric curve. The difference between the density of the lightest area and the darkest area of a print or negative. For an example of how density range is used see page 46.

Desiccant* a non volatile chemical which absorbs moisture from the surrounding atmosphere. The desiccant typically employed to keep photographic equipment and materials dry while in cases or packages in humid surroundings is dried silica gel. This material can be regenerated by heating.

Dye Change the amount of dye formed or destroyed as measured by chemical analysis or some other quantitative analytical technique.

Dye Stability refers to the stability, in dark or light keeping, of dyes in color photographic materials.

Ferrotyping a change of surface characteristics resulting in an increase in gloss. This surface is produced on prints by pressure contact to a heated metal drum or an enameled steel plate, or the cover glass in framed pictures.

Floatation a means of coating photographic paper with either a sensitizing or emulsion coating liquid by floating the piece of paper on the surface of the liquid.

Foxing formation of a brown, freckle-like pattern on the surface of the print and/or the mount.

Hydrolyze to change the composition of a compound by reaction with water. For example, the alum in a fixing bath can react with water under certain circumstances to produce a new compound of aluminum-aluminum hydroxide.

Hygroscopic* an adjective specifying a solid or liquid which absorbs moisture from the atmosphere but, in the case of a solid, not enough to produce a solution.

Image Stability used when referring to a change in an image, be it color or black-and-white, recorded on conventional, magnetic, or electronic image recording medium.

Internegative in a two-stage duplication of a print the first copy is made on a negative film and is called the internegative from which a duplicate print is made.

Interpositive in a two-stage duplication of a negative the first copy is made on a positive film and is called the interpositive from which the duplicate negative is made.

Light Fugitive a characteristic of certain pigments and dyes which are subject to fading by exposure to light.

*Reprinted with permission from the Focal Dictionary of Photographic Technologies, Focal Press, Stoneham, Mass.

Microscopic Blemishes* (also redox blemishes) microscopically small colored spots or blemishes which may appear on processed silver-gelatin microfilm after storage. The spots are caused by local oxidation of image silver, resulting in the formation of minute deposits of colored colloidal silver.

Plasticizer* chemicals added to give flexibility to a material, such as tri-phenyl phosphate added to cellulose acetate in a photographic film base.

Plumming/bronzing*
plumming
Bronzing of the blacks of bromide prints due to inappropriate processing or faulty paper.
bronzing
Change to a purple-brown tone sometimes undergone by black-silver images on hot drying which transforms the filamentary silver into smaller rounded particles with decreased covering power and increased reflection. Also known as plumming.

Preservation (Photographic) maintaining a properly processed photographic material—including the image, the base, and the adhesive layer against deterioration or degradation. This normally involves storage in the dark in a non-contaminating atmosphere at low temperature and 25% to 30% relative humidity.

Print-Out refers to increases in minimum density which occur in the light.

Pyro* (Pyrogallic acid, 1, 2, 3 trihydroxy benzene) a developing agent favored by some photographers.

Pyrogallic acid* 1:2:3 Trihydroxybenzene $C_6H_3(OH)_3$. White needle like crystals soluble in water used as a developing agent. Rapidly oxidizes in solution. Also known as pyro or pyrogallol.

Restoration (Photographic) the chemical or physical treatment of the original photographic image to restore its original condition and appearance as closely as possible

Reticulation* wrinkling of the emulsion surface of photographic materials usually due to significant differences in the temperature of processing solutions. Reticulation can vary from a coarse, net-like structure to an almost invisible pattern which nevertheless shows up markedly if the image is subsequently enlarged.

Second Original when original prints or negatives are duplicated by any photographic technique, the duplicate is often called a "second original" by conservators, curators, etc.

Stain refers to changes in minimum density which occur in the dark.

Toning changing the visual appearance of a silver image by converting some or all of the metallic Ag to a different species, such as Ag_2S or Ag_2Se. Diluted toning solutions may be used to improve the image stability with very little or no change in the visual appearance of the image.

Universal Decimal System a decimal classification system designed to classify in an orderly manner all kinds of documentary materials worldwide. Many aspects of photography can fit logically into the photographic classification scheme: manufacturing, products, processing, image stability, storage, display, etc. The International Documentation Institute in Belgium oversees the control and updating of the system.

*Reprinted with permission from the Focal Dictionary of Photographic Technologies, Focal Press, Stoneham, Mass.

Bibliography

This bibliography is intended to provide an additional source of information on the subject of conservation of photographs to those who are interested in broadening their knowledge of the subject. Included are sources of general information on photographic conservation, chemical reference literature, sources of information on the fields related to photographic conservation, and references on early processes. There has been no attempt to compile a complete list.

General

Clark, Walter., "Caring of Photographs," Vol. 17 of the Life Library of Photography, New York: Time-Life Books 1972.

Coe, Brian, "The Birth of Photography—The Story of the Formative Years 1800-1900," Ash & Grant Limited, London, 1976.

Eaton, George T., "Preservation, Deterioration, Restoration of Photographic Images," Library Quarterly, University of Chicago Press, Vol. 40 (January 1970), 85-98, includes bibliography.

Eastman Kodak Company, Rochester, NY, "The ABCs of Toning" (Pub. G-23).

Eastman Kodak Company, Rochester, NY, "Storage and Care of KODAK Color Photographs" (Pub. E-30).

Eastman Kodak Company, Rochester, NY, "Prevention and Removal of Fungus on Prints and Films" (Pub. AE-22)

Eastman Kodak Company, Rochester, NY, "Making and Mounting Big Black-and-White Enlargements and Photomurals" (Pub. G-12).

Eastman Kodak Company, Rochester, NY, "Finishing Prints on KODAK Water-Resistant Papers" (Pub. E-67).

Eastman Kodak Company, Rochester, NY, "Copying and Duplicating" (Pub. M-1).

Eastman Kodak Company, Rochester, NY, "Color Duplicates of KODAK Color Negatives Film" (Pub. CIS-59).

Eastman Kodak Company, Rochester, NY, "Restoring Faded Color Transparencies by Duplication" (Pub. CIS-22 and 23).

Eastman Kodak Company, Rochester, NY, "The Book of Film Care" (Pub. H-23).

Eastman Kodak Company, Rochester, NY, "Storage and Preservation of Microfilms" (Pub. D-31).

Hendricks, Klaus, "Preserving Photographic Records: Materials, Problems and Methods of Restoration," Industrial Photography, Vol. 27 (August 1978), No. 8, pp 30-33.

Hendricks, Klaus, "The Challenge of Preservation" Lecture Notes from SPSE Conference, 1978, May, pp 1-11; SPSE, 7003 Kilworth Lane, Springfield, VA 22151. To be included in a special publication of the SPSE on the 1982 International Symposium. In press.

Industrial Photography, Vol. 27, "Storing Color Materials," Penton/IPC, Subsidiary Pittway Corp., Penton Plaza, 1111 Chester Avenue, Cleveland, Ohio 44114.

Ostroff, Eugene, "Preservation of Photographs," Photographic Journal Vol. 107 (October 1967): 309-314. Published by the Royal Photographic Society of Great Britain, 14 South Audley Street, London W1Y5DP.

Ostroff, Eugene, "Photographic Preservation: Modern Techniques," Royal Photographic Society Symposium 1974.

Ostroff, Eugene, "Conserving and Restoring Photographic Collections," Washington: American Association of Museums, 1975, (105S) Thomas Jefferson Street N.W., Suite 428, Washington, DC 20007.

Weinstein, Robert A. and Booth, Larry, "The Collection, Use and Care of Historical Photographs," Nashville: American Association for State and Local History, 1977, 1400 8th Avenue South, Nashville, TN 37203.

Wills, Canfield and Deirdre, "History of Photography—Techniques and Equipment," The Hamlyn Publishing Group Limited, London, 1980. Printed in USA, Exeter Books, New York, 1980.

Related

Bailey, Donald and Holstead, George, "Darkroom Techniques and Creative Camera," October 1980, Prestone Publishing Co., Niles, Ill. 60648.

Eastman Kodak Company, Rochester, NY, "Photolab Design" (Pub. K-13).

Eastman Kodak Company, Rochester, NY, "Recovering Silver from Photographic Materials" (Pub. J-10).

Eastman Kodak Company, Rochester, NY, "Notes on Tropical Photography" (Pub. C-24).

Eastman Kodak Company, Rochester, NY, "KODAK Professional Black-and-White Films" (Pub. F-5).

Eastman Kodak Company, Rochester, NY, "Disposal and Treatment of Photographic Processing Solutions—in Support of Clean Water" (Pub. J-55).

Chemical

Clydesdale, Amanda, "Chemicals in Conservation: a guide to possible hazards and safe use." Published by Conservation Bureau, Scottish Development Agency, Scottish Society for Conservation and Restoration, Edinburgh, 1982.

CRC Press Inc., 2000 Corporate Boulevard N.W., Boca Raton, Florida 33431; CRC Handbook of Laboratory Safety, 2nd Edition, Catalogue No. 0352 UG.

Eastman Kodak Company, Rochester, NY, "Processing Chemicals and Formulas" (Pub. J-1).

Eaton, George T., "Photographic Chemistry in Black-and-White and Color Photography," Morgan & Morgan, Dobbs Ferry, NY.

The Merck Index, Merck & Company, Inc., Rahway, NJ.

Muir, S. D., "Hazards in the Chemical Laboratory," The Chemical Society, London, 2nd Edition, 1977.

Early Processes

Coe, Brian, "The Early Paper Processes," Royal Photographic Society Symposium 1974.

Crawford, William, "The Keepers of Light," Dobbs Ferry, Morgan & Morgan, New York 10522.

Enyeart, James L., "Reviving a Daguerreotype," The Photographic Journal, November 1970.

Eskind, A. H. and Barsel, Deborah, "Conventions for Cataloguing Photographs," Image, Vol. 21, No. 4, December 1978 International Museum of Photography at George Eastman House, Rochester, NY.

Gill, Arthur T., "The Daguerreotype Process," Royal Photographic Society Symposium 1974.

Harker, Margaret, "The Gelatin-Halide Emulsion Printing Process," Royal Photographic Society Symposium 1974.

James, T. H. and Higgins, G. C., "Fundamentals of Photographic Theory," First edition, John Wiley & Sons, Inc., NY, 1948; Second edition, Morgan & Morgan, Dobbs Ferry, NY, 1960.

Keefe, L. E. Jr., and Inch, D., "The Life of a Photograph: Archival Processing, Matting, Framing and Storage," Focal Press, Boston, MA. 1983.

Moor, Ian, "The Ambrotype—Research Into Its Restoration and Conservation," England, The Paper Conservator, Volume 1, Part I 1976, Part II 1977.

Newhall, Beaumont, "The History of Photography From 1839 to the Present Day," New York, The Museum of Modern Art, 1949.

Reilly, James M., "The Albumen and Salted Paper Book," Rochester, NY, Light Impressions, 1980.

Thomas, D.B., "The Collodion Process," Royal Photographic Society Symposium 1974.